MEN AND STYLE
David Coggins

with a foreword by Glenn O'Brien

Abrams, New York

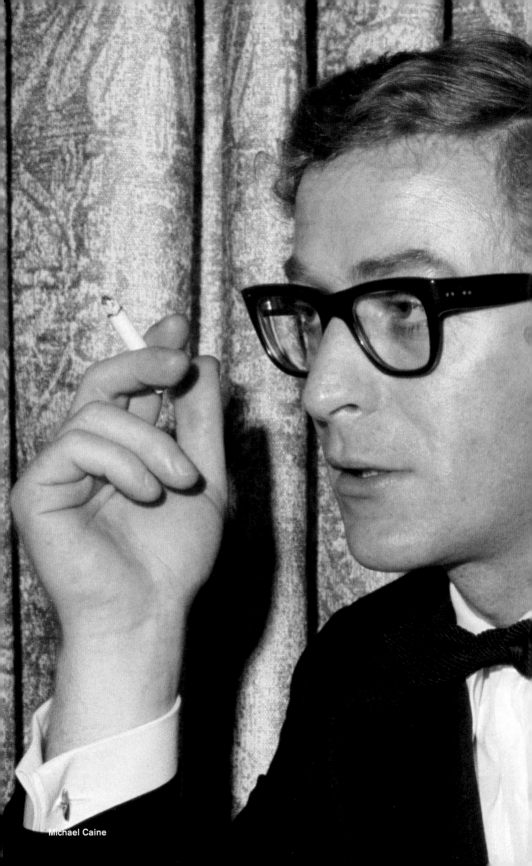
Michael Caine

The Exquisite Propriety of Men

This is not a book about fashion. It is a book about style, that holistic aestheticism that gives us reason for living. Fashion is what the social climbers are wearing; fashion is for followers. The dandy is an individualist, a man of style. He does things his own way, right or wrong—and if wrong, instructively so. If he has anything to do with fashion, he's likely not to notice because it's following directly behind him.

My friend David Coggins, the author of this delightful compendium of sartorial lore and vestmental testimony, is a dandy in the ancient and classical sense. He is not a fop or a peacock, a frak or a flamer. He doesn't make a spectacle of himself. People don't turn around to look at him as he passes them on the street. He is not an idler, a flaneur, or boulevardier—although he could be taken as such. He's quite subtle, when he wants to be. He could even pass for a conservative until you look closely because, as we all know, the devil is in the details, and thus El Diablo is the patron saint of sartorial distinction. Hence the gleam in the eye.

Coggins is relatively discreet for a man of style, lurking in a back booth of the club, dressed very properly, or sitting at home rereading an obscure first edition, wearing the tie of a club he was blackballed from and sipping some obscure distillate. He is a still-curious connoisseur and a historian of oral lore yet to be written. He is, however, a self-deprecating fellow, sometimes to the point of annoyance, and his idea of making a statement is understatement, at which he excels.

Coggins is also a dandy in the philosophical sense, the Baudelairean sense. A true dandy is not that horrible thing called a fashionista. He doesn't dress wondering what might lure the street-style strobe and the photo-remora of the red carpet, but more likely, he dresses according to what will go with a marvelous new pair of cashmere socks. The true dandy dresses to honor himself (only coincidentally to shame the flagrant) and to demonstrate the superiority of the timeless to the latest.

It is likely that the individual dandy's style (and there are many exemplars here) has changed little since puberty. It's quite possible that he inherited it from Dad, as one would a ginger beard or a Roman nose. Fashion is industry; style is culture. That's why this book is important. It's not about trends or marketing. It's about ideas and themes, arts and rituals, the things that constitute culture.

The dandy takes great pains dressing to express himself; this fastidiousness may occasionally be noticed by the hoi polloi, but the dandy's manner of dress is for himself, not for an audience, except those initiates he can count as peers. It is not his intention to draw stares on the street. His intention is to simply follow his knowledge and instinct by any means necessary to create a suitable habitat for his sensibility. The true dandy approaches life as art, doing everything as best he can.

The style of that most famous of dandies, George "Beau" Brummell—the first famous commoner, thus the first celebrity—was not flamboyant as is widely assumed today. He invented the modern suit, and changed the masculine palette from the wild gilt-trimmed peacock spectrum favored by an idle and grandiose aristocracy to the black, charcoal, navy, buff, and dove-gray of the man of affairs. He trimmed the entourage lounge wardrobe to a silhouette favoring the lean and athletic body of a chevalier, a man of action. Lord Byron

said of Brummell that there was nothing remarkable in his style of dress except "a certain exquisite propriety." He was simply creating a style that favored the man of affairs and achievement, not the hereditary landlord; a style that recognized that art, décor, and wit were the coming currency. Today's dandy is also a reformer, the enemy of sweatpants and industrially distressed faux work-wear.

Brummell's revolution coolly expressed disdain, as has Coggins and the latter-day dandies he has assembled as expert witnesses in this volume. These are "creatives." They are not corporate functionaries or the couture clad conspicuous consumers of the 1%. These men are more likely to drive a 9-horsepower Citroën 2CV than a Lamborghini Huracán, more likely to be found in a dive bar than a velvet-roped "table service" joint with knucklehead bottle prices. They are the 1% only in their intelligence.

Coggins and his witnesses are for the prosecution of the vulgarity that surrounds us, that upstages us in mass communication, and dwarfs us in resources. And so we are still following the directions of Charles Baudelaire from *The Painter of Modern Life*:

> Whichever label these men claim for themselves, one and all stem from the same original, all share the same characteristic of opposition and revolt; all are representatives of what is best in human pride, of that need, which is all too rare in the modern generation, to combat and destroy triviality.

Oh, you'll find what looks like trivia here, but its trivia that tells a story and encapsulates an attitude.

This is one of those books that's genuinely hard to put down because it's so easy and entertaining . . . Oh I'll just read *one more* chapter . . . but it's also a book you can take on a trip or even keep

in the loo because it's neatly modular. You won't lose your place or the plotline. It's all about you, about us. It's personal, but also clubby. At times reading this, I almost felt I was reading the yearbook of an imaginary university, with cliques ranging from Cynic to Sophist to Epicurean, and absolutely no requirements other than self-interest and revolt against the status faux. Of course I also know many of the contributors, and, oddly, I found myself almost liking some of those whom I had dismissed for one reason or another. (Almost.)

But the diversity of the expert witnesses here assembled is an excellent thing. It constitutes a *demos*, a community that welcomes considerable differences while sharing a common goal—in this instance, the practice of life as art. And I quite enjoy that it both heals wounds and wounds heels. It is not a manifesto—those are quite unsalable today—but it is delightful testimony from the current crop of true dandies and some of their better imitators.

I think you'll laugh again and again . . . at least twice, perhaps much more. But when you stop, you may think and think again, and dress the better for it tomorrow morning.

And when you're dressing, remember Baudelaire: "[T]he dandy's beauty consists above all in an air of coldness which comes from an unshakeable determination not to be moved; you might call it a latent fire which hints at itself, and which could, but chooses not to burst into flame."

And, of course, Thomas Jefferson: "Nothing gives one person so much advantage over another as to remain always cool and unruffled under all circumstances."

What follows is cool.

—Glenn O'Brien

Higher Learning

As a young man you're taught lessons, and if you're lucky you're taught them by someone wise. But to actually learn them you have to live through failure on your own. A life without certain embarrassments has not been fully embraced—that's why they take your picture at prom. Those photos exist to remind you that you didn't know everything always, especially if you rented a tuxedo. But it only takes one time for you to realize that you wear a sport coat to the 21 Club, bring cash to Peter Luger, and never order a pink cocktail. Ideally, you arrive at this knowledge with your dignity intact. Even if you don't, you have a good story, and you pass your wisdom on to the next man at the bar.

In the most direct sense, this is a book about men's style—what men wear and why. But it's also about emerging from the other side of youth, and having read the books, listened to your father (and argued with him), spent the night at the worst motel in New Mexico, watched your team lose in the bottom of the ninth, bluffed your way through a poker game, drank too much Laphroaig, slept past your train stop in Tokyo—how you still managed to keep it together and become a better man.

Who is the man we celebrate here? He's an artist, an editor, a designer, a writer, a musician—a person who puts something out in the world and makes us have a better sense of it. He's an individual who's himself everywhere he goes, whether navigating the wine list at Le Grand Véfour in Paris or drinking bad beer in Stanley, Idaho. He's not afraid to make the first move or be the last man standing at closing time. He may have well-known tailors, or he may prefer jeans. He may know every World Series lineup, or he may disregard sport. He may stow away first growths, or he may abstain from the bottle. But he has arrived at a place in the world and has a keen understanding about how he fits in it.

Ultimately, I like men who teach me things: what fly works when you're fishing the Madison River, where to find roadside BBQ in Vermont, what's a good orange wine from Croatia, a tailor in Florence, a still life in the National Gallery, a short story by Cheever. These are good things to know; they're why you still carry a notebook. They say if you're the smartest person in the room, then you're

in the wrong room. Hopefully, this book puts you in good company in the right room—one that, in spirit, is both library and open bar.

Most of the men interviewed here are friends, a few are strangers I admire who kindly agreed to contribute, others are men I find intriguing. It's highly unscientific—isn't that the nature of friend-ship, admiration and intrigue? This is not about being all things to all people, it's about learning from singular men who've lived well and have something to tell us about how they earned their worldview. They're smart enough to absorb the wisdom that's hidden in the world, and even smarter to wear that wisdom lightly.

Salut!

D.C.

Beginnings

How do you begin to write about the way we dress? Like many things, you don't recognize a pattern when it begins, the contours just become clear in retrospect. My interest in clothes when I was a boy growing up in Minneapolis was not historical or wide-ranging, it was intense and specific and, unfortunately, involved a pair of red suspenders when I was twelve, which I wore on the rare occasions I deemed worthy.

A childhood with creative parents, a Montessori education, artist and actor friends coming to our house for elaborate but informal dinners, a lot of travel, a love of art and literature—these things seemed normal. So did the antiques, uncomfortable wicker furniture and lack of cable TV, sugar cereal, and microwave. I remember sitting at large tables in formal French restaurants as our parents prayed that my sister and I, dressed in our finest, would behave. We still travel, still have favorite restaurants, and still dress up.

Your eccentricities start to become clear the farther you get from home. When I arrived at college in a small town in Maine, my father dropped me off at my dorm. My roommate had arrived early to train as a cross-country runner, and he had furnished his side of the room simply, with a motivational running poster, a Boston Red Sox cap, and an industrial-sized bottle of Listerine. My father looked at this blue mouthwash with wonder. "You're going to meet a lot of people here who are different from you," he said with strained optimism.

College dorm rooms, with their democratic down-the-middle decor divisions, are perhaps the starkest display of differing sensibilities. I dutifully pinned up posters of morose British bands and stowed a fly-fishing rod I mistakenly hoped would get use. I carried a Baudelaire poem in my pocket, and—wait for it—used a shaving brush that had a been a graduation gift.

Outside the dorm my habits were remarked upon. In a word, they were judged formal. Not that I wore a tie to class, but a button-up shirt and cords apparently signaled a certain amount of propriety. There was a lot of Polo Country (the discontinued Ralph Lauren line, still beloved and sought after in Tokyo vintage stores). I refined these habits on visits to New York, a semester in Paris, and train trips around Europe. I worked the *Herald Tribune* crossword with a friend who smoked avidly—at the time, the Tuesday

Alain Delon in *Purple Noon*

puzzle was the limit of our collective abilities. I returned to Maine feeling very continental, and wore soccer jerseys under a sport coat, which is not a look I recommend.

From my father I had discovered Paul Smith, and on trips to New York I would visit the store on Fifth Avenue and Sixteenth Street. I was intimidated and fascinated by this wry take on British decorum. That store closed not long ago (along with Union Square Cafe, which was nearby), which seems to represents a shift from a certain elevated ease in dressing (and dining, for that matter), before the Internet, Instagram, and the rest.

When I graduated from college I moved to Tokyo and was an English teacher of no particular distinction. I was an active visitor to the Barneys in Shinjuku, where I studied endless rows of suits and plotted acquisitions, like my hero A. J. Liebling studying menus in Paris and planning meals when he would have money to afford them. Dressing interested me then for the same reasons it does now. How you present yourself to the world, how you convey what matters to you, what you aspire to (and what you don't)— these things are never indifferent. And in the ideal case it's an expression of self-knowledge.

After a year in Japan I moved to New York. It was 1998, and I've lived in the city since then. I wrote about art for a number of years. But then I started to write for magazines and Web sites and newspapers about things that I liked but seemed less lofty: drinking, fly-fishing, traveling, tailoring. All these things are enjoyable, and there's a risk granting them more import than they deserve, but they give me so much pleasure, and writing about them heightened my sense of appreciation.

Dressing has the power to reassure and to shock. Certain well-dressed men communicate traditions that existed long before you were born. Have lunch at Wiltons on Jermyn Street, a favorite of R.W. Apple's, and you'll see a few. There are cutters on Savile Row who learned from the men who made suits for Winston Churchill. You can also be surprised and forced to reassess what you thought was allowed. Tokyo is a good place for that, but Naples is just as good. I remember being in Naples on a sweltering June day, admiring a man in a mustard-colored suit who was impervious to the heat. He had his cell phone tucked inside his helmet so he could talk while winding through traffic on his bike. He wore his formality lightly, on his own terms. It goes without saying that he was smoking a cigarette.

A wardrobe, like an apartment or a library, takes years to build. Doing it all at once doesn't work, because few people have that much self-

knowledge. Over time it evolves, just as you do. Men's clothing isn't that complicated. What worked for the last eighty years, with few variations, still works. A well-tailored coat will serve you well most places you go, particularly if you've been subpoenaed. If you think that's superficial, then consider whether you would hire a lawyer who wore a plaid shirt to work. But just because it should be simple to dress well from an early age doesn't mean it is—your adolescence gets in the way, and advice from your father goes out the window for reasons that make perfect sense to a teenage boy, if no one else.

This book is about the mistakes that are an integral part of the path to ultimately getting it right. The lapses in judgment are specific to each of us, but recognizable to all. We've all mistakenly worn red suspenders thinking we're the best-dressed one in the room.

The Power of Clothes

At some point the power of clothes becomes clear to everybody, usually because you're overdressed or underdressed, or, perhaps, not at all dressed. To me a formative moment came after a summer trip to Europe when my parents bought me a pair of white Adidas tennis shoes. But where the laces should have been there were no laces, there was only Velcro. Two strips of irreverent, contrarian, paradigm-shifting Velcro.

At that time, summer of 1982, I was nearly seven, and Velcro shoes had not yet blessed these shores. America may have invented baseball, the Weber, the Jeep, and the martini, but it did not invent Velcro shoes. They had more cultural traction than you might expect. It wasn't the arrival of the Beatles, but the novelty of these shoes that caused a downright uproar at my school. Nothing this unexpected had been seen since Liz Lauer found a condom in the gutter near the playground.

But while the condom's intended use was not clear to many of us, the Velcro Adidas were instantly and well understood by all, and very much an object of desire. People wanted to try affixing the Velcro, then retry it, and we arranged to do this in covert corners away from a teacher who understandably found the sound annoying. These shoes were better than sugar cereal, better than *Centipede*, better than snow days.

I cherished every day that Velcro shoes were not available in America, and the exoticism did not diminish. I'd like to think I outgrew this, but in high school I overpaid for rare import CDs that contained one song unavailable on the American version. Later I hauled back seemingly exotic orange Penguin paperback books from London, where they're readily available for a pound.

Sometimes people want to have something—must have it!—whether it's rare (the frenzied eBay bidder frantically refreshing a bid) or widely available (the person who camps outside for an iPhone). There are other examples: the crazed look in the eyes of otherwise sane women in line at sample sales, *Star Wars* devotees who would rather sit next to someone in costume as long as it's opening day. Some people want to be part of a collective cultural moment; some will do anything to stand apart. Sometimes these are both the same person.

A scene from *Le Million*

17

An accomplished fly fisherman I know says that he likes to pursue fish where people are not. In theory, he couldn't be more right. He was lucky to fish legendary water on his own in the seventies, as he loves to point out. But it's a more crowded world, and it's hard to find what we want away from the masses. Not only that, but it's difficult to keep up the pace if we measure our taste in relation to how rarefied it is—there's always a more obscure band, more avant-garde Japanese denim label, more under-the-radar bar.

I would prefer that people aren't able to tell where my clothes are from. And I don't usually tell them. But what sets you apart, of course, isn't anything you can acquire—I think Santa Claus told me that when I asked for a cement truck. He was trying to give my parents an escape hatch for my inevitable disappointment. I was shrewd enough not to believe Santa then, but it's still worth remembering him now.

The reasons boys like clothes are rarely clear after the fact. When the passions of the moment recede you wonder why you're wearing the same shirt in every sixth-grade photograph. This irrationality is just as true of music—which is why you spent a week listening to the Steve Miller Band before storming back to sell the CD at a loss to the same clerk who should have talked you out of it in the first place. (Record stores once had rows of abandoned Steve Miller Band *Greatest Hits* CDs—it may be the most discarded album in history.)

Tom Schiller

Boys plastered their walls with posters of bands, athletes, and TV shows. I once had a brief, intense interest in Michael J. Fox, though somehow I never realized he was from Canada. I remember that around the release of *Light of Day* (starring opposite, ahem, Joan Jett), he filled out a magazine questionnaire in his own handwriting (like a *Playboy* Playmate), that included the revelation that his favorite food was linguine with clam sauce. This very specific answer made me, at age eleven, seriously reconsider an aversion to bivalves.

I also coveted a two-tone jean jacket that he wore in *Back to the Future*. This was before the Internet, of course, when I could have found likeminded obsessives seeking similar jackets in poor taste. Just as likely, I would have discovered contrarians whose snark would have shaken sense into me before I made escalating eBay bids trying to acquire an ill-advised blue-gray jean jacket. I also wore a vest over a Baracuta jacket, following his lead, but I'm afraid to have that confirmed by my parents.

The Internet could also have warned me about the folly of sporting clothes in civilian life, a minor calamity still afflicting boys and, alas, many men, especially in the Greater Boston area. Returning from a trip to Europe one summer, I had acquired shorts that were long in the French style. I took this fortuitous opportunity to hike my favorite striped tube socks to my knees in direct imitation of the NFL players whose on-field style I so enjoyed. I did this far from the football field, which is a bit like wearing a toque around your room because you like French chefs. The Gallic shorts–American tube socks mash-up was a tragic undermining of the style of two separate and sovereign nations.

As luck would have it, the shorts were turquoise, the color of my beloved Miami Dolphins, whose quarterback, Dan Marino, was another of my unalloyed heroes. I liked things from Miami, which was strange since I grew up in Minneapolis and had never been to Florida, not even to the mythic Walt Disney World (which my sister and I heard, from trusted reports, was far superior to Disneyland). When I finally went to Miami twenty years later, to write about Art Basel, the axis had tilted, and I was as petrified walking down Collins Avenue as the first time I went to the orthodontist to get fitted for headgear.

The mid-1980s was the era of *Miami Vice*, and I was a true partisan, though I only vaguely understood the show. This Miami attraction infected my musical taste as well: I was deeply familiar with the *Miami Vice* sound track, which I owned on cassette, with the once ubiquitous instrumentals of

Jan Hammer. It sat on my shelf next to the less popular *Miami Vice II* sound track, for those rarefied enthusiasts for whom one installment of brooding keyboards was not enough (the cover showed Don Johnson sporting a newly feathered crew cut, perhaps the most divisive hair shearing outside of Al Pacino in *The Godfather: Part III*).

This rabbit hole led further down into a curious Don Johnson phase that involved a Halloween costume (whose effect was lost on most households in our neighborhood), and pins of Don himself that I wore on suitably Crockettesque light-colored jackets. I was one of the tragic few whose love for DJ was so intense that we were compelled to acquire his solo album *Heartbeat*. The title track's refrain practiced repeated, unswerving simplicity, like a hammer pounding a nail: "Heartbeat / I'm looking for a heartbeat."

It's all a reminder that childhood obsession is as immune to aesthetics as it is to logic. It's driven by passion and evocations that don't make sense to anybody else—even to the same person a little while later. You love a city you've never visited, a car you've never sat in, a sugar cereal you've never tasted. But in the eyes of boys, taste can't be explained—and shouldn't be—any more than it can be rationalized when you're older, supposedly wiser, certain in the knowledge that you'll never suffer a lapse in judgment ever again. That's why grown men never get divorced, make bad decisions, or wear flip-flops in public. Unfortunately, the promise of perspective is always just around the corner.

HOW DID YOU DRESS AS A BOY?

"I dressed poorly as a boy, but with a sense of adventure. I famously wore underpants over my pants in the effort to look like a superhero. I think a lot of young people have done this."
–Nick Schonberger

MICHAEL WILLIAMS I was the type of kid who would drag my mother from store to store to find the perfect outfit when we went school shopping. I've always been very particular. I distinctly remember going into the Gap, and saying, "Well, that color isn't right, it's not the right shade." Today I'm exactly the same way.

Wesley Stace

POGGY As a teenager I was so obsessed with clothes. I would go shopping with my girlfriend and she asked me, "Which do you like more, the clothes or me?" And I said, "Well, the clothes."

ALEXANDER GILKES My parents tell me that even from before I can remember, my mother would leave

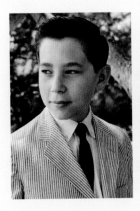 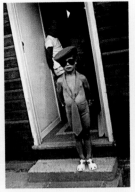 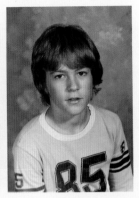

> "As a boy I remember my mom telling me that I hated stripes, horizontal stripes specifically."
> —Randy Goldberg

Clockwise, from top left: Tom Schiller, Jeremy Hackett, Mark McNairy, Hiroki Kurino, Enoc Perez, Brian Awitan, Shin Nakahara, Shin Nakahara with the sumo wrestler Takanohana

out my clothes for the following morning and would then find that I had changed everything she had left out to wear exactly what I wanted to. I think back in the day I would sport a lot of Benetton 0–12. Viva los eighties!

STEPHEN COATES I dressed quite formally. My father was quite formal. Button-up shirts, always with socks pulled up. I remember having an upright childhood, which I liked. My mother was very particular about clothes. We were very well turned out. On Sundays it would be very formal. I was a very strict Catholic, and every year was a parade. All the children from Catholic schools had to wear the same clothes—you got a new outfit every year, which was probably chosen by the priest. Then that outfit would deteriorate during the year because you wore it all the time. A year later, at a new parade, you'd get a new outfit. It was nice to see all these kids in these immaculate crest shorts and long socks. I liked that.

RANDY GOLDBERG I made a lot of mistakes—I wanted a purple suit, with all seriousness. I remember shopping at Merry-Go-Round and wanting flashy things.

WALTER KIRN I grew up in a small town in Minnesota, which is probably as unconscious of a place, in sartorial terms, as exists in America. If I was dressing for school, the idea was to get down to the mall in the Twin Cities and get the latest

Chess King jeans. They were really rugby shorts. I wanted to look like something I saw in the movies or on TV. It would have been a California look. We'd cut the sleeves off our shirts; we'd cut our own shorts in the summer. I don't think I've ever owned a pair of dedicated shorts.

WHIT STILLMAN I remember an announcement at school lunch once that there was a lost jacket. They said, "We have this lost jacket, and it's from Barneys Boys Town." And there was this massive laughter—that was before Barneys went upscale. It wasn't mine, thankfully.

J. C. MacKENZIE My first obsession with clothing was with an oversized pair of blue, wide-wale corduroys, worn until threadbare. I was seven. They had large pockets, lined with flannel, which held a frightening amount of boy paraphernalia: toy cars, Goldfish crackers, bottle caps, Pop-Tarts, guitar picks, and rocks. I was obsessed with comfort and loved anything jumbo-sized. Large shirts, large coats, large pants—anything big, I was happy.

DAN ROOKWOOD I grew up in Liverpool during the 1980s, when the city's two football teams were at the height of their powers. Until I was thirteen, I embodied the Scouser stereotype of wearing a shell suit—a synthetic "shell" tracksuit that was very likely a serious fire hazard—and a Liverpool FC replica shirt. It wasn't until I left Liverpool at thirteen that I learned there was

more to life than stink-incubating polyester sportswear.

AARON LEVINE I would gravitate toward certain things. There was this certain polo shirt with a fox on it that I loved and an uber-small running short and a cowboy hat that I liked.

MARKLEY BOYER I'm afraid that I came to dress myself for the first time in the suburbs in the mid-seventies, and I don't think that anything particularly good emerged from that period. Before I became a little rebellious, I seem to remember a lot of turtlenecks—maybe white turtlenecks? And a lot of velour shirts—possibly purple. And

ALEX BILMES The first item of clothing I lusted after was a Nike windproof. That's what the Rock Steady Crew wore. My dad was very conservative—Church's brogues, pinstripe suit, worked in the City—and I was trying to dress like Crazy Legs.

HIROFUMI KURINO My first inspiration was western movies. My mother was a movie lover, and she took me to the movies when I was very young. I was really impressed by 1950s cowboy movies—the good guy wore white and rode a white horse, and the bad guy wore black and had a black horse. The medium guy wore beige and rode a palomino. I wanted to be the man in white. Then I realized the man in

> "My father didn't make any boys' ties other than those he made for the young princes William and Harry. With tie cutting, if you're cutting one it can make sense to cut four, as long as the patterns are identical. So my father would make one each for the princes and one each for my brother and me. We'd all end up with the same ties." –Michael Hill

corduroys—thin-wale corduroys, brown, I think. The whole thing was not so good.

GUY TREBAY I was pretty basic—suburban kid clothes. I remember wearing slip-on Keds, I remember wearing a wool dickey, whatever a dickey was.

white was actually very cheesy. So I eventually found the charm of the bad guy in the black shirt or the supporting guy with the brown suit.

MICHAEL HILL My father was a tie maker and he said, "Look, we can work together on this." He gave me the same sort of advice he gave the buyers he used to work with:

Choose a solid and then perhaps a motif, a madder print, a rep tie that would work with my blazer.

TOM SCHILLER I remember these German Loden jackets that I liked to wear to my parents' parties. I'd pretend to be a waiter, holding a white napkin over my arm, and go around to people. I was about six or seven. This was in Westwood Village at the former home of Ricardo Montalban. If you grew up near Beverly Hills, it was more normal to get dressed up to go to dinner or to a show or, in my case, to go to the filming of the *I Love Lucy* show. You had to get dressed up for special occasions.

ARMANDO CABRAL When I was a young boy, I used to wear socks up to my knees with shorts or pants. I never wore jeans in the beginning. That was something that I've learned from my dad. Before leaving the house he was always dressed up in a suit with the tie. I think part of my classic reference comes from that.

MARK McNAIRY I wanted to make decisions at an early age. I wore bell-bottom Wranglers with a patch pocket and a button fly. I remember getting them and being so excited and going out into the streets and kicking my heels to rip up the back. They were from Sears in Greensboro, North Carolina—where all my clothes came from.

> "I used to get my hair cut at a place called Michael's on Eighty-sixth and Madison, and their most popular cut was called the John John, of course a reference to John John Kennedy, not that I knew that. They had a special room in the back for criers, with which I was intimate as a little boy. Only later was I able to handle sitting in the little cars."
> –Thomas Beller

Nick Sullivan and his brother Jonathan

NICK SCHONBERGER I grew up in an era where wildly multicolored trousers were quite popular. They must have been inexpensive, as I was allowed to wear them. In the late eighties and early nineties I became cognitive in things I wanted to own.

My mother still dressed us in a proper uniform, even though the school didn't have one—so she made one. It was a red check shirt, gray little short shorts and long socks that you pulled up, with elastic to hold them up, and black polished shoes. That's what we wore every day, even though no one else wore

> **"I'll put it to you like this: I dressed as Burt Reynolds for Halloween when I was seven."**
> —Josh Peskowitz

RICHARD CHRISTIANSEN I had a twin brother and we always dressed the same, every single minute. We went to country school with around twenty-two kids in the entire school.

it but us. She got some of the other kids in school to wear them too.

NICK WOOSTER The clothes have changed, the proportions have changed, but the approach is 100 percent the same. Starting in kindergarten, I refused to let anyone tell me what to wear, and if they did, there was hell to pay. I've rebelled against dress codes and advice all my life.

ANDY SPADE My uniform was Vans sneakers, Levi's 501s, OP corduroy shorts, Hang Ten shirts or Lacoste shirts or logoed T-shirts with skateboard or surf logos on them. Virtually every day I wore Stan Smith sneakers. I never wore loafers. When I was younger than that, I just wore striped T-shirts you'd see in the sixties. My mom would dress me. I had cutoff jeans and also PRO-Keds—you shopped at Sears in those days.

Henry Conover Boyer (Markley's great-grandfather)

NICK SULLIVAN I grew up in the 1960s. I was on the cusp between postwar England and modern England, which happened in the seventies. Invariably I would wear hand-me-downs that were kind of rough. I wore a lot of home-knitted

I probably didn't wear an oxford shirt or knit tie again, but now I do practically every day. So there it was. A taste of what was to come.

EUAN RELLIE I would wear different tweeds, very heavyweight,

> "There was a turquoise alpaca V-neck sweater that I told my mom I wanted really bad. She got it for me with my initials on it, and then I refused to wear it. I can still remember her chasing me around the block one morning, trying to make me wear it." —Mark McNairy

sweaters with buttons on the shoulders. There were always endless Christmas presents of yet another chunky sweater. I wore those in the summer too, because it was England.

JAY McINERNEY Even though I went to a public high school, I thought the way to go was to dress preppy. When I was in junior high the style was Brooks Brothers, L.L.Bean—that seemed like the easiest way to dress. It was something that I was raised on.

JAY FIELDEN I got obsessed with having to have a button-down shirt. It was my reward for doing my science fair project, which I somehow went on to win. I'm not a scientist, as you know, so it was clearly a complete accident. But I remember—this is not an exaggeration—I also wanted a navy knit tie to go with it. For twenty years after that,

proper tweed. Made in Harris you would have forest green all the way through stony green.

THOMAS BELLER One of the great distinctions of my childhood that blows my mind, now that I have to deal with parenting today, is that I traveled on my own in Manhattan as a kid. I took the crosstown bus to school as a third grader.

GLENN O'BRIEN When I was a kid I loved costumes, so I'd have my parents buy me an army uniform—it seemed like they were more available in those days. It had chaps and a white hat and a pistol. Then I'd be a soldier another day. Aside from that I dressed the way I dress now.

MATT HRANEK I was very preppy. I lived for anything Lacoste. I was very into L.L.Bean and Blucher mocs.

28

> **"I was forced to leave school because I grew my hair as a protest. Hair length was a big issue."**
> –Stephen Coates

BRUCE PASK I have a twin brother, so for the two of us, we were always identified as part of a unit. Dressing became a way to individuate within that unit, so we broke into color groups. I was always blue and Scott gravitated toward other colors, sometimes green. I felt like I owned blue, also as a means of identification: Bruce = blue, so people could tell us apart a bit easier.

FRANK MUYTJENS I grew up in a small village in Holland that was quite traditional, and the last thing I wanted to do was stand out, so I just wore what everyone else was wearing. That was in the early seventies, so it was a lot of polyester, printed shirts, patterns, cord pants, and turtlenecks. One of the first things I bought, in the early seventies, was a T-shirt with the American flag printed all over it. It was my favorite.

MICHAEL HAINEY I grew up without a father; he died when I was very young. And we didn't have much money, so I wore a lot of hand-me-downs from my older brother. So from even a young age I learned that less is more. I learned style is like friendship—it's not about quantity, about how many items you have, it's about quality; it's about making the most out of the least. As a kid I was particular about what I wore. I really loved navy and tan in combination. I remember I had Levi's cords, in navy as well as tan. And I had two great crewneck wool sweaters, one in navy and the other in dark brown.

G. BRUCE BOYER I was becoming a teenager just as zoot suits were going out of fashion. That was the first thing that I experimented with: what jazz musicians would wear. I just thought it was a sharp thing, that these guys were sophisticated.

JOHN BRODIE I think from one of the earliest times that I was cognizant of getting dressed, there was a dress code, which was coat and tie: no jeans, no sneakers. The blue blazer was my workhorse. I'd go with my mother to get outfitted at Brooks Brothers, which had its own designated boys' corner back then.

WALTER KIRN For fishing and hunting, I wore clothes that I later realized were pretty cool, like Red Wing boots, or down in St. Paul, we had a store called Gokey's. Those clothes were ones that lasted and ones I liked to wear. There was a certain cachet of showing up in school in hunting clothes, because sometimes you'd hunt before school. We tried to avoid as much as possible "the

lumberjack look," because we had a sense that for a seventies Minnesota kid, that was to be avoided.

TOM SCHILLER My mother would always take me to a place called Carroll and Company, which was a Beverly Hills men's clothier. I was nine or ten, and I got a little suit and little jacket and itchy wool pants. I liked it. These guys would throw on my jackets and flip me and everything. It was like being treated like a little prince!

POGGY When I was a teenager living in Sapporo, I was very inspired by Japanese magazines. It was the only way to find people like me who were into street style and companies like Bathing Ape. I was obsessed with magazines and would be at convenience stores as soon as they arrived. The magazines that didn't come to Sapporo, I had to call and ask them to send them.

> **"I became a real devotee to mousse."**
> —Jay Fielden

FRANK MUYTJENS I remember that I asked my mom to make a vest, and it was fake suede. It had metal clasps and I wore it all the time. I sat next to her while she was sewing it. It was very unself-conscious. I wasn't supposed to go into fashion; I wanted to be a graphic designer. Then I went to art school, and the idea became clear to me.

GLENN O'BRIEN I was always really into clothes. I guess I was a preppy. Pittsburgh had a Brooks Brothers; we didn't have a Brooks Brothers. But I used to shop at a store in Rocky River, Ohio, called Captain's Quarters. They stocked a lot of really East Coast brands. I had every flavor of Gant button-down shirts. I still wear a lot of the same things. I still love saddle shoes and tassel loafers.

NICK SULLIVAN We started going to France. It was hugely exotic. We started to go to a house in the South of France with friends of ours. It involved a rather long journey on the Train Bleu, through Paris, overnight—it was so exotic, and we would wake up in this completely different world, this Mediterranean world.

MICHAEL WILLIAMS One day I would dress very preppy and the next I'd be inspired by hip-hop, which was pretty forgettable.

JEREMY HACKETT I was a precocious child, and from an early age I had pretty clear ideas as to how I wanted to dress, much to the annoyance of my parents. In my scooter-riding youth, I dressed in a mod-meets-skinhead fashion, wearing button-down shirts, Shetland crewneck sweaters, Levi's cord jeans, and Clarks suede desert boots.

RUSSELL KELLY I was one of three skateboarders in Arkansas. I was

obsessed with skater style and 21 Jump Street. I wanted to be like Johnny Depp with the hair and unbuttoned cuffs and not quite grunge but, like, high school spretz.

SID MASHBURN I was really into clothes at a young age; I was always trying things out. For a little while life was like a costume party for me. When I was in the fourth grade in 1971, I wrote a letter to my older sister asking her to find me a choker and some green pants.

BRUCE PASK I remember being particularly obsessed with a pair of blue plaid Sears Toughskins trousers, though the proper term then was slacks, when I was in first or second grade. It was the early 70s after all.

ERIC DAYTON I was really into color but had no idea what I was doing. I used to have purple Girbaud jeans that I would wear with my favorite green North Stars T-shirt, a color combination that only the Joker can pull off. It was a real shit-show.

TIM SCHIFTER I distinctly remember going to Brooks Brothers every August with my mother to buy my back-to-school wardrobe, which consisted of wide-wale tan corduroy suits, button-down blue oxford shirts, and penny loafers.

TUNDE OYEWOLE I was nine years old and my aesthetic was 100 percent New Wave—or at least my interpretation of it. There was a store in Georgetown called Commander Salamander, and my parents were kind enough to take me there on pilgrimages.

ROB ZANGARDI In grade school, in Ohio, my twin brother and I owned a lot of the same things, but in two different colors. This made for some interesting styling techniques: wearing two different color sneakers, multiple watches on the same wrist, and so on.

TAAVO SOMER In nursery school, I remember being obsessed with the idea of playing army. I remember going to the Army Navy store and wanting army clothes that of course did not fit me. My dad wanted me to try clothes on right in the store, but it was very uncomfortable and the aisles were packed. He said, "Just try this one," and I said, "No!" My mom did a lot of sewing, and she altered those army clothes to fit me.

My mom brought me to Sears, which had a boys' brand. Aside from making lawnmowers or craftsman tools, they also apparently have a suit section for little boys, and I remember seeing the suit and hating it, not because it was a suit but because I just didn't like the fabric. I liked materials and textures and the tactility of things, and even at age six I thought, This is not a good fabric.

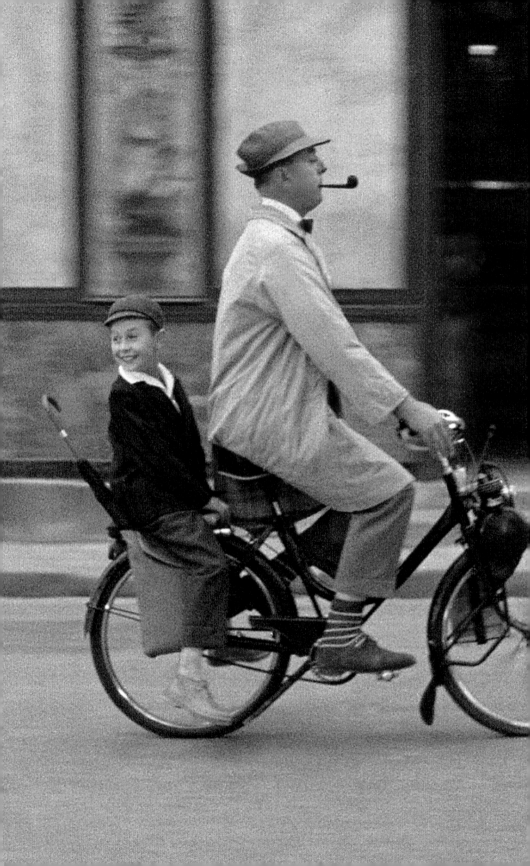

Certain Advantages

In my younger and more vulnerable years my father gave me a copy of *The Great Gatsby*. "You should read this," he said, as if the matter was settled. I did, and of course I was enthralled. The book belonged to a world of things that should be known: how to navigate a wine list, for instance, or what sartorial rules can be broken. And you simply must be able to drive a car with a manual transmission. In an empty parking lot I peeled out fiercely while my dad sat stoically, a prisoner in the passenger seat. "A little easier on the gas," he offered calmly, as the tires nearly smoked. I was sixteen. I've driven a manual ever since.

Cultural overlap is a good thing—being familiar with the current exhibition at the Met, say, or Anthony Lane's latest review in the *New Yorker*—but it can lead to the occasional aesthetic friction. Over the years my dad and I have clashed verbal swords with enough ferocity that acquaintances look on with concern.

When I graduated from college my parents gave me a first edition of *The Great Gatsby*. Holding it was surprisingly intimate, and you could imagine what it was like in 1925 when the book was new and nobody knew what lay ahead for Jay or Nick or Daisy—or, for that matter, any of us finishing school that day.

My dad asked me to look again at the first page, where Nick recalls advice from his own father. I remembered the first line, but not the second. I read aloud: "Whenever you feel like criticizing any one just remember that all the people in this world haven't had the advantages that you've had."

My dad smiled—I knew which advantages he meant.

Jacques Tati in *Mon Oncle*

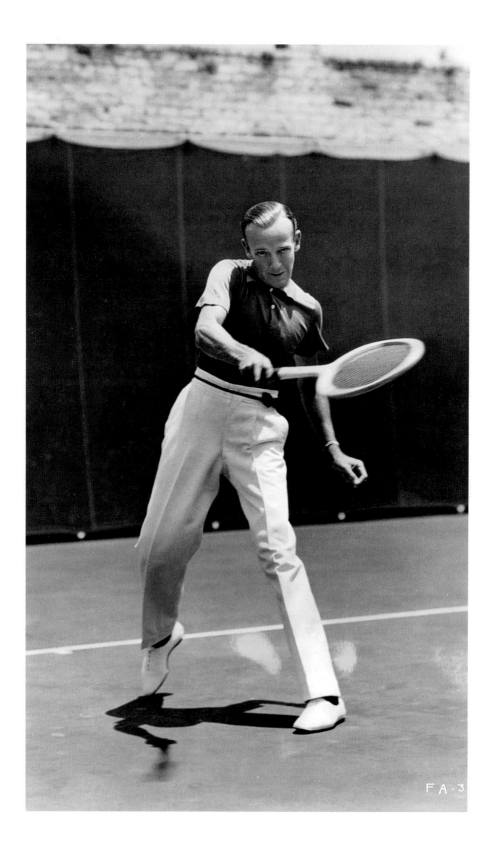

FA-3

Rituals of Court

Growing up, I had a weekly tennis match with my dad Saturday mornings. He believed there were certain things that you should just be able to do, like get your first serve in most of the time. That led him to serve and volley even when his serve disappointed, which I realize now was less a sporting strategy than an exercise of principle.

My dad is tall, six foot three, an accomplished athlete, and a direct player. An acclaimed high school point guard (game-winning shot, wearing Converse: photo on the cover of the *Washington Post*), respectable college quarterback for a woeful Colorado College team (he received offers to try out for the Baltimore Colts, though he had stopped playing after his junior year). I did not inherit his height, or his right-handedness. A lefty, I relied on a kick serve that didn't kick enough (like satire without enough bite). I was solid off the ground with good hands, a counterpuncher, with occasionally fierce passing shots. Both of our games have fallen into severe disrepair, and I play more squash, a sport that allows you the satisfaction of hitting the ball as hard as you like, even when it's tactically ill-advised. We would go afterward to the Lincoln Del and order a Rachel sandwich—a kraut-free variation of the Reuben—and undermine all our good work.

Looking back, I'm interested in my dad's ensemble. He wore a cricket sweater, purple and black stripes at the V-neck. It struck me as a bit feminine, which bothered me at the time. He carried his racket to the court in a canvas carpenter bag with the handle sticking out. I carried mine in a large professional bag, as if I were on tour and needed a change of clothes, multiple rackets, some protein powder. It was basically empty.

Only later I appreciated this contrast between his refined sweater and rugged bag, like something you'd see in an old Jack Spade ad. I thought of that during my junior year of college when I was studying in Paris. That fall I began a lifelong habit of frequenting cafés, bars, and restaurants, a strategy I recommend in the strongest terms. I went, nearly every night, to a café on the rue de Seine called La Palette. It is well known, though it was not well known to me at the time. I was naive enough that when, after an evening with friends, our perfectly reasonable bill arrived and was seventy-five dollars, I couldn't imagine a bar tab that high.

Fred Astaire

The man who ran that café had a salt-and-pepper beard and stood at the door appraising passersby. A neighborhood fixture, he practically marshaled traffic on the corner and he prowled the empty tables, wiping them with a white towel, whether they needed it or not. He was endearing to regulars and brusque to Americans. He was cool to me until the eighth or so night when, instead of reading novels, I began to bring girls there. Finally he said, "*Comment tu t'appelle?*" which was in the range of my limited French. "*Davide,*" I replied, Frenchifying my name. "*François,*" he said. "*Jean François.*"

On these new terms, he asked if I played sports. When I told him that I played tennis, he raised an eyebrow. (In fact, I was loosely affiliated with my college team, one of its worst players, except for a Japanese exchange student. He and I were exiled to the court farthest from the players of merit, like sick soldiers quarantined from the healthy, lest we infect them with our erratic ground strokes.)

On the day assigned, I was to meet Jean François at the place de l'Opéra. I had not traveled with exercise clothes, so I wore a U2 *Achtung Baby* T-shirt, some shorts I slept in, and a pair of blue Velcro shoes that Sylvain, one of the bartenders at La Palette, had donated to me, eager to contribute his part to the big match, the cause of much curiosity at the café.

Forty-five minutes late, a large silver Mercedes sped up to the steps and stopped with the aggressiveness of a car in a getaway. Jean François emerged wearing a black baseball hat that said, of all things, FBI, in large white letters. I ran down the steps. "You know it's daylight saving, right?" he said—I had never heard him speak English. That meant he was fifteen minutes early. "Yes, of course," I lied, not wanting to admit how uninformed I was in my adopted city. I got in his car, which was playing Enigma loud enough that we didn't have to speak as we drove toward the Périphérique.

When we finally arrived at his club, we entered the white bubble, and he asked me if I wanted an espresso and croissant before we played, as if that was the most natural thing in the world. I had only been drinking coffee for about a month but said yes and realized that this was a far different protocol from my matches with my dad.

The tennis, you ask? We played a set and a half. His game was impassioned but erratic. He swore. We kept score in French (*égalité!*). He told me I was fast ("*comme un lapin*"). Like many Frenchmen, he had surprisingly small feet. It was a good day.

A few years after that I was in Paris, and he asked me to play again. I felt tremendously satisfied. This time I was told to come to his apartment—

even better! I arrived at his well-appointed flat (he was partial to native African sculpture, like many Frenchmen of a certain age). I felt I was practically part of the Parisian establishment. As I was about to pass into the apartment and greet his wife and quite attractive daughter, he paused and looked back and asked conspiratorially, "Is your name Alex?"

If that was gamesmanship it worked, because I was completely taken aback as I reminded him my name was, ahem, *Davide*. I later spoke to another American at the café who, it turned out, also played tennis with him. I felt slightly deflated learning I wasn't the only one—though I was heartened to hear that Jean François mistakenly asked him if his name was Alex too.

HOW DID YOUR FATHER DRESS?

NICK SCHONBERGER My father's remembered for dressing with this abandoned decorum. When I grew up he wore Italian suits, vents sewn shut. In later life he gravitated toward colorful corduroys, cashmere sweaters. He was a fan of holiday dress. He had a sense of occasion but also bent the rules a bit.

ROBERT BECKER What I loved the most were his hats, de rigueur for a man when I was a boy. Classic gray fedoras with brims neither too narrow nor too wide, a subtle feather stuck in the ribbon. I remember him always having a glance in the hall mirror, running his fingers over the brim before stepping outside on the way to his office or a cocktail party, and his arriving home at night with it a bit more raked to one side than when he left.

ALEX BILMES My father took me to a smart shop to buy a suit. He had a very strong opinion about what I had to wear, and, of course, I resented it. You don't want to be

"My dad, in some moment of insanity, went on a game show—I don't remember the name. He did not win. He came very close to winning. But the consolation prize was a selection of alpaca cardigans, in all colors. I don't remember whether he wore them, but I inherited them at a certain point and did wear them. That was a crazy phase: ironically wearing alpaca."
—Guy Trebay

Reverend Colin Rookwood (Dan's father)

buttoned up when you're a kid, do you? But now I have a son—he's three—and I like choosing what he's going to wear. I've become just like my dad!

DUNCAN HANNAH My father was a hardcore Ivy Leaguer who had gone to Harvard and was besotted with Brooks Brothers and J. Press. Later he became a bit more flamboyant, with velvet smoking jackets, knickers, and Tyrolean hats. He was definitely in the country club set, so there was a lot of Lilly Pulitzer pants and things like that. But he took it a little further because he'd been an admirer of Fred Astaire and Cary Grant when he was growing up, so he was a bit of a fantasist himself. He was really big on blazer crests— he even had them on his bathrobes.

JOHN BRODIE My father was a banker. He was a born and bred New Yorker who had gone to college in the South. His stores were Paul Stuart, J. Press, Brooks Brothers, and his dress was fairly conservative. Gray suits, oxford cloth shirts, rep ties; the Alden tassel loafer was his major workhorse. A lot of our father-son time on weekends was spent going to see movies in theaters. Then he might do what he called "doing the rounds," which was looking at Paul Stuart, looking

at J. Press, Tripler's—there were a lot of more individualistic men's stores in New York back then.

STEPHEN COATES My first memory of my father was him towering above me, in what would have been a quite stylish 1960s shirt. I grew up in Lancashire and my grandfather ran the only gentlemen's clothes shop in the town that I'm from. It was a working-class mill town, an industrial town. They would have sold tailored suits, which in London wouldn't have been a big deal, but in this town it was the only shop.

DAN ROOKWOOD My dad was a vicar so he pretty much rocked a dog collar most of the time. And flowing robes on Sundays. But on his day off he wore a shirt and tie— often a tweed or wool tie. A shirt and tie was his default off-duty setting, even on holiday.

RANDY GOLDBERG My father dressed up all the time; he wore suits and sport coats to work and then wore sweaters and sport coats out on the weekend. He went to a clothing store in Baltimore called Rothschild, and he had a tailor there. He wore boots with suits—not necessarily cowboy boots, but some cowboy boots. I think he liked the height of those. He kind of looked

"He used to wear shirts with separate collars that had to be laundered and buttoned on. He must have been one of the last people to do it."
—Nick Sullivan

> **"He rarely appeared in public without the tie. In fact, my grandfather never appeared at all without a shirt and collar without a tie."**
> –Stephen Coates

like a mobster. I saw that the way he dressed was different, but he looked sharper to me so I appreciated that. He was the only dad that dressed like that. He wore a lot of jewelry but not a wedding ring. He wore a pinky ring; he had a chain that he wore every day. He eventually made me the same one, and I wore it until I lost it. Now I have his.

WALTER KIRN My father was a patent lawyer who worked at 3M, and he had two forms of dress. We lived about sixty miles out of town on a farm, so when he got up in the morning, he put on the suit. He'd never buy a new suit; he would only go to a thrift store called Next to New in downtown St. Paul. He wore baggy suits, but he had been a big high school football player, and he was an athletic guy who liked to go outside. So as soon as he got home, he ripped that shit off and wore the crunchiest outdoor wear

that he could find. That awful waffle thermal underwear was pretty much his shirt and pants. And he wore a lot of itchy Pendleton stuff. He felt that when we dressed to work on a farm or go hunting, you were to be armored. He liked tough, hard-working clothes.

AARON LEVINE My dad worked for the government so he used to wear suits every day, and I remember wanting to dress like that but not being able to because I didn't have the occasions to. He had this double-breasted suit that he referred to as his Dr. Doom suit, and it was awesome. I had to buy a suit for my first homecoming dance; it was a double-breasted Dr. Doom suit. I kept referring to it as that.

MICHAEL HILL I revered the way my father dressed. I thought he was the most dapper man in the world. My memories go back to Saturdays

Left to right: James Mashburn (Sid's father), Lane duPont (Stefaan's father)

when I used to drive up to London with him. I was intrigued by what he wore and would quiz him. We often used to talk about how casual he could be on a Saturday. Nothing less than gray flannels, tweeds, or a blazer, and because it was Saturday, he might wear brown shoes, contravening the "never brown in town" rule. He was almost rebelling!

TOM SCHILLER He was relaxed Hollywood casual, an upscale-writer type. Nothing special. He was a writer for *I Love Lucy*, and going to work with him was exciting. We'd sit up at the top of the bleachers, you'd look down, and you'd see the whole show unwrap before your eyes. But before, you'd have dinner with them at Nickodell's, a restaurant around the corner, and you'd see Desi and Lucy and Bill Frawley and Ethel. Bill Frawley had a tremor because he used to be an alcoholic. And little Ricky was not the real son; he was an actor.

When I saw Lucille Ball during rehearsals, she was nightmarish. I had to go take a picture next to her and she said, "Come here, Tommy!" And she had a low voice—she used a higher voice for the Lucy character—and she had red hair that looked monstrous and she smelled like Chesterfield cigarettes and nail polish. But Desi was nice.

ARMANDO CABRAL I learned how to tie a tie when I was about ten years old because of my father. He was always dressed up in a suit and tie. I was always next to him, and he said, "Here's my tie. Can you tie it?" He was this very classic guy who dressed up in suits. And he was very tall and thin like me.

ENOC PEREZ He dressed very conventionally. He teaches history. He dresses as a teacher: slacks, usually a shirt, short sleeved, because Puerto Rico is hot. Everyone wears a guayabera—I started to wear those later—but he wore one with no irony. But it's a statement shirt when you wear it outside of Latin America.

Left to right: Lawrence Herndon (Tunde Oyewole's grandfather), Omer Denayer (Michaël Borremans's grandfather)

MARK McNAIRY He always wore a suit to work, which was kind of strange because he worked for NCR, National Cash Register. At that time, the cash registers were mechanical, and his job was fixing them, so he worked on those machines with grease and tools—and he was wearing a suit and tie.

MATT HRANEK I'd say he had good style—pretty classic, very upstate. My favorite style moment was him in wide-wale tapered cords, black wool turtleneck, and a tan Baracuta jacket with desert boots, tooling around in a 1959 Triumph TR3A.

dressing that way. He would wear Bass Weejun loafers usually and a monogrammed alligator belt.

NICK SULLIVAN He had a very reduced wardrobe. He had a couple of suits, he had a couple of Hackney jackets, tweed jackets, and flannels, and he was firmly on the cusp between the fifties and the sixties, in the sense that he was a young man in the army, Berlin in the late fifties. Then he came back and became a dentist, but he dressed like a man who had been in the army. He wasn't particularly bothered by clothes, so he reduced everything to essentials.

> **"He was a guy who waited for it to get cold so he could start wearing thermal underwear."**
> —Walter Kirn

NICK WOOSTER My father was a mechanic. He wore chambray shirts, selvedge 501s, and Red Wing boots with the equivalent of Sol Moscot sunglasses with a flattop. That's how he dressed every day of my life. I did everything in my power to be the exact opposite of him.

ANDY SPADE My father worked in advertising as a creative guy. He always wore a sport coat, a repp tie or club tie, a simple stripe like a Princeton stripe, and gray trousers. He had four versions of gray: gray, light gray, medium gray, flannel gray. We were in Arizona, but he's from Michigan, so he grew up

JAY McINERNEY My father was a real dandy, sometimes embarrassingly so. In the seventies he went in for the double-neck shirt and the white faux Gucci loafers. He actually embraced the seventies. He always went in for color and pattern, he had a very keen interest in clothing, and he was a very good dresser. He took it a little far in the peacock direction in a way that made me a little self-conscious. I will wear a pink jacket—but I think hard before I do it.

JAY FIELDEN My dad did not have terribly great style as a father, and I think that bothered me a good

deal. From pictures, I noticed that he once had been more interested in clothes. He'd had what I might even call a cool style as a young man in the 1950s, and he still had many of those clothes in his closet. He didn't wear them anymore, but he hadn't thrown them out, and I remember getting to a certain age where my mother started to pass them down to me. This was my introduction to razor-thin lapels and unpleated tapered pants and topcoats that looked like something that a jazz musician would've worn.

EUAN RELLIE My dad comes from a different generation. He thinks you should dress to take an airplane flight. My dad had most of his clothes come from Welsh & Jefferies on Savile Row, even though he wasn't particularly rich. He believed in having his suits made, and he would wake up on a Sunday and put a suit on because he would go to church, and he generally encouraged us to go to church. He wouldn't twist our arms too hard, but usually one or two of his children and occasionally his wife would go with him.

THOMAS BELLER My father was an immigrant who didn't get to America until he was sixteen years old. He'd grown up in Vienna, and he became a psychoanalyst. Within the psychoanalytic gestalt is a rather formal conservative look, and within that there's a frumpy professor version and a more nifty, Continental version. My dad was the latter. Nice

shoes, suits, not three-piece suits but jackets and slacks, suits and ties. He had a thick head of black hair that he'd comb very neatly to the side, the real telltale thing—this is a generational thing. When my dad was at home, he would maintain that formality. Not the same clothes but the same feeling. He would wear robes and slippers.

JOSH PESKOWITZ We would steal my dad's Polo sweaters that had snowflakes on them. Anything Polo was a big deal when we were in high school in the early nineties.

FRANK MUYTJENS He was a salesman and so I remember him always in a white shirt and a tie and a sport coat. He was dressy—that's how I remember him.

MICHAEL HAINEY My sense of his style comes to me primarily via photographs of him. He worked in this incredibly glamorous time and place: Chicago newspapers in the fifties and sixties. It was like *Mad Men* meets *All the President's Men.* Men then wore coats and white shirts and ties. Men got dressed for work. Dark suits. White shirts. Thin ties. After he died I'd look at those photos. To me those shots of him in the city room, sleeves rolled up, his tie loosened—very glamorous. And he looked supercool and modern.

MICHAEL WILLIAMS My dad's a blue-collar guy. He would say things like, "If I wore my nice shirt, I'd walk through the shop and get it

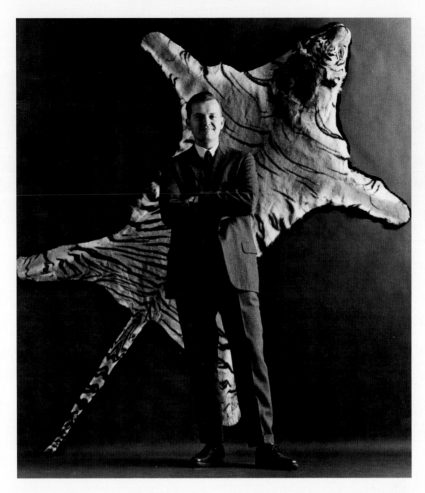

Rowland Wilson

dirty, and it'd be ruined before I have my first sip of coffee."

RANDY GOLDBERG He would wear a shirt and tie to the office, come home, take off his jacket, put on sweatpants, but keep his shirt tucked into his sweatpants. Formal leather slippers, dress shirt, sweatpants, and that's the way he'd spend every night in our house when we were having dinner or hanging out. That seemed really normal.

ROBERT BECKER My father wore pinstriped, three-piece suits from Brooks Brothers. Narrow lapels. Wide lapels were foreign to him. He also wore sock garters and braces. Casual meant a blue blazer and gray or light trousers, sometimes tweed jackets, sometimes corduroy pants; in the summer, by the shore, he wore alligator polo shirts, knee-length shorts, Top-Siders. The simple uniform of his circle.

SID MASHBURN He worked as a chemist for a cement company, so he always had dust on his shoes—that's one reason I like bridle leather where the wax is still coming out, kind of like dew on the grass.

ERIC DAYTON I think of him in a navy two-button suit and tie for work, but then always the same old pair of beat-up jeans on the weekend and maybe a flannel shirt and Patagonia jacket. Clothes aren't really important to him, but he has his go-tos and they do the job.

TUNDE OYEWOLE My father provided me with the freedom to dress how I wanted when I was growing up. And my grandfather, my mother's father, with whom I would spend my Sundays, provided me with an ideal. How to describe his manner of dress? Classic. Easy. Self-assured. The man knew the power of his silhouette, and he was not afraid to show it.

TIM SCHIFTER I mostly remember my father's weekend clothes during summers in the sixties in our small house in East Hampton. Sears chambray work shirts (always with a pack of Camel non-filter cigarettes in the pocket), Levi's jeans, and Indian water buffalo leather sandals—very bohemian for a businessman.

CHRIS BROWN I remember his raw, selvage Levi's jeans. He always wore really great chambray shirts and bandannas and white T-shirts, like James Dean–ish. Very classic. Red Wing boots, cowboy hats, I mean—I dress like that today, so I know where it comes from.

My father always wore a Stetson. As a child in the early sixties, I have great memories of trying on his beige Royal Stetson while he was at work in the oil refineries. It was sweat- and smoke-stained from days in the garden and nights around an open fire during frequent weekend camping trips in the piney woods of southeast Texas. It smelled like him and gave me comfort in wearing it. I own that hat today.

ROB ZANGARDI My family always put stress on always looking "put together." To this day, my parents would prefer I dress like a toddler on school picture day, with a tucked in colored shirt and my hair parted. It's an endless battle—they still ask why there are so many holes in my jeans.

Clockwise, from top left: Duke Goldberg (Randy's father), Sylvester Hooks (Glen Ligon's grandfather), Thomas Kelly (Russell's grandfather), William Boyd (William's grandfather)

FATHERS & GRANDFATHERS

Clockwise, from top: Daniel and Hebert Hartman (Darrell's uncle and father),
Ron Hranek (Matt's father), Markley Boyer Sr. and Jr.

FATHERS & GRANDFATHERS

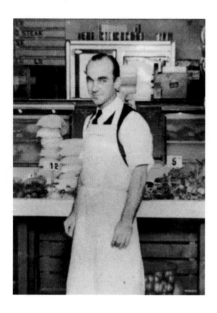

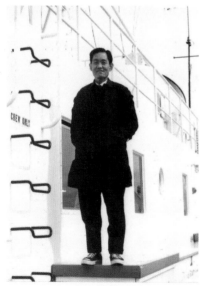
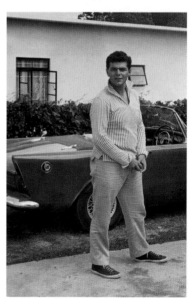

Clockwise, from top left: Dal Ray Brown (Chris's father), Charles Hill (Michael's father), Richard Blackmore (Russell's father), Byung Hak Park

Jeremy Gilkes (Alexander's father)

Top to bottom: Byong Mok Kim, M.D. (Byron's father), Ariston Awitan (Brian's father)

FATHERS & GRANDFATHERS

Top to bottom: Adrian Dannatt and his grandfather Howell Davies,
James Sullivan (Nick's father)

Top to bottom: Joseph Micoli (Jay Batlle's grandfather), Felix Sullivan (Nick's grandfather)

Clockwise, from top left: Timothy Baker, Robert Becker (Robert's father), Bill Chapman (Greg's father), James Hannah (Duncan's father)

Top to bottom: Dave James (Al's father), Robert Brydges (Shawn's father)

GREGORY PECK

ANTHONY PECK My father inhabited his clothes as effortlessly and deliberately as he inhabited his life, which is to say, in correct proportion. Clothes were not a be-all, end-all for Greg. But men must clothe themselves and Greg did. He loved pure technique and great craftsmanship in all fields: on stage, in a painting, a sculpture, brick laying and carpentry, ballet or a Sandy Koufax fastball. And the cutters and tailors at Huntsman, his lifelong tailor, are master craftsmen. Greg had an artist's appreciation for line and for detail, for quality and craft, and he felt all of this in the Huntsman cut. He never wore clothes that called attention to themselves. Instead, they simply supported who Greg was: a humanitarian, a man of taste and refinement, an artist, a storyteller, a family man.

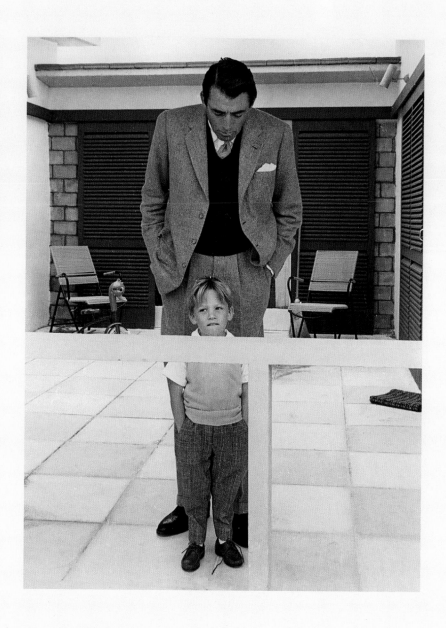

Greg had a natural elegance in voice, in speech, in posture and gait, in the way his mind worked. He couldn't make a false step because he was true to himself above all else. And, in his bones, he was decent, kind, and fully alive. Greg had an inner glow that can only come from an inner glow. If you met him, you knew it.

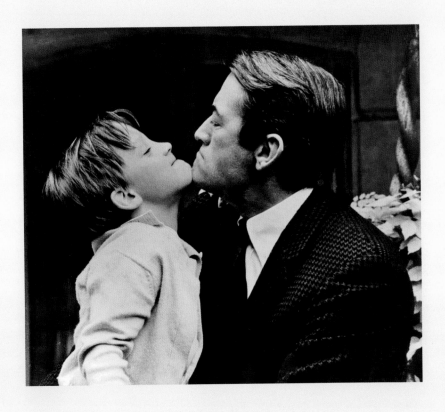

I remember the day. We were rubbing our faces together like horses. Then it evolved into this chin-to-chin one-upsmanship. Greg is wearing a Huntsman cashmere tweed in dark green-and-black dogtooth. Made in 1960, the fabric was woven on the Isle of Islay in the Inner Hebrides, Scotland, in one of the world's oldest mills. Greg wore this tweed to night games at Dodger Stadium, on walks in Central Park and down the Champs Elysees, to drop us at school on his way to the studio, and to visit museums all over the world. He allowed me to borrow this particular tweed in college where I wore it playing a character in a George Bernard Shaw play. I paired it with the spectacles he wore in The Boys from Brazil and thought I looked very professorial!

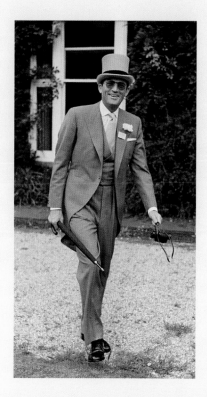

A summer favorite, Greg would wear this to a concert at the Hollywood Bowl or an evening dinner at Swifty Lazar's or the Sinatras'. That beautiful polka-dot tie is another example of Greg's lively spirit at work. He was not a dandy in any way, rather he truly appreciated the care, the attention to detail, the close and careful work of the cutter and tailor who would have constructed this garment.

On his way to opening day at Ascot. Greg owned racehorses as a hobby and loved going to the races with his friend David Niven. Greg had the dove grey swallowtails made at Huntsman and would have seen the whole day was a delightful lark. Greg would wear the appropriate finery with a sense of fun and appreciation for the history and tradition of the event, the clothes, the pomp of it all.

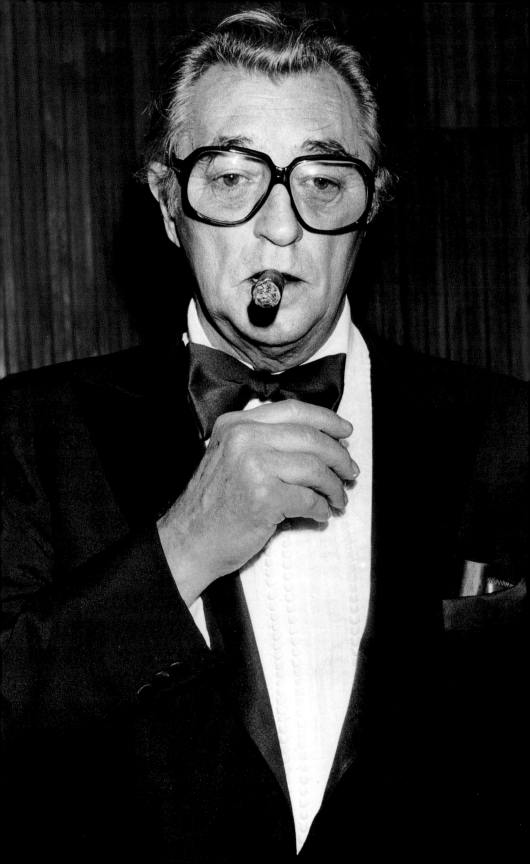

The Dress Code: Rules of the Game

An unsettling article tucked away in the *Times* a while back announced that the few remaining Manhattan restaurants still requiring dress codes—bless you, 21!—are now providing a better class of jacket to their delinquent underdressed visitors. "These were not the stained, ill-fitting, polyester jackets of shame from decades past," the author assured us. Apparently, there's a perfectly good coat waiting for you at Per Se, so you can hide your complete lack of protocol under a 40 long from Ralph Lauren.

While the restaurants are being admirably hospitable—Daniel, in fact, has its coats custom-made—that does not mean you want to join the sartorial class of clothes-swapping masses who wander into serious establishments in their shirtsleeves. Perhaps you prefer to rent a tuxedo as well.

Show a sense of occasion! When you stride into Eleven Madison Park, why not wear your most devastating pinstripe suit? Break out a double-breasted coat for your lunch at 21, and honor the dapper *New Yorker* cartoonist Peter Arno, who was once a fixture there.

Unless you are known by one name or have taken your own company public, a dress code is not to be tested lightly. You might think you're getting away with something, but who wins in the scenario where you are the most casual man in the room? Certainly not your date.

So take it upon yourself to be the man who makes an impression, honors the house style, and sets a higher standard.

Robert Mitchum

Ties and the Meaning of Things

The first tie I remember remains a favorite. It's dark blue silk with light blue diagonal stripes. Polo, late eighties, straightforward, classic. A little wider than ties are now, but after the madness for thin ties it's quite satisfying to return to something with a bit more heft. Ralph Lauren got his start selling ties of course, and he did well by this.

I brought it to college in Maine, and it served admirably when called upon for formal dances. It represented a developing comfort level with dressing up, part of the path of growing up. I loved this tie out of proportion, and it became a reassuring staple, like a dependable Scotch, or a favorite Smiths song.

Then something happened in my late twenties. I was spending a lot of time in London, so much that I was dating an English girl. I suppose I dressed formally, probably overly conscious of being an American in an English setting. I was particularly devoted to Anthony Powell's novels at the time and read in quick succession the twelve books that formed *A Dance to the Music of Time*. I was drinking at rarefied bars, spending time in the East India Club. I was probably insufferable.

One evening my girlfriend's father took us to Wiltons, the old guard restaurant on Jermyn Street that serves Dom Pérignon by the glass and Colchester oysters by the dozen to the great and the good. Out came my best suit, out came a sharp shirt, and, of course, out came my tie. As we gathered at their town house before heading out, her father shook my hand vigorously and took in my ensemble. I was ready for it.

Then he said: "I wasn't aware that you had attended Eton." He himself, as well as his sons, had indeed attended Eton. And he was very aware *indeed* (as he would have said) that I had not come anywhere near the storied walls of the school founded in 1440.

How could Ralph do this to me? How could he make a tie that was essentially that of the old Etonians? But the fault was, of course, my own. I was certainly not the first American to crash his English aspirations in a poorly navigated sea of tradition and propriety. I deserved it—like a character satirized by my hero Anthony Powell. You learn a lesson like that once and you don't need to be reminded: When in doubt, go for the knit tie.

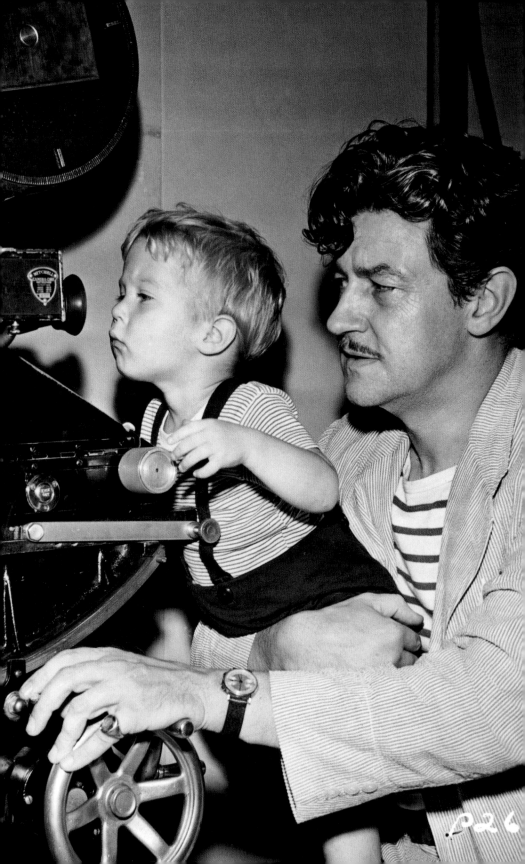

DID YOUR FATHER HAVE RULES?

> **"He thought if you're wearing a dinner jacket, your shoes should have a patent sheen on them. He would say, 'Americans like to match their clothes—you're British, remember always to clash your clothes.'"**
> —Euan Rellie

ANDY SPADE He always took me to men's clothing stores: one in Arizona called Captain's Quarters. He'd take me there and buy me the right shirt and the right tie. He gave all of us kids a silver belt buckle with our monogram on it. He loved taking us shopping when we were kids. They were divorced, so he'd pick us up and go throw the Nerf

Above: Mohammad Moshir al Tojar (Kamrooz Aram's great-grandfather, on left)
Opposite: Preston Sturges

> **"He didn't really like it when I had long hair in the eighties. But nobody liked that."**
> —Enoc Perez

ball around, and then we'd go to Captain's Quarters and he'd buy us something. Then he'd take us to happy hour and let us play Pong and video games while he hit on women. He had his cocktails and then he'd take us home and say, "Don't tell Mom about the cocktail hour part."

ALEX BILMES I had a father who had strong opinions about what people should wear, and I was the person who rejected everything his father said. Almost every time we went out to some family occasion, we would have cross words about what I intended to wear. I would always try to wear something I considered hip, and he would be not impressed by this.

RANDY GOLDBERG The lasting thing that my dad would say to me was to make yourself indispensable, make them want you. If you're looking around and you have to ask yourself, do they need me to

do this job? and the answer is no, then you're not doing enough. Do more to make yourself essential. I think that also speaks to style, about carrying yourself and caring about your appearance and making that part of what you do and being on time. Handshakes. All the things that sound cliché that aren't as much about what fabric you're wearing or what sport coat, it's about how you carry yourself as a man.

TOM SCHILLER He showed me how to military tuck in my shirts. You'd pull them really hard in the back so that it's flat in the front. He was always straightening my collar to make sure that it was properly adjusted. He came out of the army, so you had to look sharp.

DUNCAN HANNAH He was a real stickler for propriety: Always wear a belt. Don't mix brown or black. Make sure you have the right shoes.

DAN ROOKWOOD That it's always better to be slightly overdressed than slightly underdressed. Both of my grandfathers were from the wartime generation where things were done properly, and my father inherited that and passed it on: Shoes were polished, ties were firmly in their collar, jackets were brushed

66

down, and hair was neatly combed. Everything had its place.

JAY McINERNEY I remember my dad taking me to Brooks Brothers when I got my first suit. Although the problem then, going to Brooks Brothers if you were somebody with a slender build: That cut is made for businessmen with potbellies. The shirts too—vast acres of fabric. It wasn't a perfect look.

JOSH PESKOWITZ I grew up only listening to hip-hop music. My father tried to correct that in as many ways as he could by introducing me to soul music and reggae, which was the basis of rap, but he didn't dissuade me from rap. And not for nothing, my pops was into rap too. When my brother stole his car in '91, we found the sound track to the movie *Juice* in the tape deck. It wasn't like he was all crazy.

POGGY He's very serious. He told me not to dress in a crazy way or to go out looking sloppy. I still asked him to lend me money to buy clothes, but he said, "No way."

ANDY SPADE He had one that I disagreed with, that he never cuffed his pants because he said that we aren't tall people, and that actually shortens your line.

SID MASHBURN Most importantly how to dress out of respect for the people you're with and the occasion you're going to. He was always amused and bemused by my clothing choices. He tolerated my experimentation a lot more than most dads in early 1970s small-town Mississippi would have.

Every Easter I would get a new Easter suit (some of them were hand-me-downs from the Beasley brothers)—and one year I went to McRae's with my sister Kay and we picked out a brown pinstriped double-breasted suit with brown-and-white spectator shoes. My parents didn't make us go back, but they were close.

JEREMY HACKETT I remember him saying to me one day, "I am too poor to buy cheap shoes"—advice that I have taken to heart, and therefore I have a wardrobe full of good shoes.

DO YOU HAVE RULES?

> **"I don't do fringe."**
> –Michael Hainey

WHIT STILLMAN The principle for me, since I separated from my wife in 2002 and I became essentially an itinerant, is just to have just one suitcase. So I have very few clothes and tend to wear things over and over.

G. BRUCE BOYER I have very few rules. One: You should dress your age. I think you can look good at any age. I think it looks ridiculous when sixty-year-old guys try to look like their surfer son. Two: Buy the best quality that you can afford. And going along with that idea, you should keep your clothes forever. It's the best diet you can get.

STEPHEN COATES I think that guys over thirty should wear good shoes. I'm not keen on guys over thirty-five in training shoes at all. I mean, that sounds horribly pompous, doesn't it?

GUY TREBAY I'm interested in fewer decisions. There's a place down the street from my hotel in Milan—one of those typical Milanese haberdashers—which I passed a thousand times before finally going in and discovering the pleasure of having shirts made. They have my measurements now, and all I have to do is reorder.

MARK McNAIRY Birkenstocks: Please, please, stop it.

> **"A jacket hides a multitude of sins."**
> –Nick Wooster

NICK WOOSTER There was a seminal book in terms of style that I remember—it's really embarrassing—it was called *Dress for Success*. It was a book written in the seventies, and it

"It's a casual-wear world. The baseline has moved." –Thomas Beller

would say things like if you're short, which I am, you should always wear one color, head to toe. Well, I do that. It helps not to break up the eye to make you appear shorter. I also just think it's easier. If you work in a business-casual office and you want to look smart, wear head-to-toe navy or head-to-toe charcoal gray. That will automatically make you look a billion times better than everyone else.

GLENN O'BRIEN I think men are less afraid now, which is really great. I'd rather that people look like show-off fools and fashion victims than look like boring schlubs. Just go for it.

JOSH PESKOWITZ I still have a pretty strong inclination to match my shirt to my shoes. Doesn't have to be exact, but even today I'm wearing a white shirt and my shoes have a little white. I could be out here looking like the fucking leader of the Branch Davidian compound, but the oranges and the yellows are going to be very close to each other. I never clash.

JOHN BRODIE I was reprimanded in my eighth-grade graduation because

I had worn a blue blazer, a blue oxford cloth shirt, a red linen tie, and really busy madras trousers. I remember one of my favorite teachers saying to me, "Really?" The madras trousers were really busy, and everyone else was in navy chinos. But I had to bring it.

MICHAEL HILL I think you have to know what works for you, what you feel comfortable in, and sometimes that takes time. I like something to be fresh and relevant too, as opposed to costume. But I'm still learning as well. A lot of great-looking guys are in their sixties, and that's because it can take some time to develop your own style.

ARMANDO CABRAL People always ask me, "Why do you always smile?" I love smiling because it makes me happy, it's a gift, its very contagious. It costs nothing to smile.

ROB ZANGARDI I think this is why I love the rugged, classic, all-American vibe. It was always the traditional classics my parents bought me as a kid, but somehow I would try to fuck them up and make them as "mine" as I could.

"A blue blazer, flannels, or khakis and a shirt and tie will get you where you need to go. No one has proven otherwise for me."
–Nick Schonberger

"I would feel silly in a caftan." –Glenn O'Brien

THOMAS BELLER One of the more influential fashion pieces that I've read in the last fifteen years is one that *New York* magazine ran, by Adam Sternberg, called grups—which is shorthand for grown-ups. But the upshot of it is, there's a certain generic look of "I'm smart, educated, and I might even have money, but I don't have to go to the office." There's a spectrum within that look. It's kind of an informal look: T-shirt, sweatshirt, hoodie, sneakers, jeans, or some variation of that. I'm smart, and maybe even solvent, but I don't go to the office. For a long time I was working within that context. But the point of grups was, these guys became grown-ups but never really stopped dressing like kids. That message had an effect. Now I'll actually wear a blazer in New York, when I didn't used to. For a while the only person who I knew who wore a blazer was David Berman, who wore it with a thick leather wristband, or someone like Rob Bingham—crazy people with style and some Southern thing, which made them more comfortable in some kind of—maybe it's not Southern, maybe it's just prep school. But for a long time I wouldn't do that, wear a blazer.

DID YOU WEAR A UNIFORM?

"Secondary school, the rule was any suit, provided it was either two-piece, three-piece, or double-breasted and gray. Mid-gray. You could go as far as charcoal; you couldn't go as far as black. Unless you were in the sixth form, where you were allowed to dress in black—but I didn't, tellingly." –Nick Sullivan

Keio University baseball team

GLENN O'BRIEN I don't think we were allowed to wear jeans, but people didn't really wear jeans to school back then. The first time I ever had any dress code was when I was in a Jesuit high school and we had to wear a tie. That was it. We would wear a tie and a turtleneck over it, so the Jesuits would come up and pull your turtleneck down to see if you were in compliance.

uniform: It takes so much anxiety out of life. It's so liberating.

GUY TREBAY When I went to work for Andy Warhol's *Interview* in the seventies, I had a uniform. My hair was cut in a platinum-bleached crew cut. I wore a very tight *Meet the Beatles* T-shirt, lace-up work boots, and olive drab army fatigues.

> "The schools that we went to were strict on clothes. They had to be brown. At my school the headmaster, who's a priest, would stand at the school gates and raise your trousers as you left to check what color your socks were."
> —Stephen Coates

DUNCAN HANNAH I went to a prep school from sixth grade to tenth grade, and we had to wear a jacket and tie and short hair—so we tried to figure out ways to get around that. I wore the most outrageous tie you could possibly get: It was like fluorescent green paisley. Or shoes—I had boots with zippers up the side, which really pissed off my wrestling coach.

WHIT STILLMAN The good thing for me was not having to choose my clothes. I went to Collegiate, the school my brother had been to before, and we had a school dress. Flannels, blue blazers, white shirt and tie, and loafers. It's just easy and a really good way to dress. That's the thing about a school

DAN ROOKWOOD I went to a school in Liverpool called the Blue Coat, and our uniform was a navy blazer trimmed with roped gold piping. I believe this was a maritime throwback—the school originally had links to the then world-famous shipping port that put the city on the map. It was a fairly hideous blazer, and I didn't enjoy wearing it, mainly because it made us more visible targets for thugs from rival schools.

MICHAEL HILL I went to a different school than my brother, and I remember when we used to go to his sports day, one had to dress up—but again, there was a freedom. I recall one year choosing to wear a tartan suit. I thought it was the business! I just loved the cloth and really wanted to wear it as a suit. It

struck me as being great fun, and I didn't feel conspicuous in it in any way.

ROB ZANGARDI In private school, we wore uniforms. Growing up with a twin brother, it often felt like we wore uniforms even when we weren't at school. When we were little, my parents dressed us in the same outfit, but in two different colors. One of our neighbors knocked on the door to ask "if the blue one can come out and play."

BYRON KIM When I attended La Jolla Country Day School, we had to wear uniforms on Friday. It was ridiculous that we had to wear them only on Friday. What was the point? I hated it. The boys had to wear

TOM SCHILLER I went to prep school for one year, which I loathed: Cate, in Santa Barbara. I had to wear a blue blazer, white shirt with a school tie, and gray pants and black shoes. I hated that, although secretly I liked wearing a little schoolboy uniform.

In study hall I was right next to the radiator. I laid my jacket flat on top of the radiator, foolishly thinking that it would catch on fire.

ARMANDO CABRAL In Portugal, it was pants during the winter and shorts in the summer with the socks all the way up. And a shirt, we called them Balalaika, like those shirts African presidents usually wear. A Cuban-style shirt with all the pockets.

> **"We customized our uniforms, which I think everyone does—you want a certain amount of rakishness." –Alex Bilmes**

blue blazers, gray slacks, and black shoes. The girls had to wear the same except for gray skirts instead of pants. You could wear a white turtleneck instead of a button-down and a tie, so of course I went with turtleneck. During the rest of the week, it was cool to look like a surfer even if you weren't. That "uniform" involved pastel colored turtlenecks and either short or long corduroy pants, also pastel. I generally liked a pale yellow shirt with baby blue Levi's cords or OPs if it was warm out. Remember OP shorts?

NICK SCHONBERGER In middle school we had a dress code of "blazer, shirt, and tie," or "blazer and turtleneck," or "sweater, shirt, and tie." I don't know why turtlenecks were deemed as appropriate as a shirt and tie. Naturally, almost everyone just wore turtlenecks.

RICHARD CHRISTIANSEN We were so remote. My mom used to get a lot of stuff made, and we loved the attention. My mom would always iron our shirts, every morning. Our socks were always perfectly straight.

We were decked out with little lunch boxes with stickers on them.

NICK WOOSTER When I was the men's fashion director for Neiman Marcus, I had to dress to conform to a dress code, and it obviously got me in trouble because I don't do that very well. The minute someone tells me I can't do something, I do everything in my power—to say fuck you to that. Kids that go to schools with uniforms, I don't know how they do it, because I would have had to have been put in an insane asylum.

STEPHEN COATES That school had a pleasant brown-and-yellow piped jacket. Quite a nice jacket, actually, and a brown-and-yellow tie. A little bit old-fashioned—it was a prep school for Catholic boys that forced them to become priests. Obviously it wasn't a funnel to priesthood, because nobody became priests. They were very, very picky about uniforms. I remember them raising young boys' trousers, which probably isn't legal. You worked creatively to express yourself. It came down to things like the width of the knot of your tie—could you expand the width of the knot of your tie? It was a way of being different than everybody else. Once they caught on to that, of course, and wide knots were not allowed, then you'd go the opposite way and have a very long tie and a knot the size of a pea.

ALEX BILMES Blazer, gray shorts, long socks, and a cap, which was a little black peaked soft cap with a red cross across the top. I liked it. Until you were eleven you wore shorts, and then you were in trousers. I liked safety pins. I don't know why the hell I did, but you'd rip the seam at the side and then refashion

Brighton Cricket Team: Keith Scrase (Nick Sullivan's grandfather, third from right)

it so it was thinner with safety pins. All these things were not allowed. The main thing was the tie. You'd have a really long back part and really short in front. It was a way to express a certain amount of subversion. I don't think it was quite subversion on the Separatist level, but it was inspired by all that.

NICK SULLIVAN At primary school, we used to have to wear flannel shorts that stopped about three-quarters of the way up your thigh, summer, winter, rain, snow. You were not allowed to wear trousers unless you had a medical reason from your doctor. We wore them with a gabardine coat. It was a very strict uniform, a cap with gold braid around it and a crest. Not like a baseball cap, like an English school cap. A white shirt, a yellow striped tie, and a blazer and knee-length wool socks.

MICHAEL HAINEY To me, a jacket and tie and being dressed was a structure in which I could rebel. I could never wear a T-shirt and jeans. But it was more that that was who I was; I felt comfortable.

ROBERT BECKER My elementary school had a uniform. Maroon jackets, gray flannel trousers, white button-down shirts, gray-and-maroon-striped ties. There was nothing the slightest bit tasteful about it. I remember our school patch, sewn to our breast pockets, was an embroidered crest with a wolf, arrows, and a crown. We also wore jackets and ties in prep school but were able to improvise by wearing polo instead of dress shirts, at least for classes.

BRUCE PASK My brother and I both worked at Jack in the Box with friends in high school and we absolutely loved it. The uniform was this ballistic polyester pullover in a rust and navy plaid. We had Jack in the Box jeans that were piped down the seam in red, embroidered with the logo on the back pocket (real "designer" jeans!), and grease-covered after every shift.

WESLEY STACE The uniform for my public school, King's School Canterbury (ages thirteen to eighteen), was beyond beyond: undertaker's pinstriped suit, a waistcoat, a wing collar—literally a starched wing collar, which wasn't even attached to the shirt, it was held in place with collar studs—and a black tie, which became a dark blue tie if you went to Oxford and a light blue tie if you went to Cambridge. On top of all this, because I was on a scholarship, I had to wear a gown in the mornings. On Sundays, an extra treat was a mortarboard and some kind of white surplice. Honestly, craziness, beyond even your vision of the worst possible school uniform. Except the one they wore at Christ's Hospital: You can look that one up.

The Case for Imperfection

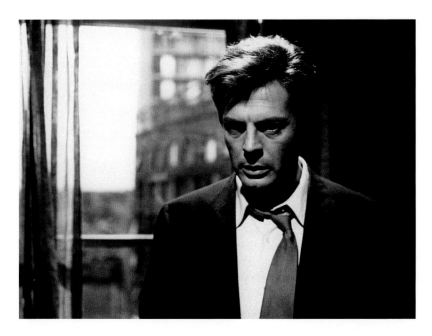

Is it possible that white shoes can provide insight into the world? Over the years I've cultivated an appreciation for white bucks, spectators, cricket shoes, and more bucks. I fully support wearing them from early spring deep into Indian summer (though I have friends who will blow through the winter and still look great). When you acquire white shoes, of course, they embody perfection, unsullied by the world, without a trace of age. There's nothing wrong with admiring your new pair for days, even weeks, before wearing them. I have an unworn pair that's been sitting in my closet for a few years, like a prince patiently waiting to take the throne.

But in this Platonic state they do not yet exist the way the sartorial gods intended. They are not yet worn, they are not yet tarnished, they are not yet truly yours. The white shoe, of course, does not remain white, nor should it. It should reflect your trip to New Orleans, the time you were caught in the rain, the grass stain from a lawn bowling escapade. Conversely, it is only then that they achieve white shoe nirvana.

I confirmed this theory a few years ago when I ran into a particularly well-dressed friend on one of the hottest days of summer. He wore a

Marcello Mastroianni in *La Notte*

gray suit, a yellow tie, and white bucks—he looked immaculate. When I got closer I realized he had a dark footprint stained across the top of one of his white shoes. It was brilliant. The flaw, in the context of the meticulousness of everything else, was inspired. He knew what mattered, and what mattered was embracing the unexpected.

We are attracted to things that show a sense of their history and are honest about that. The boxer's broken nose, flawed heroes, the singer's aging voice. Yes, Fred Astaire threw his suits (or had his valet do it) against the wall to take the newness out of them. The master knew that a suit shouldn't look fresh, it should looked lived in and reflect its wearer, not its maker. (Of course, his given name was Frederick Austerlitz, so he also knew the power of reinvention.)

You trust the apparent mistakes of a well-dressed man—he doesn't mind that his collar is frayed, so you don't either. A chef is the same way. Julia Child said that when you're hosting a dinner party, you should never apologize for anything that comes out of the kitchen. In the first place, people often think the effect is intentional, and anyway, we all can forgive a slightly deflated soufflé. How many times have I gone back to the grill when somebody found the steak I served just a little too rare? No problem, we're here to please. Another trip outside isn't the worst thing—just refill your wine glass on the way.

All of which is to say there's a fine line between the quest for perfectionism and cultivating specific taste. As I get older I find myself attracted to those whose style is less conventionally impeccable and more singularly eccentric. But that style can't be achieved in a day: A pair of distressed jeans isn't going to do the trick; you're going to have to break them in yourself. Yes, you can track something down on eBay, or in that store in Tokyo you won't tell anybody about. But that's not the same thing, and secretly we all know it. Yes, in the end, we all have to make our own way down the long, rewarding path toward hard-earned individuality, with all its flaws.

There Goes the Neighborhood:
The Unending Pursuit of Authenticity

Like pornography, we know authenticity when we see it. It's the coin of the realm, though it can't be bought. But that doesn't stop designers from trying to capture it and marketers seeking to sell it. It manages to be new but recognizable, imitated but unrepeatable, instantly classic.

And one more thing: It can make people furious. That's because the line separating authenticity from posturing is very fine. This all leads to a friction without end, and it defines the contours of the culture. The battle is joined among urban lumberjacks and fervent locavores, the heavily tattooed and the early adopters, precocious MFAs and analog purists. They may not all scale the heights, but they remain savvy enough to know who's a pretender to the throne.

Portrait of John MacWhinnie, Fairfield Porter

Yes, you lived in the right neighborhood, before there was a barista, a bar that's barely open, or even an ATM. You knew the artist before he had a gallery, heard the band before it had a record deal, and ate at the restaurant before it had a liquor license. You've been on the front lines—it's invigorating, but it's also perilous.

Once you stake your pride (more than you'd care to admit) on having a table at the restaurant with no phone number, you're setting the bar high, and it only gets higher. There will be another chef who learned foraging tactics in rural Scotland and another bartender making every cocktail Fitzgerald ever drank. And the quest for access begins again.

You've had a good run—you were in Marfa when it was still Marfa, you were backstage at the Pavement reunion. But you want to withdraw from the extremes of the artisanal avant-garde, ease your way out of the game. It's not easy, because after you there's another wave. There always is. And they're trying harder, riding their fixed-gear bikes farther.

When you've been raised on the nuances of what's next, you can recognize those in relentless pursuit. And more often than not, their efforts will strike you as transparent. Why are people excited about this band or that actor? Why is there a line out of *that restaurant*? You've seen it all before, and you've seen it done better. But you're going to get a closer view than you wanted, because these people are going to move into your neighborhood.

Did you think you were safe? Did you think they wouldn't find out your secrets? Of course they will—they're hungry. And the Internet makes the exotic familiar faster; anybody can access the out-of-print in real time. But don't resent it. Everybody is entitled to a vinyl collection, just like everybody discovers Salinger.

It can be easy to forget that it didn't start with each of us. Just like it didn't begin with the Lost Generation or the Beats or Paul Newman. We all look for what distinguishes itself in our own time, what's singular. Our taste remains very much our own—but the desire to stand apart defines us all.

IN COLLEGE

"You just put your hair up and hoped it would stay. It was before hair products, so you used soap. When it started to rain, your hair would start to feel soapy. There were braids in the back—it was very experimental. I think my mom had a tough couple of years."

—Frank Muytjens

Duncan Hannah

JAY FIELDEN My college style was hardcore Ralph Lauren. Not to make San Antonio sound like an overly interesting place, but it had one of the first official Polo Shops in the country. I got obsessed with that place, and I decided I would apply for a job there. It was my senior year in high school, and what it meant was "I'm not really working here, I'm just wearing the clothes at a discount. Oh, did you ask for something, sir?"

By the time I went to college, I had amassed this war chest of 30 percent–off stuff that I spent my

ENOC PEREZ I went to art school at Pratt. Everyone had a style—not a style of their own, more of an archetype, like Goths. I didn't know what to do; I was just a guy in surfing T-shirts. So I had to think about style and basic things, like wearing coats, sweaters—I didn't own any. I was nineteen in 1986. The first place I went shopping was Antique Boutique on Broadway. I remember getting a lot of pajama tops. I wouldn't be caught dead wearing those now. But I used to buy a lot of those because they were five dollars.

> **"In college I wore blue jeans every day, and then when I graduated I decided not to wear blue jeans ever again, and never have."**
> —Whit Stillman

entire check on every two weeks. Because one of the first things we would do at the shop would be that the moment something cool in our size arrived, we immediately put it aside for purchase. This gave the guy who owned the place an aneurysm when he figured it out. He practically wrapped one of the polo-mallet props around my neck.

WHIT STILLMAN I remember going with my friend Campbell Chen to the Brooks Brothers, downtown Boston, and they were selling spats, and we looked at the spats very closely. We adored things like the detached collars and collar buttons. We should've bought them.

THOMAS BELLER I graduated from St Ann's in 1983. I only went there one year, but it changed my life. The previous school was one of the conventional prep schools of the city, and the taste was very conventional. St. Ann's changed my life. I went from Zeppelin, Stones, Beatles, the Who to all this other stuff. Run DMC entered my life. I was hanging out with all these white guys who were really into hip-hop, and I was dressing like a Wall Street banker—and then I did this weird thing where I tried to integrate those things which could've been cool, but I wasn't quite the person to pull that off. It was, like, a blue blazer with a *Playboy* baseball cap, but I don't

know, I'm seventeen or eighteen. Suddenly I had the blazer and I was wearing a Fred Perry polo shirt buttoned to the top.

DUNCAN HANNAH In college I was all over the place. I went to Bard and Ziggy Stardust had just come out, so I was dressing in a Bowie-esque kind of fashion, which is ridiculous in a rural setting. Huge black fedoras and a lot of, well, women's clothes. There was a thrift shop in Woodstock that sold great Joan Crawford overcoats, which I thought looked very forties space age. I would see one and say, "Oh that's perfect!" Whenever I flew back to Minneapolis in those clothes, I was always pulled over by security and frisked. When my poor father picked me up at the other end, he said, "Oh God, what is this, *Mildred Pierce?*"

STEPHEN COATES I was fifteen or sixteen. I went from quite a posh place to Bolton Technical College, which was a very un-posh place. That was the place for people who had been expelled from school or people who were a bit freakish. But you could wear whatever you wanted! I dressed like a hippie, an Afghan coat, very long hair. Unfortunately, I've never been able to grow a beard, so I went for sort of jaded glamour—that's how I would describe the look. I had to go to Manchester to get anything decent. Bolton wasn't the mecca for sartorial stuff at all.

WHIT STILLMAN My proctor in the room next door was William Bennett, who was later author of *The Book of Virtues*. Wearing big boots and leather jackets, and he was in the law school, and he seemed like a really tough guy. He gave this delightfully square advice, which was just what we needed: Don't be entrapped by young high school girls at Harvard Square.

WALTER KIRN For some reason—I don't know if I saw a picture of Albert Camus before I got to college—but I had a notion in 1979 and '80 that to be in college was to be a depressive, chain-smoking, hooded dark character. So I got some knock-off raincoat. It wasn't a Burberry, but something like that, darker, not the tan color. I wore that thing until I was in my late thirties. It's funny, I wanted to be a writer and conceived of myself as one at age seventeen. But there is no uniform for being a writer. There are a lot of different potential uniforms, and you don't know how to mark yourself as one. I think that raincoat was part of it.

AARON LEVINE Flannel shirts, corduroys, Birkenstocks, Pirates hat. That was it, man. Kind of crunchy, not dissimilar to how I dress now. I've come full circle.

HIROFUMI KURINO I started growing my hair and the teachers hated that. This was the late sixties, the period of the international student movement. I joined a group of high school boys against the Vietnam

War. People were dressing very expressively. Later I became very interested in Bryan Ferry, who was wearing a dark blue suit with a tie with dots. He never looked like a rock musician—I was really charmed by the way he did it. I realized I could keep a rebellious attitude and dress traditionally. In a way it's more interesting to look classic but have an avant-garde spirit inside. So I started wearing suits and cut my hair, and my friends said, "You've converted!"

tons of shorts. I always tapered the pants. There was a company called Rough Hewn, where I worked in college, with Walker MacWilliam.

JAY McINERNEY I went to Williams and I was dressed the way everyone else was. Some of the Euros and some of the prep school guys had some new ideas. Shortly after I graduated from Williams, the *Official Preppy Handbook* came out, and it kind of spoofed and popularized and bastardized the whole thing. By then it wasn't much fun anymore.

> **"The first month at Georgetown, I met several people who I'm still friends with. They had never owned a pair of jeans. The idea that someone couldn't own a pair of jeans meant that they came from a universe that I had no insight into. They grew up in Newport and went to St. Paul's, and there was no need for denim. I couldn't imagine!"** –Randy Goldberg

NICK SCHONBERGER I had one of those tower sound systems with a mini-disc player—I had just been to Singapore and bought a portable mini-disc player. I thought it was really awesome to have that. And then iPods came out like a year later, and it was redundant.

ANDY SPADE In college I wore desert boots every day. I was a runner and triathlete, so I would wear Patagonia shorts. I still wore Lacoste and a lot of oxford shirts, similar to how I dress today. But it was Arizona, so

FRANK MUYTJENS When I was there I needed to catch up. It was a very interesting time in London, and there was the Romantic movement with Spandau Ballet and Duran Duran, and a bunch of us were into that. I dyed my hair with a highlighter. It was sparkly and then the next day it was red and the next day it was blond. I was into Vivienne Westwood.

THOMAS BELLER I went to Vassar and Vassar was a big school regarding diversity at that time;

they weren't really on it, particularly with men. I'm semi-embarrassed to say it: I was Mr. Hip-hop at Vassar for the first couple years, practicing with two turntables in my dorm room. Then I chilled out a bit.

RUSSELL KELLY I was a freshman in college and I started working a part-time job in the mall, oh, what was the name? That horrible men's store owned by Express. There was this weird store at the end of the mall called something like International Male. They had, like, expensive blazers, pointy boots, and flowery shirts, and I loved buying stuff there. I had this horrible, huge patterned, black-and-white houndstooth blazer that I would wear with a silky shirt buttoned to the top.

WHIT STILLMAN I let my hair grow long in college. I had my picture taken for the yearbook, and it was so shockingly awful I've never had long hair since.

BRUCE PASK One summer during college I worked at The Gap on Wisconsin Avenue in Georgetown. I was pretty fastidious, so every evening I was usually assigned to tidy up the massive jean wall because my folding was impeccable. I was there for an hour or two folding jeans after closing. It was methodical and totally satisfying.

The next summer, I worked at Esprit in its heyday, just down the street. We wore these brightly colored neon short-sleeved camp shirts with an Esprit Staff logo. I would sometimes wear mine out because I thought it was so cool.

GAY TALESE

I always drink every night. I don't drink during the day, wouldn't touch anything in the day. But come seven thirty, eight o'clock, I'm at a restaurant and I always have a dry gin martini. If you're drinking martinis, I'll have a half with you. So one and a half, but never more. I don't ever get plastered.

Boyhood

What my father gave me was an appreciation of tailoring, an appreciation of clothes, the recognition that clothes are part of your personal fabric. You're linked to how you look, and how you look not only makes an impression upon those who are looking at you but also, and more important, how you feel about yourself.

I started being aware of fine tailoring not long after I could walk. I have photos of myself at age six, age seven, age eight, in clothes that my father made for me. Not only suits and jackets and overcoats. Not that he made hats, but he always wore a hat, summer and winter. And I did too. I have photos of me walking along the boardwalk at Atlantic City with my mother and sister, wearing a fedora at age nine and ten.

A Young Reporter

When I became a reporter for the *New York Times* in 1956, I always dressed exceptionally well. In those days people dressed better than they do now. Yankee Stadium in the thirties and forties, people in the stands were wearing hats and suits and ties. When I was a reporter, the only person I knew who dressed well was on the *Herald Tribune*—it was Tom Wolfe. I knew him; we were very young together. I believed that when I knocked on the door looking for an interview, it was very important I made an impression. I felt when I dressed well I had confidence in what I was wearing and my own appreciation of style, and I also felt that I was showing respect for the people I was interviewing.

You show respect when you go to a funeral or a wedding or a bar mitzvah or a christening—you dress up. A lot of people I see in four-star restaurants, expensive restaurants, the women make an appearance but the men are very, very underdressed—sometimes not even with a jacket. I don't know why.

Yellow

Yellow can work very well with the blue and black suit. Especially if the shirt sets off the yellow, if it's a striped shirt such as this or a white shirt. Almost all my shirts have white collars and white cuffs, because the suits, especially at night, are always dark. I don't want to look funereal but then

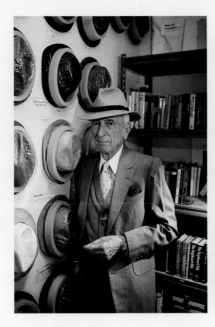 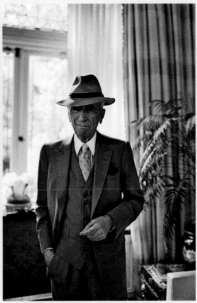

red, patterned reds and maroons or burgundy, that requires wearing a different shirt, usually a shirt without too much action, not too many stripes, a plain shirt. I do that but then the suit has to be light in the summertime. It gives a contrast to my face, there's a little spark about the color that I like, and it plays against a more sober suit. I think it's bright and sunny and cheerful.

Family

When I was in the army, I was stationed in Frankfurt. I was the lieutenant attached to a general. I'd never been to Europe before. I was twenty-two years old. I went to the southern part of Italy where my family comes from, Calabria, the most southern tip of the boot, the point. My father has very well-known tailors in his family and one older cousin of his named Antonio Cristiani whose name is on all those suits that you saw here.

My father was trained in the little village, from Cristiani's father. It's a tailoring family of five generations—they actually go back to the time when Napoleon ran southern Italy. In 1804, there were Cristiani tailors. Men dressed for the courtship. You couldn't hit on women, you'd get killed. But what you could do on Sundays is parade around the town square. Every little village has a town square with a fountain, and on weekends, Sundays, men would dress up and go arm in arm with a cigar, smoking

and talking. The town square has balconies on every side, and the women would look at the men. This particular type of male procession is called the *passeggiata*. It's a parade of peacocks.

I picked up on all this when I went for the first time to see my cousins in Paris. I went to the shop on rue de la Paix, and I saw photographs of Cristiani with Gary Cooper. I saw a photograph of the prime minister of France in the 1940s, named Léon Blum, the first Jewish premier of France.

I once went to a shop, there's this tailor called Roland Meledandri, used to have a shop at 74 East Fifty-sixth Street. I have a Meledandri suit: It's a wonderful dark blue, red-pinstriped suit I bought from him in the mid-1960s that I still wear with pride—to a New Year's party in 2016! I met this Meledandri in 1964 at Elaine's, and he told me that when he started his shop, some ten years before, a young kid would peddle ties to him, and they'd display some of these ties. And the ties were by a young man named Ralph Lauren.

Touches

I look for tone in writing, a little special touch in your writing, in your clothing, in your general way of living. People who are in the literary game say your work speaks for yourself—well, not only. The work might speak for you, but I believe there's more than just what you do, it's how you live. What kind of personal style do you exhibit in the way you conduct yourself? The way you walk away in the morning to leave the house and how you return. How you walk into a restaurant. It's a whole exhibition of life. You're living in the spotlight of it, the shadow of it. Unless you have a sense of self, you're not going to wear clothes with any pride, because the clothes are wearing you. You have to wear the clothes.

Hangovers

I haven't been hung over for a long time. I got an assignment from *Esquire* to interview Peter O'Toole in London, and I went to London, and he's a very nice guy. He said, "I really have business I have to do in Dublin. Do you want to come with me?" Sure I did. Well, he drank a lot. And I never hung around Irish pubs before—they never use ice in what they drink!

After I did the piece, I got to know him, and he called me up once and said, "We're at P. J. Clarke's. Do you wanna join us?" This was about

five years later around 1970. I remember they'd closed P. J. Clarke's—they stayed open for us. I was with Jason Robards and Pete Hamill. It was about three in the morning. I walked up Third Avenue from P. J. Clarke's uptown, kicking every corner, and I came out and fell on the sofa right there. But that's a rare thing.

The Dry Martini

I make them myself. There's a shaker right here; upstairs I have a bar. I just fill the shaker with the ice. I put in a little dry vermouth—Boissiere French dry vermouth, put just a drop, just a little, a thimbleful—and then I'm very free with the gin. I'm only going to have one and I do fill it to the top, shake it up, twist of lemon. I always have martini glasses ready in the freezer. I use Bombay regular, not Sapphire, something about the Sapphire I don't like. It's rather perfumey. You drink gin, right?

I think probably in the 1980s or maybe before that, I started liking martinis. I used to drink Scotch, and I'm never affected by Scotch. If I have to preside over a big dinner party—sometimes my wife has a book party here, and maybe a hundred people will show up—I'll have maybe a Scotch or two, but I want to have a gin when I have nothing on my mind.

MEN OF STYLE

Miles Davis

STEPHEN COATES Gainsbourg, particularly in the sixties. I absolutely loved that look, even that no-socks-and-loafers thing, which is kind of objectionable in principle, but he made it look good in denim. But in the sixties, it was Michael Caine. I loved those peacoats, sixties-style mod.

He would take me to this opera restaurant, an Italian place, and all the waiters would say, "Kim, sing for us!" And he'd sing something in Italian even though he didn't speak Italian and barely spoke English. When he first got to New York he attended Juilliard, but he eventually got kicked out because he refused to

> **"Richard Merkin would say wearing white shoes with a white belt is called a full Cleveland. He always would say this obscure stuff like it was common knowledge. He was living in a different time, but it was as if he didn't know it."**
> —Duncan Hannah

GLENN O'BRIEN My big fashion influence was Fred Hughes, who was Andy's right-hand man, his social secretary, and art adviser and decorator. Fred is one of the greatest, best-dressed men in American history. He was so elegant. He had a strange life: He grew up in Houston and his family didn't have money, but somehow he had been adopted by the de Menils. He had the most beautiful khakis, the most beautiful English shoes. He was just impeccable.

BYRON KIM I had an uncle who always looked great. As far as I could tell, he delivered the *New York Times* to Japan via JFK for a living, but, somehow, he shopped at Barneys. He usually wore penny loafers and a white shirt. Oh, at some point he owned the first Korean restaurant in New York, Korea House.

take any classes that involved any other students. Florence Henderson was his classmate there. Eventually, she became famous as the mom of *The Brady Bunch*. I miss my New York uncle. What an amazing guy.

GUY TREBAY People around my parents seemed swanky. My godmother—who, alas, I never met again after my baptism—was the daughter of the man who was general manager of the Plaza. As an infant I was taken by my parents to parties there and parked on the bed with the fur coats. I guess they couldn't afford a babysitter at the time.

My maternal grandfather was very stylish and six foot seven. He had slicked-back hair and a tidy mustache. It was a challenge for my grandmother being married to him, not least because she was pos-

"My grandfather was an army sergeant and ran a hospital during World War II, just north of London. When he came back he took over the family business, a plumbing supply yard. He was a very uptight guy, very clean shaven, very austere, high and tight with the fade. The day he retired, he grew his hair out, he grew a beard, and he turned into a complete fucking hippie. Not really a hippie, but he looked like a hippie—he started wearing cowboy hats and bolo ties. I idolized my grandfather, so I started wearing cowboy hats too." –Josh Peskowitz

sibly five foot five in high heels. In a photograph of them together, she is wearing platform shoes and some sort of top hat, and she still only comes up to his armpits.

TOM SCHILLER My father's father lived in Sacramento; he was in the ladies' garment industry. He had a thing called Studio Fashions, which wasn't for the Hollywood studios—it was just the name. He would travel with a model, up and down the coast of California, trying on his line, which was cloaks and suits. I said, "What's a cloak?" He said, "Just a fancy way to say coat." I said, "Why did you travel with a model?" "Well, if you just hold up a garment on a hanger, it doesn't look so great. But if you have a model, and she's prancing around in front of the client . . ."

ANDY SPADE My dad's father, Wayne Spade, was very stylish. He would always send me Brooks

Brothers and Lacoste for holidays, and he had monogrammed them for me. They lived in Delray Beach in Florida. He was a stockbroker and a very traditional, very good-looking guy.

JAY FIELDEN I think there was some accidental—or occupational—style in the family. I had an uncle who ran the original family homestead—a lot of rocks and cactus in central Texas—where the family landed around 1890. My mother grew up there and has very fond memories of riding her horse like a scene out of *Giant*, and my great uncle basically ended up living there as a bachelor his entire life. He had a really simple way of life and of dressing, which a lot of other ranchers in that part of the world did at the time too.

I still think of it as one of the greatest uniforms you could ever have. Basically, he had two things he wore. An all-khaki outfit, which was made by Sears, Roebuck. Thick

military-grade stuff. Khaki pants, khaki shirt, a tooled-leather western belt with a double buckle. It was slender, not some honking, J. R. Ewing thing. The other outfit was jeans and a chambray shirt, same belt, and same boots—the old Red Wings, made with saddle leather. Plus a Stetson hat: the Roadster model. In my mind's eye, Uncle Bill always looked very put together, always cool in the high Texas heat, yet always ready to kill a rattlesnake or castrate a bull.

ALEX BILMES My father's father was a judge, extremely dapper and cared a lot about clothes. I have a memory as a boy of sitting on my grandfather's bed, watching him get dressed to go out in the evening, and the meticulous way in which he did it. He was wearing garters. I once trod accidentally on my grandfather's shoe, and he was genuinely angry.

My grandfather was a Jew from the Ukraine, so I think he felt more than anyone that it was necessary to conform to the role of English gentleman, be more English than the English. So he very much cared about clothes, and my father inherited that, and subsequently I did as well.

My grandfather had an amazing holiday wardrobe. He loved France, he loved being abroad, he loved heat. I'd see him in a powder-blue safari suit, with shorts and sandals. He was a dandy; he had a look for every occasion that was slightly different. The panama hat comes out, which would never be seen in London. Not that my grandfather loved the countryside at all, but if there was, like, a Sunday out of town, shoes you'd never seen before came out. I think that was great. I think dressing for the occasion is very pleasurable.

G. Bruce Boyer

Clockwise, from top left: Eric Dayton's grandfather's naval officer pins, Jay Batlle's father's pocket watch, Nick Wooster's father's watch, Jay Batlle's father's vest, Russell Kelly's grandfather's lighter, Chris Brown's father's Stetson, JP Williams's father's dog tags, Brian Awitan's father's watch

Clockwise, from top left: Aaron Levine's father's army jacket, Jay Fielden's father's Western shirt, Don Weir's great-grandfather's pocket watch

Toshiro Mifuni

PART II
Intricacies of Dress: *From Head to Toe*

Do
Clothes
Matter?

Of course they do.

They explain how we imagine we fit into the world. They're about self-knowledge and, in rare cases, self-realization. We seek rules of dress—and it's important to know them—but the best-dressed men create their own sartorial world with its own internal logic and controlled anarchy. They make new rules: of possibility, of expression, of improbability. We celebrate men who defy the endless branding of every space of the culture. They go forward and dictate the terms of perception, knowing that in the end, clothes serve to reveal their own personality.

Gordon Cooper

Revelations of the Hat

As a cultural barometer few things rival the hat. A glance at a picture of a behatted man can reveal his profession, the occasion, the era when he lived. By hat, we refer to the real thing: homburg, trilby, fedora, bowler, and even the top hat. To wear one is to take a stand, to assert one's sensibility on a populace that may still be catching up to you. There is no neutral hat. Today's man wears a hat to invoke his unique place in the world: He is not a company man, a member of a boy band, or the leader of a religious sect. You wear your trilby and you walk alone. And that's as it should be.

We know who wore hats: Sinatra, Capone, Bogart. And we know, chiefly, who did not wear one: John Kennedy. Of more recent vintage we admire the late Richard Merkin, the artist and fierce dandy, who was one of the few men to wear a bowler and look entirely himself. He was the most singular dresser in any room, yet he made you self-conscious. His secret knowledge made you question what you thought about society. That's a man who knows how to dress.

Kennedy may have banished the hat for generations of the ruling class, but the cycle has swung round again and there's an increase in hatted men from the runway to the midway. Not caps, mind you, or little straw hats perched atop C-list actors in West Hollywood, but more assertive options. Step into the opera house wearing a trilby with the assurance that you'll be dressed on par with the maestro. You came to the party in a fedora to see if it was worthy of your time. Arrive at the auction in your homburg and let the bidding begin.

There's no guide to wearing a hat, any more than there's a guide to having a winning personality. Though it helps when you wear one if you have the other. The key to a hat, like countless sartorial challenges, is to wear it on your own terms. There are no half-measures. The hat should serve your personality and express how you view your place in the world. You should look more yourself in one, not less.

The fedora has raffish Rat Pack undertones. The bowler, always iden-tifiable with Chaplin, has a performative quality, playful, vaudevillian. And yet it can be read as a challenge.

One reason men are donning hats again is that they're returning to clothes favored by previous generations. The smoking jacket, the velvet

Pablo Picasso

slippers, double-breasted coats, heavy tweeds. These are the pillars of the classic gentleman's wardrobe. Yet when they're combined and recombined, they look anything but traditional. If anything, they draw the present into extreme focus. You choose these things not because you inherited them (though that is convenient), you choose them because they express what you ask of the world and what you think the world should ask of you.

Go forth in a trilby and you convey a sense of appreciation in what men's clothing was and what it can be. Urbane, festive, forward, daring. You have a sense of formality but also one of occasion. Accept no substitute. A remarkable hat doesn't express itself until it's worn, when it's joined with the wearer. Afraid of a top hat? Ellington wasn't. It underscored how fearless and formal he really was.

The same hat can convey infinite meanings. Just tilt it. Wear it until it falls apart, even with a formal suit. A friend wears his panama hat backward; on him it belongs no other way.

A hat covers the head, but it reveals the man.

The case for the custom suit is well known and irrefutable: It's the last frontier of superior craftsmanship, entirely built by hand. The word "bespoke" has been hijacked by marketers and nearly rendered meaningless, but the genuine article—a bench-made suit, cut specifically for you—has no substitute. The knowledge that goes into a Savile Row suit can rightly be deemed historic. Your cutter might have been taught by the man who cut suits for Winston Churchill. The sheer range of fabrics is just as astounding. You may think you know everything there is to know about tweed—think again. Some sheds in Scotland make only a handful of bolts of fabric a year. One of those bolts should be yours.

Look through your closet and be reminded how little else you need; if you're going to get something, it should matter. There's not a well-dressed man I know who doesn't advocate fewer, better options. There are exceptions, of course—a transformative overcoat, say, or a good pair of English brogues. But without the background noise you can focus on tailoring traditions that existed since before you were born and will continue after you've ascended to menswear heaven. So take the long view and ask: Could this piece of clothing have been worn ten years ago? If not, it will look dated in a few years, and you'll be praying your photos from some defunct street-style blog won't turn up when somebody Googles your name.

That doesn't make it any easier when the reckoning comes: The price is going to be dear, but you're going to take it like a man. You probably don't want to disclose just how much it cost, the same way you don't want to broadcast the rent of your West Village apartment. And if you live with somebody who knows your rent, well, she might still be so shocked that you don't want to tell her either. Men who resort to stealth smuggle their suits into their closets under cover of darkness. That's not enough! You must also feign nonchalance when she notices your dashing suit and comments upon it. "What," you say, as if you're talking about the weather, "this gray flannel suit with a devastating rolled lapel? Had it forever. But feel the lightness of the fabric." She'll be on to you because she likely does the same thing, knowing that you can't tell heel widths apart.

It's a slippery slope. Once indoctrinated, however, there are few complaints. Rare is the man with only one handmade suit—he'll do everything in his power to buy another. But be assured that that money does not go into an advertising campaign for a cologne destined for duty-free stores. Instead, it returns, as is right, to tailors who've apprenticed for years to become expert at what they do. In fact, the profit margins of Savile Row tailors are surprisingly small, and many have closed or left the Row.

If you'd like to make a pilgrimage to London or Naples, by all means do. But plenty of tailors now visit their American devotees on our own shores, where they rightfully receive a hero's welcome. They usually take a suite of rooms in a discreet hotel, and it can be strange to pay a midday visit to a hotel room in the town where you live. When the door opens, there's an odd fear of encountering an upscale escort.

Another client may be emerging as you enter. He may have the abashed look of a man who intended to get a summer suit and has just ordered a blazer, a topcoat, and a winter suit for symmetry. Not unlike the man who returns the wine list to the sommelier with a slightly uncertain look after he was convinced to head much further down the page of prominent Bordeaux houses.

It's worth taking a break from the heavy traffic on the menswear highway. If you care about tailoring, abstain for a few months, even a year, and get back in the game with the best jacket you can afford. You'll gain a new sense of clarity. You'll arrive at a point when you look back and won't believe you saw the world any other way. When somebody tells you you're overdressed, remember, if done correctly, it merely means you're the best-dressed man in the room. That's a burden you deserve to bear.

Enduring Appeal: The Blazer

Sean Connery

The blazer represents classicism in the best sense—its appeal is both historic and immediate. It stands for unimpeachable sartorial ideals, which is useful, while flattering the wearer, which is vital. If a gin martini is the one cocktail you should make with a sense of authority, then a well-tailored blue blazer is the article of clothing that should hang in your wardrobe, ready to ease you gracefully through society while setting the stage for your winning personality.

Yet the blazer endures despite its somewhat traumatic childhood associations for many men. It's often the first piece of formal clothing in a boy's

life. You are taken, perhaps under false pretenses, and certainly against your will, to Brooks Brothers or Ralph Lauren and inserted into something that feels very much of the adult world.

As their wisdom grows, however, men move beyond these memories and the blazer is welcomed back for one simple reason: It looks terrific. Back to Ralph Lauren our hero goes, now with a spring in his step, as a regular customer, perhaps to try on a double-breasted number in a wool-cashmere blend, which he'll add to his growing collection.

Wear one that fits well and the opportunities are endless: Wear it with jeans if you desperately need to communicate creative credibility, wear it with a knit tie if you're of a Continental mind, wear it with gray flannels if you share a kinship with Fred Astaire. Hell, wear it with shorts if you're Thom Browne (but only Thom Browne).

Get a good one and you'll be shocked at how often you choose to put it on, and how many compliments you receive. Do it for no other reason than to have something in your arsenal when you stride purposefully into the 21 Club, an institution that hasn't done away with its dress code. Conversely, you could enter in shirtsleeves and be asked to don one of the "house jackets" at the restaurant's coat check. If you're on your way to a business meeting with, say, Jack Donaghy, he'll know who has the upper hand when he takes your measure in an ill-fitting, possibly stained jacket. If you're with a date, she may have already left.

How did we get to this point? Like many of our clothing traditions, it arrived from England. But the first thing to know is that the blue blazer didn't begin its life blue: It was red. Members of the rowing club at St. John's College, Cambridge, in 1825 wore searing jackets that led to its name. While those at St. John's felt a proprietary sense toward the red color, other sport coats became known as blazers as well.

And become known they did! Worn to indicate the membership of clubs, they multiplied in various colors, stripes, and crests. They weren't just worn to attend sport; they were worn while playing sport. Wearing your jacket sends a clear message. It recalls the line from the great Luciano Barbera: "Any time I see a man playing tennis or golf in his jacket, I know he and I can be friends." *Luciano, amico mio*, let's hit the court, then get Negronis.

If you feel the double-breasted coat with gleaming gold buttons looks like you're about to dock a yacht or is too much like Dr. Emil Schaffhausen in *Dirty Rotten Scoundrels*, then consider the more discreet two-button coat

with dark buttons Sean Connery wore as 007 in *Dr. No.* Still too clubby for you? Then take the versatility and indispensability of the coat from Jonathan Ames: "If one's sport coats were as important as one's inner organs, then the blue blazer would be the lungs—absolutely essential; you can survive without the seersucker, for example, the spleen of sport coats, but try getting by without a blazer!" Amen, brother Ames.

So go forth and conquer in your jacket. Wear it when you're a guest on Charlie Rose, wear it with white jeans to a Riviera nightclub, wear it with a sober tie to your parole hearing. Wear it with the confidence that comes from being part of a classic tradition that continues to help men carry the day.

Ties: Setting the Bar

When Jason Kidd coached the Brooklyn Nets a few years ago, he became noticeably more relaxed as the team went on a hot streak. The *New York Times* noted that this went beyond the team's play: "From an aesthetic standpoint, Kidd's development has included growing a considerable gray-flecked beard." We always support beards in leadership roles, even among titans of finance (you can approve the beard and not approve the investment strategy).

The piece went on to note that during the winning streak, Kidd had also forsaken wearing ties during games, and he looked pretty good without one. Still, our first thought was that this was another step down the path of informality—like the sad day when the 21 Club dropped its tie requirement at lunch.

Why is that? The tie is a declaration of intent. A good tie announces your understanding of society and your place in it. The tie maintains a cultural power even in its absence; that's why you notice when somebody in a position of authority isn't wearing one. Would you hire an accountant who wore a flannel shirt? Consider the downward spiral from Tom Landry to Bill Belichick. Both are brilliant coaches; one was dignified and natty, but the other looks like he should be replacing used towels in the locker room.

That doesn't make the tie a default mode for every man—we're long past that point. But if you are going to forsake the tie, it should look like a proper consideration. You don't want to look like you've been ejected from a fancy restaurant and are looking for the nearest bar with a television.

Boys are made to wear ties against their will; men understand a sense of occasion and rise to it. Ultimately there is a time to wear your tie, and you should know when that is. Whether you're eating at Daniel, attending the opera, or sitting through your sentencing hearing, wear your tie from a position of strength. In the meantime, if a tie constricts you, then find another path. But let that path be true.

Lee Marvin in *Point Blank*

Al James
That's easy and embarrassing: One.

Chris Black
Five—for weddings and funerals only.

J. C. MacKenzie
Eight.

Thomas Beller
I would say twelve.

Enoc Perez
Maybe twelve. Five of them are from my grandfather.

Brian Awitan
Thirteen, all gifts.

Frank Muytjens
About twenty-five. They come and go.

Russell Blackmore
Thirty, which seems like a lot for someone who doesn't wear a tie very often anymore.

Alexander Gilkes
About thirty, but I always use the same three.

Richard Christiansen
About thirty. But the odd thing is that I only ever wear two of them. But when push comes to shove, I'm not brave enough to embrace pattern and I pick a solid color.

JP Williams
Thirty-three ties, four bow ties.

Jay Batlle
Enough to know each one personally.

Dan Rookwood
Fifty-three.

Nick Sullivan
About sixty. I wear two.

Robert Becker
Around one hundred.

Russell Kelly
Over a hundred, but I consistently wear less than ten.

Andy Spade
One hundred and six.

Mark McNairy
A shitload.

Nick Wooster
After a massive culling, 137.

Adrian Dannatt
Countless, literally.

Jay McInerney
In active rotation, around fifty. Another hundred or so in the closet.

Glenn O'Brien
I counted last night and seem to have 179 ties. I think Oscar has my Calvin Curtis $ tie in his room, which would make 180.

Gay Talese
Nearly two hundred.

Duncan Hannah
I suspect around two hundred.

G. Bruce Boyer
I've got about two hundred ties. I cull the herd every few years, but they keep multiplying anyway.

Derrick Miller
Three hundred fifty, or an embarrassing amount.

Michael Hill
Could be five-hundred-odd, including those made by my old man and great-grandfather. As far as those I keep in the wardrobe and wear, probably no more than two dozen.

WHAT DO YOU COLLECT?

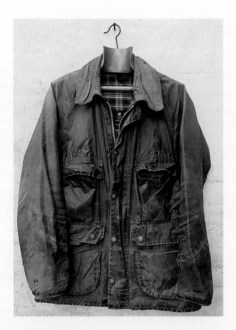

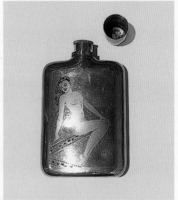

> **"I've actually become a collector of collections of cowboy boots. Other cowboy boot people will become weary of their addiction, and then I'll buy them."** –Walter Kirn

Clockwise, from left: Matt Hranek's Barbour, Al James's fishing reel, JP Williams's ball of twine, Brian Awitan's flask

> **Cuff links are an obsession. They can be whimsical or a little baroque in a way that men's couture doesn't otherwise allow unless you're a game show host or a hip-hop star."**
> –Jay McInerney

JAY FIELDEN I probably have a hundred knit ties. I'm easily overcome by Charvet. I go there all the time when I'm in Paris. I love all the wackier colors, the really French ones: Indian blue, chartreuse, tangerine, apple green. Colors I could never wear with my red hair, but I sometimes still buy them. There they hang on the goddamn hook in my closet, enjoying the free air-conditioning, I guess.

ALEX BILMES I do have a lot of ties. I have a lot of suits. I have a lot of shirts. I don't need any more shoes. But I'm going to get some anyway.

G. BRUCE BOYER I love tweed jackets. My wife says they all look the same—browns, greens. I like those mossy colors. I see a huge distinction between all of them. But not everybody else does.

STEPHEN COATES I've got too many single-breasted, three-button suits. There's just not enough difference, really, between them to justify having them. I should narrow them down to five.

GUY TREBAY I probably have more than one more Brunello Cucinelli puffer vest than I need. I don't buy them at full price. One of the compensations of living in New York City is sample sales.

HIROFUMI KURINO I have so many clothes, and countless shoes. But my biggest collection is vinyl records. I have about ten thousand records, and I keep buying them. I saved for records when I was in elementary school—each month my parents gave me 300 yen, which was about three dollars. Three dollars is enough for a kid. But a single record costs 370 yen. So I saved two months and bought one single. If I saved six months, I was able to buy an LP.

MARK McNAIRY I had two hundred pairs of Adidas, Nike, and Converse. I had them meticulously lined up around my room. That was from working at the sporting goods store and getting sneakers from the basketball teams. I was younger than sixteen, because I wasn't allowed to legally work there.

NICK SCHONBERGER I have a lot of T-shirts that I don't wear. Every time I move, I put T-shirts in a bag and put them in storage. I have most significant T-shirts of every era of my life in a bag.

"I had twenty thousand records. I'd cut my grandmother's lawn for twenty bucks and would ride my bike across town and blow it on records. Back then, the only way to hear it was to buy it. If I didn't like it, I would warp it on the stove and put it back in the sleeve and take it back to the store and say, 'Hey, I want a different one.' But they would only exchange it for the same album—but the day before, I would take all of those albums and hide them in the jazz section. School Kids Records was the hippie record store—but I didn't do that to them. I did that to Record Bar, which was the chain shop in the city." –Mark McNairy

ROBERT BECKER I've been collecting since I was old enough to have my own money. I still have the first object I ever bought at a flea market, a framed tobacco card of a Chinese circus performer. Right now I'm obsessed with nineteenth-century Japanese ambrotypes, tiny glass photographs housed in delicate kiri wood boxes decorated with calligraphy.

ANDY SPADE I'll buy shell cordovan loafers, shell cordovan brogues, the same simple oxford. They last for years but when they're gone, they're gone. I'll buy desert boots from Clarks, the same one color, over and over again. I would buy white and blue oxfords from Brooks Brothers, over and over again.

NICK SULLIVAN I started buying souvenir ashtrays from India that were all made in the 1930s and '40s by kids in the metalwork shops. They were bought by British civil servants, who'd bring them back and give them as presents. Amazingly, they are all the same. They're all maps of the Indian subcontinent, and you can tell whether it's pre-Partition—'47—by the names on the areas, and for the most part they're pre-Partition, World War II and before. I'd buy them for eight or nine quid and take them to a silversmith in the jewelry district, and he'd replate them for me.

JOSH PESKOWITZ I have an exorbitant amount of overcoats; that's my biggest weakness. I don't like wearing puffer coats. Obviously I have a parka, but I'd rather wear two overcoats than wear a fucking fifty-below Canada Goose—shoot me if I ever wear Canada Goose.

FRANK MUYTJENS Chambray shirts. I find them at vintage shops and they're a little roomy but I like that. Another thing I can never get enough of is French vintage linen. I find that in Japan.

MICHAEL HAINEY I tend to hoard papers. I don't hoard clothes, but I keep letters that people write me and all my notebooks—anything I've written. If you wrote me a note, I'd keep it.

MICHAEL WILLIAMS Bags. A bag is so utilitarian it's like a tool in a way: The right bag for the right situation or the right trip. If I'm going out to Maine, I'll always pack my Filson bags. If I'm going to Tokyo, I'll pack a black Porter bag. Notebooks are the same way. I have whole categories of things that I will never need to buy in my life. When I go to Japan I tell myself, Don't buy any bags, don't buy any notebooks, you don't need any fucking notebooks, you don't need any bags.

(I probably have fifty), Calvin Klein underwear, and Paul Smith socks. Maison Margiela denim shirts, J.Crew sweatshirts, and Acne sweaters: my closet looks like a cartoon character's—same outfit everyday

WESLEY STACE I collect way too many things. I collect lots. I have lots and lots of records, and lots of books about and by Laurence

> ## "I can't name anything that I don't have a lot of."
> —Nick Wooster

ROB ZANGARDI Right now, I own about sixteen pairs of Saint Laurent jeans. I go through phases with jeans. Before Saint Laurent, it was A.P.C. I'll find a pair I absolutely love and then buy as many as I can. Same goes for James Perse T-shirts

Sterne. I have lots of first editions, particularly of Patrick Hamilton, Edward Lear, Angela Carter, L.P. Hartley, and Anthony Powell. I have lots of copies of the *Fortean Times*, but you can have them if you like.

Canvas Sneakers, David Coggins (the author's father)

Scarves: Wrapped in Meaning

Many years ago I was a student in Paris. It was fall, I was twenty, and as the weather turned cooler I began to consider what scarf to wear. But I didn't want to look too eager and be the first person strolling down the rue du Bac in advance of the season. I need not have worried. On the first cool day, men, women, and children were all draped in a brilliant array of scarves. Brightly colored, nonchalantly wrapped, inevitably elegant—this was accessorizing as high expression.

The scarf does more than keep us warm. It shows the world a flash of color, a blaze of pattern. In the proper hands it can even be a stroke of genius. I've learned this firsthand: My family feels very strongly about scarves. My sister, mother, and father wear them religiously and generously give them to each other. But then they "borrow" them back, sometimes without asking and for extended periods. It's not uncommon for my dad to say to my sister, "That's a great scarf, is it mine?"

This leads to good-natured accusations—and some less so. I suspect Dries Van Noten has started more fights in our family than any other subject. I roll my eyes, but I understand the connection people have to their scarves. Why is that? You develop an attachment to something you wear every day. While the rest of your wardrobe rotates, the perfect scarf captures your feelings for the season, and you feel oddly naked without it.

I am partial to short scarves, those you can wear under a sport coat. This trend, alas, hasn't taken off. I've tried to convince designers who are friends to make a short scarf just for me. I'm still waiting.

Ultimately, a scarf offers a change of pace from our habit of dressing. It's a well-earned point of interest, something optical, something warm, something close to the heart of anybody who cares about style. Just ask a Parisian.

Great Detail: The Pocket Square

There's a reason there's a pocket on the front of all your sport coats: You're meant to adorn your ensemble with a pocket square. It's been that way for more than a century, and it's one sartorial tradition you should proudly carry on.

If a suit represents your adherence to classical style, then the pocket square is a chance to express your individuality, one that should not be passed up. Once you dive into the pleasures of the pocket square, a coat that lacks one looks somehow unfulfilled, like a Porsche that never breaks the speed limit.

The easiest way to sport the pocket square is the Don Draper approach—straight and white as an index card. This no-nonsense approach works best with a narrow-lapel coat, an ice-cold martini, and a worldview that takes no prisoners. An added benefit is that most white silk pocket squares arrive folded in just this manner. Simply insert in the pocket and prepare for ad-world domination.

The tuxedo is also a good chance to dip your toe in—you're dealing in stark black-and-white contrasts. It's one part of the ensemble that allows you to be more expressive, to show you're the master of your uniform. Then, critically, forget all about it. You don't want to be beholden to the thing. When you're in a tuxedo you've got better things to worry about, like accepting your Lifetime Achievement Award at the Daytime Emmys.

The pocket square is your chance to add dynamism to any suit. And though you may pass your pocket square to your date at the opera when she tears up during *La Bohème*, under no circumstances do you blow your nose into silk. That, my dear fellow, is why you also carry a handkerchief.

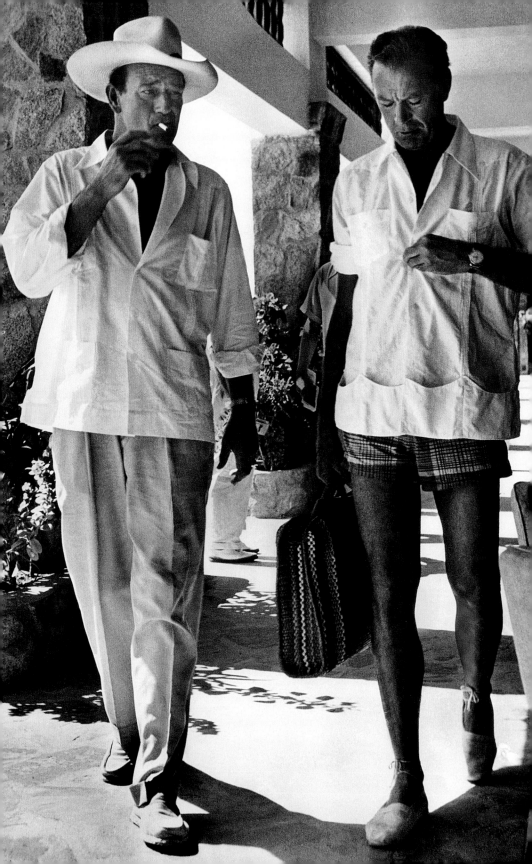

Southern Exposure: Men Without Socks

When you meet a man, you observe certain sartorial and social cues. You notice a firm handshake, perhaps a whimsical Hermès tie, or maybe a watch the size of a coaster. But if you're really to take the measure of the modern man head to toe, you are increasingly likely to discover something else: He's not wearing socks.

We're not talking about Vans on the beach, Top-Siders aboard a sailboat, or espadrilles on the side streets of Saint-Tropez. We're not even talking about brilliantly colored driving mocs as you step onto a Vespa. No, we're talking about a man in the city, in a suit, with nothing beneath his brogues. More and more, the ankle is where men are empowered to flash a little flesh. Where once a man wore vibrant Paul Smith socks to introduce a sense of play into his wardrobe, now men are inclined to trot out their ankles, au naturel.

How did we arrive at this point? What began as a relaxed summertime tradition migrated to the city with the cleaner lines of modern tailoring. And by clean lines we mean shorter trousers that show off shoes. But short sometimes means really short—like culottes. It's likely that today's young man has never even uttered the phrase "a good break" to his tailor, whose trousers are probably pooled around his own ankles.

This trend can be attributed to the immense influence of Thom Browne: the maestro of schoolboy dress, whose suits look exquisite on him but may appear slightly shrunken on anybody not fully indoctrinated in his sensibility or not built in good, concise proportions. Mr. Browne wears his trousers just below mid-calf (when he's not wearing shorts, that is) and pairs them with substantial wing tips. He's taken the businessman's uniform and turned it inside out, undermined the system from within.

Just because Mr. Browne has mastered the art of ankle exposure, does that mean you should too? Those who are not consummate fashion insiders are embracing this with a fervor that leaves others uneasy. The bare ankles strike some as unprofessional and have led certain companies to introduce a mandatory sock-wearing policy during non-summer months.

It should be said, however, that many men are now going sockless in name only. In fact, beneath their beautiful shoes they're wearing "footies"— little slip-on socks that allow them to invoke the nonchalant air of the sock-

John Wayne and Gary Cooper

119

less while keeping their hygienic prerogatives intact. At a recent Midtown cocktail party with some men in the fashion industry, I realized that of the half-dozen men I was with, I was the only one chaste enough to be fully socked.

Each of the dapper fellows had his own strategy for his footies: Some bought high-end versions at the country club pro shop; others found acceptable three-dollar substitutes that they bought in bulk in a California grocery store. Some prefer a size too large, because they tend to shrink; some wear them a few times and toss them out. But I found that they all were well versed in the trade-offs around the toes. And I realized that I, in striped socks and uninitiated in these matters, was the most conservative man from the knee down.

One young friend wears socks less than five days a year. As a firsthand witness of this behavior, I went through a swing of emotional phases in my response. It began with curiosity and veered into a form of mild aggravation at the utter indifference to the elements, bordering on willfulness. In the end, however, I settled into grudging admiration, with slight concern about the sock abstainer's disregard for the long view. It's like the morbid fascination you feel for the Polar Bear Club members, who plunge in the ocean every New Year's Day.

Ultimately, what's striking about this flash of flesh is how something that began as a sign of relaxation now signifies a sort of formal rigor; to look offhand and relaxed now takes considerable strategizing. This is, in the end, a sign of the modern man's evolving view of fashion. He's not a strict minimalist who's sworn off accessories or bursts of color. In fact, many of the sock apostates delight in vivid pocket squares or the dramatic seasonal scarf. The sockless dandy is not afraid to experiment, to express, even to slightly enrage. And, perhaps as important, it helps him to better understand the fair sex: When a woman remarks that her feet hurt, now he can feel her pain.

In Praise of White Shoes

When warm weather finally arrives there's a natural desire to get into the optimism of the season. You drink Negronis with a vengeance, dust off the fly rod even though the fishing hasn't picked up yet, you even watch your local baseball team before they take their annual swan dive in the standings. Spring is a time to express yourself, and that's a very fine case for white shoes. Real shoes, mind you, not Vans or something straight from the court: bucks, cap-toe oxfords, cricket shoes, even wing tips. A few years ago, Crockett & Jones released an elegant pair made of deerskin–they were practically criminal.

When worn properly, white shoes go beyond the country club, and they have nothing to do with nonsense about "redefining what prep means today." Like Belgian Shoes, they veer toward dandyism but return to a position of strength. If not quite subversive, they still impart a sense of exhilaration, like eating steak tartare with a raw egg cracked onto it.

Fred Astaire wore them so filmgoers could follow his terrific footwork. Our friend JP Williams wears them year-round, in part because of his Southern upbringing but also because of his iconoclastic streak. White shoes won't stay white for long, nor should they. Their imperfections are rightly seen as a badge of honor; like a frayed collar or a coat's thinned elbows, they're a form of sartorial scar. A man in white shoes asserts his individuality, conveying a sense of liberation. He appreciates the seasons but isn't constrained by them. He understands uncertainty and welcomes it. And, most important, he asks, When can we celebrate, if not today?

360 part

361 part

360
Group of Seven Pairs of Shoes
Comprising a pair of brown suede lace up shoes, labeled *Maxwell Dover Street, London, W*; pair of black calf lace up shoes, labeled indistinctly; pair of brown calf wing tip pull ons, labeled *Anthony Cleverley, 79, St. Joseph's Road, London, n. 9*; pair of brown suede tassel slippers; pair of brown calf slippers; pair of brown fleece lined zip up ankle boots; and a pair of black and white spectator shoes.
C
$200-300
See Illustration of Part

361
Two Pairs of John Lobb Shoes; Together with a John Lobb Box
The box with paper label *John Lobb, Ltd, Bootmaker*, containing a pair of brown lace up oxfords, labeled *John Lobb, London, Paris, New York*, and a pair of black calf slip ons, labeled *John Lobb, London, Paris, New York*.
C
$100-150
See Illustration of Part

362
Two Pairs of Italian Shoes
Comprising a pair of cordovan leather ankle boots, labeled *Universal Bologna-Italy, Made for Lefcourt, 400 Madison Ave-New York*, and a pair of brown suede Gucci loafers, one stamped *Gucci, Made in Italy*.
C
$100-150

363
Pair of Monogrammed Evening Slippers
Midnight blue velvet with gold bouillon *DF* monogram, labeled *Maxwell Dover Street, London W.*
C
$150-250
See Illustration

364
Collection of Douglas Fairbanks, Jr.'s Shoehorns
Approximately thirty-four pieces.
C
$50-75

363

Man of Auction: Bidding Wars

A few years back the Hollywood effects of Douglas Fairbanks Jr. went to auction at Doyle on the Upper East Side. Old Doug was a committed Anglophile and a bold dresser, though he had an unfortunate penchant for caftans in his later years. But if you can handle being married to Joan Crawford, you can handle a dinner jacket in brown velvet.

My target was a lot comprising seven pairs of shoes, in particular a pair of suede Henry Maxwells, at that time based on Dover Street in London. I adhere to the Neapolitan tradition of wearing suede shoes year-round—and the catalog said they were 9½, exactly my size. But it was still a gamble since you couldn't try them on. If they fit they would be a coup for all time; if not, they would become reluctant gifts for taller friends who may or may not deserve them.

The bidding was surprisingly robust for Doug's monogrammed gold sock garters, which went for a cool three thousand dollars. When my lot came up I just found myself wielding a paddle as nonchalantly as I could, though I'd never done it before (bidding on eBay in pajamas is not quite the same thing). Blood rushed to my ears as I kept waving away. I couldn't even hear the final price. Around three hundred dollars or so—either a boon or an amount that would nag at me until the story became enjoyable to tell, which I estimated as five years hence.

When I gathered my lot the next day, I couldn't wait to try a pair on. In the back of the cab downtown, I practically screamed. The slightly alarmed driver turned around to make sure everything was all right, he couldn't tell that they were screams of joy.

Page from Doyle's auction catalog for the estate of Douglas Fairbanks Jr.

MAJOR ACQUISITIONS AND INDULGENCES

> **"My first pair of bespoke shoes was at George Cleverley in the early nineties. I read about this shipment of leather that had been recovered from the Baltic—it had sunk in the mid-nineteenth century, and somehow these tanned hides had survived. As soon as I read about it I thought, I have to have these. Whatever it cost, it seemed like an awful lot, and I remember that I was just buying an apartment and I was thinking, I can't do this, I can't do this. I went to London—there was another excuse, but I went almost specifically to get these shoes."**
> —Jay McInerney

BRUCE PASK For the longest time I have loved Volvos, especially that really boxy 240 station wagon that often appears in movies, driven by characters like a liberal college professor or the slightly bohemian sibling at a family gathering. It just has so much personality and looks so sturdy. At the time, the early naughts, I was working as a stylist with Annie Leibovitz doing numerous *Vanity Fair* shoots and commercial projects; and we did *The Sopranos* ad campaign, one of my biggest gigs at the time. After we wrapped, as a treat to myself, I went out and bought a '93 hunter green 240 wagon with caramel interior,

a real shoebox on wheels. It was love at first sight. I still have her and she's always been dependable. We've been through a lot together over the years.

HIROFUMI KURINO I mainly wear just one pair of glasses. My first pair is from 1977, by Hakusan opticians. It cost forty thousand yen, about four hundred dollars, quite expensive at the time. It was more than half my salary, but no other people were making these one-of-a-kind glasses. So when I got my first salary I went directly to the shop and bought them.

For twenty years I've had another pair that was made to order, which were based originally on my wife's glasses. I found these glasses that she wore as a teenager. I found them by chance when we started living together. They needed some adjusting, so I brought them to a store and they fixed them just right for me, and I wore them for about ten years. I liked the model so much that eventually I made a replica of it, and I've been wearing it ever since.

NICK SCHONBERGER After graduate school I bought, at auction, a chest owned by J. Welles Henderson, who was the founder of the Independence Seaport Museum

Hirofumi Kurino's glasses

in Philadelphia. It was described as a tattoo chest that's in *Jack Tar*, Welles's collection book. I bought that in Portsmouth, New Hampshire, at Northeast Auctions. That was the most expensive thing that I ever bought. Unwittingly, I was bidding against the museum, which I've now loaned the object to.

NICK SULLIVAN I bought a lot of my favorite things on eBay. I'll find a genre I'm interested in, I will look at fifty examples of that as they come up, and I'll hold off. By that time I'll know when I see a picture of one, that's the one I want. Yesterday I bought a 1950s French workers' shirt jacket. It's a little gnarly, seems to be the right size, maybe a little short in the sleeve, but I can do something about that. But I looked at fifty before I got to that one.

JAY McINERNEY The first time I ever went to a real tailor was in the early nineties. I went to Huntsman, and it was intimidating because I felt like you had to dress up just to go there. I thought, I wonder if actually this suit doesn't fit perfectly. I was very self-conscious the first few times I went to a bespoke tailor. I went to Huntsman, to Anderson & Sheppard. It's very intimidating. Suddenly you feel like your accent is particularly crude. This wasn't that long ago.

MICHAEL HAINEY When I moved to New York, there used to be this place on Broadway, I think between

> "The first time I went to England, I had just graduated from college. I was twenty-one. I took the summer to bum around Europe. I got a cheap flight, I slept on beaches, and I hitchhiked. I went from Ireland to Amsterdam, all the way across to Italy and back, and ended up in England. I went to a tailor: It was then on Regent Street, it was Bailey and Weatherill—absolutely authentic. I got a three-piece, single-breasted, gray flannel suit. This was really British: side vents up to the waist. In a week you could get three fittings in, and it was beautiful. And the buttonholes on the sleeve opened. I thought, Oh man, this is it. My life was never going to get better than this. And it may not have!"
> —G. Bruce Boyer

Thirteenth and Fourteenth, called Cheap Jack's or something like that. I didn't have much money, I was making fifty bucks a week at *Spy* magazine. But this place was near the office, so I went there and I bought this great houndstooth sport coat. I wore it for years; it was secondhand (you see the pattern here, a guy comfortable in hand-me-downs?) and I always got a ton of compliments.

I tend to get attached to clothes. Nostalgic. If it has served me well, I have a hard time letting go of it. So, with this coat, I kept it for years. When I started dating my wife, she found it in the back of my closet and was like, "What is this?"

MICHAEL WILLIAMS When I was twenty-five, I went and looked at these IWCs and loved them and really wanted one. I felt like one day I was going to own one of these watches. So I ended up going back and buying an IWC Portuguese, the watch that I looked at years earlier. It wasn't about the flash of it, it was about having something nice—and it was the first time I had a real watch, and that was pretty symbolic for me.

GUY TREBAY The strangest thing I've bought at auction was a pair of eight-foot teakwood pillars from a Chettiar mansion in South India. I bought them by phone from a Palm Beach auction. I'd spotted them cataloged incorrectly and thought they were a find. Now, of course, I realize that is where I should have left them—in the catalog.

Interview

PHASES: TROUBLED
AND OTHERWISE

Dennis Hopper and Peter Fonda

ANDY SPADE When my mother married my stepfather, they moved us to a town called Casa Grande, between Tucson and Phoenix. He was into hunting, and so I would get up in the morning and wear skeet jackets and shoot clay pigeons. He gave me Frye boots, and I would wear them with shorts because it was so hot. My real father once said, "I pulled up to come visit you and I saw how poorly you were dressed. I turned around and went home, because I couldn't take you out with me that way."

and '81, when I was going down to the discos in New York, maxed out.

G. BRUCE BOYER I wore zoot suits—if an average suit takes four yards of cloth, a zoot suit had about six or seven. The trousers went from just under your armpits to vast folds of pegged pants at your cuff, and then the coats went down to mid-thigh.

STEPHEN COATES I became a cross-dresser for a while. In London, in Soho, in the early nineties I dressed like I was a woman. It wasn't full-on drag, I think just started with very

> **"I've had some bad haircuts in my day. I had one that looked like Prince Valiant that wasn't doing me any favors. I think I was trying to look like Keith Emerson, but it just didn't quite work out right." –Duncan Hannah**

WALTER KIRN I had a David Bowie period, a glam period. In 1980 with Studio 54 still open in New York, I had a bunch of girlfriends who liked to put makeup on their guys. So I would "Bowie out" with makeup and go down to New York City. We knew these rich girls in New York, and we'd do it at their apartment. It often involved drugs, and often you never really got out that night. It was a period when guys were piercing their ears and there was a definite kind of androgyny, and you'd be wearing eye shadow. You had to wear a T-shirt and just sort of be minimal in your dress. But that was about two years there, '80

long hair, started using makeup. I loved that kind of glamour look, a New York Dolls thing. I was living in Ladbroke Grove and was going out in Soho a lot. I've thought about it since, but I don't quite know what was going on because it was a phase that lasted and then stopped. It wasn't an erotic thing, it didn't feel related to sexuality or gender, but I definitely had strong feelings to dress as a girl. There was a glamour club scene. But I wasn't doing it during the daytime; it was a nighttime thing.

RANDY GOLDBERG I have a picture with Sandra Day O'Connor,

and I'm wearing purple jeans and a really ugly rugby shirt. It probably came from Structure. I can't show the photograph to anybody.

J. C. MacKENZIE I loved women's clothing for a year when I was eleven. I spent afternoons in my mother's closet looking for pink taffeta and stockings. My father, a repressed pharmacist, came home early one afternoon and found me in nylons, a blonde wig, pumps, and an erection. He quickly arranged for a psychiatric evaluation at the Royal Ottawa Mental Health Centre, and my "Bowie phase" soon ended.

GUY TREBAY I had a very distinct super-hippie phase, hair down to the middle of my back in a braid.

DUNCAN HANNAH In the early eighties I started making a little money, and I was buying jackets with shoulder pads, which are just horrible.

MARKLEY BOYER In New England in the seventies, there was a real aesthetic of slight shabbiness—the fanciest families in town would drive beat-up old Volvos, and if your sweater didn't have holes at the elbows, it was considered a little flashy. So I think that some of that same attitude colored the acquisition of thrift store clothes.

So I went through a big army surplus phase. My father had been a Navy SEAL, although back then it was called Underwater Demolition Team, and its logo was a slightly ridiculous pugnacious frog with a sailor's hat and a cigar in his mouth. At some point my father gave me his green army jacket—like a simple Carhartt-type jacket today—with his name over the pocket, and I wore that for years. I went to my high school graduation in my father's dress-white navy uniform.

TOM SCHILLER Antoine Doinel in *The 400 Blows*. I was fifteen and I absolutely wanted to be this French kid. I was growing up in LA, which didn't seem very European, so I wore these black turtleneck sweaters and would go to cafés and drink espresso.

I do see pictures of me at *Saturday Night Live* functions, and I was getting a little toward the big collars. I didn't go that far, but I was approaching that and fortunately didn't go all the way.

ENOC PEREZ I didn't realize I was a Puerto Rican until I came here. I grew up in Puerto Rico, so everyone was Puerto Rican. But by coming here I realized that when you go to Barneys, you have a security guard following you. So after college my reaction to that was to play it up. I started to wear a gold watch. Nothing's more Latino than a gold watch. I was twenty-three. I graduated from school and then I went to Hunter College to study for my master's. At that point I started to embrace the guayabera, with some ridiculous Dolce & Gabbana pants that I would buy at Century 21.

I was in this circle of people, and we were poor and fashionable.

You can be fashionable and be poor. That's the nice thing about style.

MARK McNAIRY I think the most embarrassing period was the end of high school and first few years of college. It was the New Wave thing: peg-leg jeans, Capezio jazz oxfords. That was the worst.

NICK SCHONBERGER Everything before I was twenty-five. Between twenty-five and thirty you figure out who you are. And after that you wear the same shit for the rest of your life.

RICHARD CHRISTIANSEN When I was at Benetton, Oliverio Toscani, who was such a lunatic in the best way, made us wear white jumpsuits. A Bond-girl-type jumpsuit. Everyone, without exception. It was made of a fabric that's like paper, and if we ripped them we would just get another one. He called it a laboratory of ideas. All personality came through work, which was so interesting.

NICK WOOSTER I moved to New York in 1983 and still dressed like I did in college, which was on the preppy side. I remember wanting to have New York clothes. Parachute was big at the time, and I really wanted to look like an upside-down triangle. But the reality was I couldn't afford it, so I worked in advertising. I didn't work in fashion for a few years. I had a failed advertising career.

Jay McInerney's 1980s author photo

NICK SULLIVAN The most formative clothing period was when my great-uncle's clothes became useful to me, when I was just about fifteen or sixteen, and *Brideshead Revisited* came out and it informed an entire new generation of thrift store purchases. At that time you could buy 1950s and 1940s clothes quite easily. It inspired this whole nightlife of people wearing granddad shirts and white tie to a nightclub.

JAY McINERNEY When I moved to New York I moved downtown, and it just didn't really feel quite right wearing Harris tweeds and chinos and Docksides. It was the waning years of punk, and I eventually picked up black leather jackets and black jeans. I had this uneasy transition—the gap was pretty stark between olive green and tan and the black-and-white uniform of downtown New York.

THOMAS BELLER In *Wise Blood* by Flannery O'Connor, this Southern

Baptist milieu, the guy drops out, he rebels, but his means of rebellion is to start a Church Without Christ. He couldn't reject the world he was in, in terms other than that world. I had a very weird period in my life where I was very into finance. I went from wearing Frye boots and an army jacket to a suit and carrying a briefcase and being a pretend financier. In high school at St. Ann's, my first rebellion against that religion was to become a stockbroker and walk around with the *Wall Street Journal*, reading the options tables. Now that I think about this, where did I get that suit? It must've been my dad's suit.

MARKLEY BOYER In 1977, "God Save the Queen" by the Sex Pistols came out, and a friend came back from London talking about it. Somehow I got the 45 and started playing it on the countertop record player in the science lab, and for the next five or six years I was very interested in the punk scene. There was a club in Boston called the Rat— the Rathskeller—that I spent a lot of time at, and there were great Boston bands that we all used to see all the time. So a lot of my style choices only really made sense from the obviously ridiculous position of the upper-middle-class suburban punk rocker. But still, I loved it. Leather jackets, earrings, purple hair.

JOSH PESKOWITZ I remember working as a bagel baker illegally when I was fifteen. On the day I turned sixteen, I started working at

Up Against the Wall, a mid-Atlantic chain of what would now be referred to as urban fashion. I started working there because I really wanted Polo sweatpants and couldn't afford them. They were eighty-five dollars, and Stussy T-shirts were thirty dollars. Now I was getting paid, and I was getting a discount.

The predominant feeling I get when I look back at photos of myself is, Wow, look how skinny I was! That's the main thing. But the majority of the things in my wardrobe tie directly back to what I wore in high school.

GLENN O'BRIEN I first lived on the Upper West Side. I was in college during the hippie years, so I was like a hippie in preppy clothing. I had hair down to here and a beard down to here and a tweed jacket.

FRANK MUYTJENS When I moved to New York, I checked out malls. I was curious about everything, even junk food. People said, "You don't know what an Oreo cookie is?" I went to all the clubs too. Clubs were big at that point. I was so impressed by restaurants. I always went to the Odeon.

CHRIS BLACK If anyone says they didn't have a bad phase, they're lying. My teenage look was mostly big pants, hardcore/punk T-shirts, and a wide variety of ridiculous beaded necklaces.

EUAN RELLIE We would go there to these secondhand shops in Clapham

> **"I saw a purple suit in a store and I said, 'Well, that would stand out at synagogue.' I wanted to wear it because I thought it would be rebellious. I only wore a suit to synagogue, and that was twice a year."** –Randy Goldberg

Junction where you could buy what were more or less zoot suits, and demob suits were what the soldiers would get if you survived the war and came home. They'd give you a suit to readjust to civilian life, in demobilization. They were called demob suits, and you'd get these ill-fitting, inelegant suits of checks.

DUNCAN HANNAH When I became a late sixties, marijuana-smoking, countercultural misfit, my dad was just crushed because up to that point I'd been following in his wake. Suddenly I was wearing pink corduroy pants and sailor suits, but that was because of T. Rex, David Bowie, Roxy Music—none of which he found to be a good influence on me.

One night he was getting dressed to go to a party, and I was getting dressed to go to a party. I was waiting for my ride and he was waiting for my mother, and we were both sitting in the living room staring at each other. I was wearing a sailor suit. I was about eighteen. He had been a naval officer, so he found that to be extremely inappropriate. He said, "Where'd you even get that?" I said, "The Goodwill." He said, "Why are you shopping where poor people go?" I said, "Because you get all this great vintage stuff for ten bucks!"

BRIAN AWITAN Honestly, I feel like my whole life is a bad-dressing phase. At forty-five years old I do feel less and less remorse when I look back as the years go by. Regrets, however, I have few, as even my questionable choices were reflections of my head space. It's a time stamp.

WALTER KIRN My dad went from a very conservative dresser to a very mod dresser in the early seventies. He suddenly grew a mustache; he started wearing turtlenecks. He was one of the earliest gym members I knew. He belonged to something called the European Health Spa. Its logo was an Atlas-like muscle figure holding up a globe. I look back, and he may not have known that he was in a vanguard of gay culture. He was wearing these very tight synthetic turtlenecks. It was the first time I've been conscious of my dad trying to be sexy.

So I thought I would try becoming a turtleneck person. It was the seventies; turtlenecks were in colors like burnt orange—bad-appliance colors. I had a bunch that were yel-

> "When I was thirteen or fourteen I wanted to express myself. There was something called Winkle Pickers, that all of the boys of my generation wanted. We would go down to Kensington Market on High Street, and you could buy Winkle Pickers, very pointy leather shoes, or you could buy Bottle Creepers, which were usually suede.
>
> I wanted Winkle Pickers and Bottle Creepers, and my mother said to me, 'Absolutely not.' She wouldn't buy me these abysmal, gray leather, awful shoes. It was a huge trauma."
> —Euan Rellie

low. They were very stretchy and bad for your skin, but I wore them for a long time. There's something about having your neck and face framed in the way that turtlenecks do. It makes you very conscious of your hair. So even in the days of very natural, fluffy, early eighties hair, I was into hair products. Vitalis and strange Brylcreem.

THOMAS BELLER I liked this idea of being a kind of subterranean person, an off-the-grid character. I got around on a bicycle. In a way it's the antithesis of the uniform. The bicycle thing was kind of a big deal for me, because that was how I got around. Not that you could be wearing anything on a bicycle. In fact, there was a moment there where bicycles were explicitly written about as this twee accessory. Candace Bushnell did a piece on boys and their bikes in the *Observer*. Plimpton, Rick Hertzberg—my

friend Kip Kotzen, a literary agent at the time, was in it. I still remember his quote: "I'm touching it right now."

ROB ZANGARDI Two words: leather pants. When I first moved to New York and was working in fashion, I felt compelled to dress more…fashion-y. This resulted in all the things early 2000s nightmares are made of: pairing a navy blue turtleneck with navy blue leather pants, snakeskin cowboy boots, and more styling experiments that should have never left the pages of Teen People. No matter how much I try, I always go back to the classics. Trying to be a fashion kid never felt right.

MARK McNAIRY Reminiscence was the big thing. Do you remember? It's still around, it was sort of like Basco but shitty quality, but still cool. Copies of military chinos—it was always in *GQ*. It was the first

134

place we went when we were here, right around the corner on Eighth Street. I bought a pair of Kenneth Cole black boots, and they had six buckles on each boot, and they jingled when I walked. I thought I was so fucking cool.

FRANK MUYTJENS When I was in art school I went on vacation with friends, and they were horrified by what I was wearing at the beach: orange-and-red shirt, red pants, pirate boots.

TOM SCHILLER I moved to back to New York in the mid-seventies, which was like *Saturday Night Fever*. Everyone was in white suits with those big black lapels. I thought that looked silly, so I just stayed in my uniform: jeans, white shirt, a corduroy jacket. A little lapel pin.

EUAN RELLIE I somehow got the idea of wearing my pajamas. I had these paisley pajamas, and I would go everywhere in paisley pajamas, on the Tube."

> **"I probably had a few bad years in the nineties. That's when we had big-shouldered Italian suits. I'm still blaming Pat Riley."**
> —Glenn O'Brien

RICHARD CHRISTIANSEN I was living in London and all these guys were outside a bar by King's Cross. I thought, There are the guys that I want to be around. I walked in the bar and I asked for a job. I was tall, I was blond, I was in great shape. After a while a couple men took their shirts off, then their pants off, and all of a sudden we're all working out in our underpants, so that went on four nights a week. I used to stuff Wonder bread in my pants, because I was just working for my tips. One of the younger girls working the bar said that she heard that stylists used to stuff sliced white bread, scrunch it up, and stuff it down people's tighty whities. So I said, "Let's do it!"

RUSSELL KELLY I was the band geek who drew the big signs that the football players would run through. I was a tuba player in the marching band—the skinniest tuba player ever. Then I played baritone sax in the marching band, upright and electric bass in jazz band.

BRUCE PASK In college during the late 80s, I had three sets of shoulder pads I wore in my jackets: day, evening, and night, each progressively more statement-y than the last. I had this vintage dinner jacket that I would wear with the sleeves rolled up, very Bananarama. For days, I would use the more subtle set, but for nights out I'd really amp the look with the hefty pads.

> **"The first time I went to Area, I was wearing a black-and-white Harris tweed jacket that I would get at Brooks Brothers when I graduated from high school. I just realized that I was kind of out of place. I'm not sure why they let me in."**
> —Jay McInerney

TAAVO SOMER In high school, in Chadds Ford, Pennsylvania, everyone was preppy and kind of a Deadhead. They wore frayed baseball hats, they skied, they'd have beat-up Volvo station wagons and Range Rovers with Dead stickers on them. I basically faked it—I would put Dead stickers on my car even though I hated the Dead. I remember taking a sander to my baseball hat and bleaching it and trying to accelerate the aging of these clothes, even though I didn't spend the summer in Nantucket. At parties I remember girls that I was in love with saying, "J.Crew is my favorite magazine!" And I said, "You know it's not a magazine, it's a catalog, that's not real, those photo shoots aren't like a documentary of someone's life," and they said, "I don't care, it's my favorite magazine."

SHAWN BRYDGES I had one of history's worst phases. It was the era of the "male" Bolero jacket. Need I say more?

WESLEY STACE I may or may not have had bad phases—I think I did pretty well for the difficult times—but I certainly had some woeful haircuts, including a semi-mohawk.

ADRIAN DANNATT: "I AM VERY CHEAP INDEED"

A Monologue on Secondhand Clothes, Dressing Gowns and Thrift

I never wash clothes—well, I very rarely wash clothes.

I have a set of shirts that I can't wear because they are far too big for me. But if you see a five-pound shirt by Charvet or Sulka, you simply must buy it, regardless of size or even style. I've got a hideous Sulka shirt that's five times too big for me. I have some shirts that I bought just because of the label. I have Nightwalker for Men—I don't know where it comes from, but it's got these huge letters: "NIGHTWALKER" and "for men" under it. I have another one that is "Old Man," and I just had to buy it.

I go to a charity shop and sort through the labels. I can do it really quickly. I am wild cheap—I am very cheap indeed. In London recently I saw something and said, "Now, that is interesting." But I didn't want to spend the five pounds without checking into it. So I jotted down what it was and then investigated, but went and checked it out and decided it wasn't quite good enough.

I just got a shirt—did you see me wearing it?—it's got crazy hand stitching from India, and it's by someone who has the same name as this Surrealist American artist, Robert Graham. I thought the shirt was really beautiful, and then I went and checked on it, and I couldn't find one for less than what they were on his website—350 pounds! So I thought, Hmm, ten pounds for that. So I raced back and got it. Though on occasion they'll be gone, which is really annoying.

I have one particular favorite charity store in London, which I never reveal. I never go to the preselected store—I hate to shop anything so-called vintage. I strictly go to charity shops and thrift stores. I wouldn't go to Housing Works, because it's already too upmarket—they look at what they've got. I want no preselection whatsoever. I hate preselection.

So the Salvation Army, in Portsmouth, somewhere up in New Hampshire, that was really good. That's where I got my Prince Oleg Cassini shirt—maybe he wasn't a prince, but he should have been. It's pure seventies, and it's this monstrous but fabulous thing, made out of 200 percent acrylic. When you wear it, you have little sparks of strange things steaming off you.

Do I wash these things before I wear them? Never! Are you mad? That's part of the heritage! It costs money to get things washed. I'm worried they'll fray. But a third of my collection are really seriously frayed. Having said that, I took my Kilgour shirt to be dry-cleaned on Mott Street, and I suddenly realized that it isn't so expensive after all. It was nine dollars. I thought, My god, I can get other things cleaned. So I took in my other Cassini classic, and I had another nasty adventure. They handed it right back to me with a funny little expression and pointed to the label. It said: Interior lining: 100 percent Rayon, Exterior: 50 percent Polyester, and 50 percent something I'd never even heard of—a chemical compound. They must have abandoned it; it's probably illegal.

So there are three parts to my clothing. This is so much fun, talking about this. First, there's the charity shop, which is a big thing. Second, then there are things from famous people (or famous-in-my-world people), which I love. Many of whom I've written obituaries about—which I get given by their families, or by an associate. Finally, there's another source of my shirt collection, a shop on Jermyn Street. In the back they have an entire section—a vast row, in a kind of alcove—of all of these Turnbull & Asser shirts. It's on the completely opposite end of Jermyn Street from Turnbull & Asser itself.

William Nicholson

I said to them, "What's this?" They said, "These are all the things that were made for people at Turnbull & Asser, people who were so rich and grand that they never bothered picking them up." And these shirts were all five pounds. So I probably have forty shirts from them. And then I realized—the genius of it—that I could go to Turnbull & Asser, get them made for me, not pick them up, and then go pick them up at the other shop and pay five pounds.

Unfortunately, it didn't work. I went in to Turnbull & Asser to try it out, and they were very excited about it. I said, "What's the setup? They said, "Well, you pay 75 percent up front, with a five-shirt minimum." I said, "What?" And, of course, 75 percent up front was rather more than my usual five pounds.

But my collection of five-pound shirts—some have elaborate crests and weird globes and the best initials. One of them has the craziest crest: It has to be some kind of royalty, but I've never worked out from where. The crest is on my nipple—right on the point of my nipple there's a weird crest, which could be from some neo-Nazi movement or very grand Romanian royalty. I'm waiting for the day—I'm almost praying for the day—I'm going to be in some bar and Prince Zog is going to shout out, "My friend! Why are you wearing my grandfather's shirt?" Either that or I could be taken hostage in a coup. It could go either way!

Some of the best things I inherited came from Miguel Abreu's father, Jean Claude Abreu, who was one of the most impeccable figures ever. He lived in absolute discretion. And this guayabera was made in Latin America for the sugarcane workers. He took this classic guayabera and had them made for him by his tailor in Paris.

I have several of these guayaberas, and this one that I'm actually wearing is in the Slim Aarons book on Portofino, and it's got the best picture of Jean Claude wearing this exact one. The picture is so good. He's even carrying a brand-new Concorde bag.

One other thing I inherited from Jean Claude is the summer suit from H. Harris. And H. Harris was very famous—he was JFK's tailor. The suit, when you have it on—you're not even aware that you're wearing it. This suit is older than I am. It was made in 1961, and the incredible thing is, at the time when he had it made for him, it cost four thousand dollars. Which is an insane amount—I think a house was seven thousand dollars.

My grandfather was the Welsh science fiction writer Howell Davis. I have his Sam Browne belt from when he was in the Royal Welsh Fusiliers,

in the First World War. I have a beautiful photograph of him when he became an officer. He's in *Good-Bye to All That*, in a section where Robert Graves had also been wounded. He's in Wales and he talks about my grandfather, who then became his editor. I love these connections between clothes and the past.

I particularly love old-fashioned comfort. I wrote a poem and the first line is something like, "Too much of my life has been devoted to dressing gowns." And I do indeed spend far too much time in them. That poem is called "On a NY Balcony," and I love balconies and I love dressing gowns, especially when combined. The balcony is an extension of the house that is part of the outside world, but it is also part of the house. So you're both in a domestic setting and engaged with the street. Likewise, the notion of this dressing gown is that you're most relaxed at home, but you can go out in it.

The first time I went out in something like that, I remember wearing pajama bottoms—you had to get yourself into it, slowly but surely. In my pretentious youth, I had my mother have her tailor make me a James Bond black-and-gold kimono. God, that was embarrassing. And I did go out in that, because I so loved it then.

Every summer when I'm in Walberswick, the cottage is a seven-minute walk from the beach, so I'd walk in my dressing gown down to the water to swim, usually with my coffee cup. And I had a particularly thick old dressing gown, and I loved coming out of the North Sea, or the German Ocean, as we used to call it, before anyone is even awake.

All of my clothes are used, so I had to ask myself, Do I feel all right wearing someone else's dressing gown? Yes. But you know, I do just draw the line at underwear. But I am prepared to wear somebody else's underwear if it was a really, really good person!

THEORIES OF DRESS

"I love madras. I'm wearing a madras shirt tonight. I remember these wonderful madras jackets from '62. I finally threw it out, but one of the places I was buying clothes—it was downtown but I'm a total cheapskate, so I don't want to spend any money—and they had a Ralph Lauren down there, and they would have these sales that would go on all summer, and it would be like the fourth reduction, things they really couldn't give away. I got this cool madras jacket, and I thought, Why doesn't anybody want this?"
—Whit Stillman on Madras

ALEX BILMES *on The English Scene*
England has a rich, diverse, tribal history. Fashion moved very quickly throughout the seventies, eighties, even into the nineties. I don't think it happens so fast now. Brit-Pop was the last of it. You'd buy something one week and you wore it the next week and it was done. You'd say, "Oh fuck, I'm wearing last week's clothes." Two things that connected them: football and nightclubs. People move around a lot on Saturdays because of going to the different games. You'd go to Liverpool for football and then you'd stay to go to the nightclub, so you'd get this mix.

It was regional. You'd have a guy in Leeds who would never wear what a guy in Liverpool was wearing, and they would have ways of telling. You could tell: Oh, he's from Manchester, because of a certain label that he was wearing that would've not been cool in London. The Northerners always looked down at Londoners, who thought they were too flash. And the Londoners think the Northerners look like fools. But even people in Leeds think that people in Sheffield have it totally wrong.

Marcel Proust Deciding What to Wear, Hugo Guinness

143

DUNCAN HANNAH *on Dandies*

I think of a dandy as someone who's stepping out of the norm, someone you raise an eyebrow at when he gets on the subway. It's ballsy to do that, to draw that much attention to yourself. Dandies are outsiders, because there's no immediate gain, except over time. You get used to it so that's who you are. Initially it feels funny, because you realize most people dress to conform to what's happening. A dandy doesn't concern himself with that. He's stepping into his fantasy or the way things used to be. Even now, when I wear a tweed suit around, I get called nostalgic. But in 1935 a painter in London would always wear a tweed suit; the poorest bohemian would wear a tweed suit. I'm not making a big statement about being fancy or affluent or anything like that, I'm just thinking of the way a painter would dress back when painters dressed moderately well.

RANDY GOLDBERG *on Halloween*

I like Halloween a lot. I know most sane men, especially in New York, despise Halloween. I think it's fun to put on a costume if it's done well. I like that idea of the sanctioned moment to dress in a ridiculous way.

Once I dressed like *Cats*. Not the animal but costumes from the stage production of the Broadway musical *Cats*. We rented four of these things and they came in huge boxes; there were wigs and spandex. My ex-girlfriend did the makeup. We went to a couple parties—we went to the Box, because it seemed like the only place to go for something like that. This was years ago. My friend got in a fight with Jude Law about our costumes. It was a weird night.

WHIT STILLMAN *on Church*

There's this beautiful church I go to downtown, French speaking, mostly Haitian, and they have this absolutely traditional immaculate service that is so perfect. A lot of people that go there are Haitian—elderly and really well dressed. I worry about what I'm going to wear because they're really formal there. I feel there's something theological about clothes, something correct, democratic, and meritocratic about traditional clothing.

HIROFUMI KURINO *on Japanese Style*

In the late seventies and eighties there was a blooming of Japanese designer clothing: Kenzo, Yohji Yamamoto, Issey Miyake, Comme des Garçons. Until I went abroad as a buyer, I didn't feel like these clothes spoke to me. When I went to Paris in the 1980s, I found out just how independent Japanese fashion was; it felt so new. European fashion culture refers to history—even the creative people like Jean Paul Gaultier and Giorgio Armani are based on classic history. But Japanese designers are usually totally different, and that's what makes such an impact on fashion history. I was interested in the balance between tradition and invention. So I started mixing designer clothes with classic tailoring. I keep wearing both sides. There are so many choices now. You

> **"You have a housemaster; you're in groups of ten per year in a house of fifty boys. The housemaster, Martin Whitely, had been in the army with my dad. I was put down for Eton at Marty's house when I was six months old. Martin said to my dad, "You've been very irresponsible, Alex, at this late date to put your son down, but since you're an old friend, we'll find a place." My sisters were both put down for Eton before they were born and crossed off the list when they turned out to be girls."** –Euan Rellie *on Eton*

can wear a suit not as a uniform but by choice. You can buy in a store, online, on eBay. It's a decision decade. Japanese men are free of social hierarchies when it comes to fashion. They are free to choose whatever they wish to wear.

This style of Western dressing is still very new. We opened our country 150 years ago. We put away our kimonos and started wearing Western clothes not long ago. After the Second World War we opened up further to foreign cultures and changed our society. It meant consumers had to think about why the new styles of tailored suits were so expensive or why the lapel has a certain shape or why linen is good for spring and summer or why tweed is good for winter. For Western people this may be common knowledge, but for us it is still new. Also, Japanese people like to "study."

JOHN BRODIE *on Topcoats*
Your topcoat in New York is like your car in LA.

MICHAEL HILL *on Wearing Tails*
We thought the concept of wearing tails was strange for five minutes. That was it. After that it was a case of feeling strange not to be wearing tails. My brother's came from New & Lingwood, mine from Billings & Edmonds. I also had to wear a hat. It was a bit like a straw boater but with a deeper crown. We would sit in our rooms of an evening, varnishing this thing with Araldite to reinforce it and make it stronger, so that it lasted the five years you'd be at school. It does seem a bit austere and British, thinking about it now. My mother was forever buying me clothes three sizes too big so they'd last me, and it was the same with my hat. Thankfully it did fit me properly come my last year or so, but I still joke with my brother about how we never ultimately grew big enough for many of the clothes my mother bought us.

FRANK MUYTJENS *on American Prep*
I didn't grow up here so I was look-

ing for culture references. I was never preppy, but I was always able to look at it from the outside and take it with a grain of salt. It's such a part of the culture that you can play with it a little.

EUAN RELLIE *on Discretion*
Even though it's Britain and you're supposed to be understated, Savile Row tailors would have the suits of the most famous customers strategically placed with the name, so in those days it would be the Duke of Westminster, the Prince of Wales, and Claus von Bulow.

JAY McINERNEY *on His Tailor*
My current favorite is Cifonelli. I really like British tailoring, but I can be a little more flamboyant than an investment banker can—and at the same time, I'm always going to be less flamboyant than hip-hop.

EUAN RELLIE *on The Barber*
As a young boy I'd go to the barber at Harrods who cut boys' hair, but when I was twelve years old, it merited promotion to a trip to Mr. Holgate at Truefitt & Hill on Old Bond Street. My dad would buy the hair oil, and Mr. Holgate would say, "May I tend to your nose and your ears, Mr. Rellie?" And my dad would say, "Thank you very much, Mr. Holgate." They were both on last-name terms. I loved it. I started to recognize the rituals of being an Englishman.

JOHN BRODIE *on The Black Tong*
At our school for four nights a week,

you had to wear a coat and tie to dinner. Girls had to wear dresses. You had an assigned table, and the master sat at the head of the table. It was practice for being at a dinner party, to a degree. After seated meal, there was an area outside of the common room, where kids had smoking permission—which fourteen-year-old or fifteen-year-old boys had permission from their parents to smoke. I wasn't a smoker so it wasn't really appealing.

There was a group of us, a secret society called the Black Tong. The idea would be we would put on black tie before seated meal, rather than coat and tie. We would do a couple bong hits, maybe have a drink, and then go down to seated meal. And those in the know knew the guys wearing black ties were there under the influence.

WHIT STILLMAN *on His Tailor*
My father had a tailor from London who'd come over: Wilson Mayfair. They would be in town, and my father said I could buy a suit. There was a wonderful version of the Dorothy Sayers books, with Ian Carmichael playing Peter Wimsey, set in 1920s London. There was one called *Murder Must Advertise.* He wore a three-piece suit and the vest had a collar. I just thought that was the coolest thing I'd ever seen, so I got that first. It was some sort of brown check. And then I got serious and got a charcoal pinstripe and a blue suit. It looked really, really sharp.

Real tortoiseshell, unbranded, from the 1960s. Totally illegal to produce today. This is especially cool to me because it's inscribed "Made in Germany"—but written in French.

The classic Persol 649, a.k.a. "the Steve McQueen," with a twist. Eighties designers took more risks, making this version in dark red with proprietary Persolmatic photochromic lenses.

Persol made too many white versions of this design in the 1980s. Opticians around the world got creative and dyed them black as best they could. The result is the purple Persol. This is one of my all-time favorite shapes, made by Persol in various versions for over two decades.

Late 1970s Ray-Ban with Ambermatic lenses. I'm not normally a fan of layered acetates, but this layering and faceting of brown, tortoise, and white give this frame the appearance of buffalo horn.

These are 1960s Persols I acquired from Art Optic, which was the first US distributor of Persol. I love that these might have been among the first Persols sold in the United States. They are so bold and futuristic, with bubble-like lenses.

I knew Vuarnet mostly as a brand that utilized nylon for frame material, but this acetate frame is one of my favorite shapes anywhere. I've always been drawn to these frames, where the lenses are shaped differently than the frame.

Porsche Design with Carrera made many of the most iconic aviators with interchangeable lenses. These lesser-known ones are far more interesting to me because of the lens shape.

Serengeti Kilimanjaro, 1980s Italy, with proprietary glass lenses from Corning Optics. The epitome of classic aviator.

Mitch Epstein: Dad's Briefcase 2000

My dad ritually settled into his easy chair after dinner to watch ball games and the local news on television. His briefcase sat on his lap. The dull thump of its unlatching meant that he was back at work, even though he was among us all in the family den. Dad carried home as much paperwork as he could cram in there: accounts payable and receivable documents, all kinds of furniture and appliance product catalogs, and customer and tenant correspondence. My father was born into a generation of men who believed that if you worked hard, you would do well. Work insulated him from the emotional demands of family.

Dad's Briefcase was photographed in one of the vacant showrooms of Epstein Furniture shortly after it was liquidated in the year 2000. The picture became a part of a project I call Family Business.

Clockwise, from top left: Robert Becker's father's watch, Jay Fielden's Ray Bans, Russell Blackmore's father's sunglasses, Robert Becker's father's pocket watch, JP Williams's father's shoe trees, Patrick Grant's father's dinner jacket, Russell Kelly's grandfather's dog tag, Robert Becker's father's watch (back)

Clockwise, from top left: Jay McInerney's father's velvet jacket, Matt Hranek's father's hunting jacket, Randy Goldberg's father's casino VIP cards

2010 IWC Portuguese Pure Classic This special edition of the iconic Portuguese was so rare it never made it into the catalog, and its 43mm, ultra-thin, nothing but hours and minutes profile has made it a coveted modern classic meant to revive the same purist sentiment found in the original Portuguese from the 1940s.

1939 Universal Geneve Compax This is an exceptionally rare oversized chronograph dating to the early wartime period. These enormous for the day timepieces were made for two groups of people–fighter pilots and gentleman racers, both of whom wore these watches on the outside of their suits.

1976 Rolex Submariner Issued to the British Ministry of Defense–a so-called "MilSub"–represents the very finest in Rolex technology in the mid 20th century, featuring the most robust self-winding movements, the most rugged cases, and remarkably legible dials and hands not found on consumer-oriented dive watches.

1931 Jaeger-LeCoultre Reverso Believed to be the original sportsman's watch, the Reverso first gained notoriety on the wrist of colonial polo players in India, who would reverse the face of their watches mid-match. Eventually the other side of the case, a blank canvas, would receive the family crests of many of Europe's royal families and bon vivants.

2005 A. Lange & Sohne 1815 Chronograph Arguably the finest chronograph ever produced by anyone. A. Lange & Sohne set about an revolution in watchmaking by building a mechanism so fine and beautiful that all of Switzerland would soon follow.

1963 Heuer Carrera The Carrera, named after the famed south American rally on which the chronograph cut its teeth, became the wristwear of choice for all Formula 1 drivers for decades. It was launched alongside another watch that would come to shape racing–Rolex's Daytona–and the two can still be found on racers' wrists the world over.

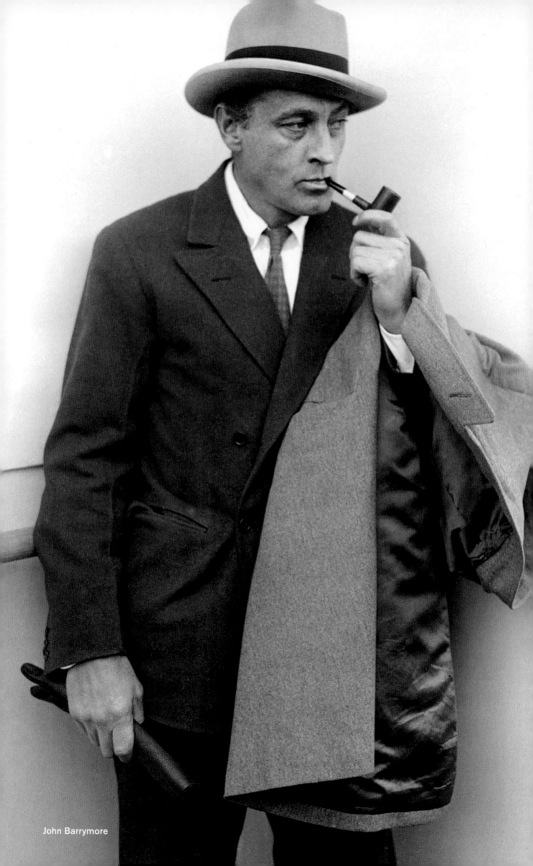

John Barrymore

PART III
Manners and Misbehavior: *Fine Distinctions*

Mrs. Moultrie. It has five lady boarders.

No. 116 W. 26th St. is a parlor house kept by Sarah Wilbur, this house is most elegantly furnished, the proprietess is a very pleasant and agreeable lady, and of a fun loving disposition. She has seven lady boarders, who are very affectionate and agreeable. Gentlemen seeking for pleasure, will be very agreeable entertained. This is a first class house.

No. 119 W. 26th street is a ladies boarding house with five lady boarders, kept by Mrs. Conklin.

No. 121 W. 26th street is a ladies boarding house, kept by

Miss Sarah Wilbur,

116 West 26th Street,

A First Class House

Six Lady Boarders

A Lot To Learn: *The Gentleman's Directory*

Modern media documents so much graphic misbehavior that it's surprising to discover a small book still has the capacity to shock. The volume in question, profiled by the *New York Times* a while back, is an 1870 guidebook of the ins and outs of Manhattan's brothels. *The Gentleman's Directory* was an indispensable tome for those who required details about the houses of ill repute in our good borough. It couldn't be more discreet—yet there's an implicit appreciation of worldly topics that should be known but not discussed.

The Directory makes special mention of Harry Hill's on Houston Street, where "an hour cannot be spent more pleasantly," while Greene Street is dismissed as "a complete sink of iniquity." There's a map that allows you to learn whether you reside in a former house of ill repute. Unless you live on West Twenty-seventh, Houston, or a few select blocks of Soho, you're out of luck. And even if you do, most of the buildings were torn down long ago.

It all seems very far away, but recalls an event from one of my early evenings in Manhattan, almost two decades ago. For a variety of reasons I was drinking with purpose in Sardi's—the legendary restaurant and watering hole near Times Square—and entered into conversation with two women who couldn't have been nicer. In fact, they may have been too polite. Slightly suspicious, I asked what their professions were. They paused, looked at each other, and laughed, and answered in unison: "We're nurses."

The look in their eyes couldn't have been any more knowing, and the silence that followed communicated clearly: "Welcome to the city, kid."

Pages from *The Gentleman's Directory*

Playboy: Heightened Anticipation

When you were a boy, *Playboy*, perhaps more than anything else, specifically enticed you and slightly frightened you. Like all illicit things, it balanced excitement and danger. In this case it was coming to terms with something wildly seductive that you didn't fully understand. You schemed to find it, if you inherited one (oh blessed day!) you schemed to hide it, and at that age the articles were just getting in the way.

There's not a verb, as far as I'm aware, for inserting an adult magazine inside a respectable one, though maybe there is in French. This happened

Hugh Hefner's *Little Black Book*

in the corner store in my neighborhood, and countless times across the country. After some deft sleight of hand, you found a *Playboy* that was not in the infuriating plastic wrapper, a gift from a neighborhood collaborator. It would often be well worn and hidden in an unexpected place, though not unexpected to you since you heard unverified rumors about where it might be, like the address of a speakeasy during Prohibition. So there it was, behind a copy of *Midwest Bass Fishing*.

Then you slipped it into a magazine that could handle its dimensions. Part of the art of it was using an external magazine that was believable—you couldn't just slide it inside the *Economist*, it had to me more like the *Sporting News* or *Inside Sports*, two titles that have, alas, ascended to newsprint heaven. The centerfolds were a challenge that had to be enjoyed in stages. That was a challenge we were prepared to meet. If you went with a friend, then if there was trouble you could hope to scatter and escape to view another day. The problem was that it was very difficult to enjoy a *Playboy* with another thirteen-year-old without breaking into hysterical delight or downright laughter.

Technology changes even if the impulse remains the same. In 1996, at summer school in Providence, I finally connected to the barely understood Internet, in a moment that was, if you'll excuse me, providential. I don't think I had an e-mail address. But I had heard about the Internet, which had access to all sorts of visual material, much of it erotic, nearly all of it focusing on Pamela Anderson. I remember landline access, which made an audible screech before connecting. I stared at that black-and-white screen of an IBM ThinkPad as each row of pixelated imagery appeared on the screen. There, line by line, appeared topless Pamela as I squinted at a screen that had the resolution of the first dot matrix printer. It took about fifteen minutes to download.

Now, of course, you can call up anything on demand. And most kids have seen Pamela, and dozens more. I'm not here to moralize, but I am here to say that not everything should arrive at once, accessible all the time (the same perils exist for adults—just observe any party with an open bar). It's true that a huge amount of mental capacity was spent by thirteen-year-olds trying to predict the hiding places of male relatives. That's no longer the case, and it may be a good thing. But there's something vital missing from the current lax access to what we lucked into so rarely as kids. As any good burlesque dancer can tell you, what matters most is the sense of

FINDING *PLAYBOY*

> ## "I was brought up to believe porn was the devil's work. So naturally I was fascinated."
> –Dan Rookwood

MARK McNAIRY I can remember when we first found *Playboy*s hidden in my dad's drawer. Then you started driving and you could go to the store and buy them, but it was so embarrassing. I remember driving by this 7-Eleven and chickening out—I went inside and there'd be a woman working at the counter, and I'd just buy some gum and leave. I didn't have the nerve to ask for a copy of *Playboy*. Now you've got the Internet and whatever you want.

G. BRUCE BOYER I remember the first one with Marilyn Monroe. There were those two nude photos of her, and she was gorgeous.

I outgrew *Playboy* pretty early on, for the same reason that I outgrew burlesque shows and stripteases: I never really got the point of looking at nude women that you weren't gonna go to bed with.

RANDY GOLDBERG My dad did not get *Playboy*. It was not in my house. I searched and I searched every corner of that house—if *Playboy* was there I would've found it. I was intrigued by it. Your brain explodes when you see something like that.

THOMAS BELLER Mr. Hines on the eighth floor had a subscription. There was no permission; there was a kind of borrowing. His subscription arrived a little later than everyone else's.

WHIT STILLMAN *Playboy* was hugely important when I was fourteen and fifteen—that was the *Playboy* age. I don't know how we had them, but we had a ton of them. We were still playing with toy soldiers at Millbrook, rolling dice and pretending to be Winston Churchill, so our development was a bit retarded. The line between childhood and sex and adolescence was so thin.

AARON LEVINE We had to go to an outside household for this. Two of my friends' parents, Jimmy Costanza and Alex Puchur, their fathers both had *Playboy*s. And I remember specifically Alex Puchur going up into the attic above this garage where we had made this makeshift fort and plowing through all of his dad's old *Playboy*s. He was obsessed with Batman figures and making sure you never opened the package. It was unopened Batman figures and *Playboy*s.

GUY TREBAY It didn't turn out to be my thing, but it was very exciting. Looking back, I think what was most appealing about it was the textures—everyone so smooth and plastic. I think subliminally it provided the basis for Photoshop and Instagram culture, the Kardashians.

TOM SCHILLER We didn't have them in our house. But another writer on *I Love Lucy*, named Bob Carroll, we got to go to his house and he was a real bachelor. He had these women by the pool in these really tight T-shirts with nothing underneath. For me, as a seven-year-old, it was very exciting. He also had stacks of *Playboy*s in the bathroom, so I'd sneak away and read.

ENOC PEREZ My dad had a stash in the closet. That's completely formative for any person, any straight or even not straight male in America.

NICK SCHONBERGER I bought it for my brother when he was seven years old. I think we were in Crested Butte, Colorado. And we went to a convenience store, and my brother came back with the College Girls issue that comes out in March. He held it for a decade.

MICHAEL WILLIAMS I think that I could always find my dad's *Playboy*

> **"Early *Playboy* exposure fixed my erotic tastes for good. I think Joey Heatherton still might be my ideal woman."** –Walter Kirn

magazines, he had a lot in the attic. But I'm sure he knew that I was finding them, because I was such an idiot. I would go through everyone's shit, even my dad's–I went through everything he owned, I swear to God.

NICK WOOSTER My dad used to keep it next to the toilet until I was of age when it started to mean something then they started to hide it. Though, of course, I would find it.

JAY McINERNEY *Playboy* was big in a lot of ways. *Playboy* helped you to know what a man should be, what he should look like, what he should smoke. The first thing you look at is the girls, and the joke is "I buy it for the interviews"–but you do read the interviews, because you want to know what some of those accomplished guys thought about life and style, women. My

father got it and he tried to hide it, and we tried to find it. It was a big game. My mother was appalled. It's hard to believe that that stuff really mattered. By the time my kids came along, I just couldn't be bothered to tell them not to do this.

TIM SCHIFTER I distinctly remember the first Playboy I saw. Doesn't everyone? Once a month my father and I would go to the barbershop on the second floor of the Carlyle hotel, and under the seats in the waiting area there were stacks of old *Playboys*, and I would sneak a peek while my father was getting his hair cut. Happiness!

GLENN O'BRIEN I found it in my grandfather's closet, and we used to go to the drugstore and try to steal it. *Playboy* was a big influence. Hef was a big influence on me– *TV Party* was in a lot of ways based

164

on his TV shows. In the sixties it was called *Playboy's Penthouse*, and then it was in color, it was called *Playboy after Dark*, and basically it was driven off television by crazy Christians who would threaten the local television stations that would pick up the show. Did you ever see it? He would have Lenny Bruce on. It was a party format, so it wasn't a desk and a guest talking about their new book. It was Hef, a comedian, and some jazz musicians and Ella Fitzgerald. It was really incredible.

ROB ZANGARDI They belonged to my friend's older brother. He hid them under his waterbed in the basement.

MICHAEL HAINEY It was the seventies, so I remember my brother had them in his bedroom and I found it.

ALEX BILMES I didn't look at *Playboy* growing up in London. Here there's the *Sun*. You'd have a girl with her tits on page three of Britain's biggest newspaper and with a silly caption related to what was happening in that day's news. My dad did not read it, he read the *Times*, but at school a kid brought in the *Sun* and we went into the loo, and Michael Bedmond had got a copy of it. They only stopped it last year, which was a huge thing. It's amazing it lasted this long.

TAAVO SOMER It was probably fifth grade, and we lived in Pennsylvania next to a farm that had an abandoned barn. In that barn all

the neighborhood boys gathered 'round, and there was this stash of *Playboy*s that I think one of the boys had gotten from his older brother. I remember everyone was mesmerized. It was interesting that it was a group activity. We hid them there and they stayed there as this sort of collective.

JAY FIELDEN My uncles subscribed to *Playboy*. They are all three big personalities who love to tease people and tell jokes and laugh and get into a reasonable amount of trouble. *Playboy* was kind of like that itself, as I recall. It had a stylish aesthetic and an urbane tone. I could still tell you with photographic recall all the silly things the Playmates said on those questionnaires: "I like to read Trollope." "I'm studying to be an aeronautics engineer." "I don't like to wear clothes around the house."

SHAWN BRYDGES I was ten years old and my big brother had a stash in a loft above the garage. There was a massive pile he and his friends had been stealing from a divorced dad in the neighborhood.

TUNDE OYEWOLE I have one word for you: Overwhelmed.

WHO WAS YOUR FIRST CRUSH?

"I like moody French girls and brunettes. Those two groups are not mutually exclusive."
–Euan Rellie

The British Invasion, Duncan Hannah

ARMANDO CABRAL Helena Christensen, of course.

ALEX BILMES I think Madonna was the first aggressively sexual woman in pop culture that we were aware of, and I absolutely loved Madonna and still do.

JOSH PESKOWITZ The first woman I remember having a for real, like, I know this is a crush, was on Mary J. Blige in the "Real Love" video. That was 1990; I was eleven.

JOHN BRODIE I was always more of a realist than a fantasist. I was never the kid with the Farrah Fawcett poster or the *Playboy* pinups on my wall. I could just never imagine how to get from A to B. So I was always more having these infatuations with somebody who would have been the girl in the John Hughes movie, but my local variety of that.

WALTER KIRN Angie Dickinson. I realized that the "cigarette voice" was a big part of what turned me on about women, after I realized what cigarettes did to your voice. I liked tough blondes: Angie Dickinson, Joey Heatherton, Julie Christie. I never liked the big, healthy, eighties supermodel look. I liked those harrowed, late seventies women.

WHIT STILLMAN I considered the Hepburns so uninteresting and so sexless, and it's interesting that as a boy, I only responded to very sexy women. Now I can see the charm of Katharine and Audrey Hepburn.

But then it would've been Linda Evans in *The Big Valley*. My main heartthrob was Inger Stevens, and of course Diana Rigg.

GLENN O'BRIEN I always thought Ursula Andress was pretty major. All of the actresses in *What's New Pussycat?*, mostly the European ones. And Tuesday Weld.

AARON LEVINE Actually, her name was Anne Simmer. She was not an actress. She was four years older than me and she lived up the street.

MARK McNAIRY I think it was Cher at a very early age. I remember seeing the *Sonny & Cher* show. They were so bad at prime-time variety shows, music and comedy. I'm still waiting for those kind of shows to come back.

NICK SCHONBERGER Sophia Loren.

JAY FIELDEN Farrah Fawcett.

MICHAEL WILLIAMS I always thought Audrey Hepburn was so beautiful. She was very much my type.

Proms and Noble Errors

Many well-meaning, misguided sartorial mistakes start out with the premise that society has simply not caught up with us. If only the public knew that a tuxedo jacket looked great with jeans, then they would know that what I wore to prom in 1991 was a definitive cultural moment. I consulted a remarkably well-dressed man in the preparations for this event and he encouraged me. He may have been able to pull it off. My date looked me up and down, paused, and said, "Jeans? Nice." Her derision seemed to echo from her house to the venue, an upscale department store that shut down a few recessions ago.

Those of us who've experimented with sartorial daring that we fancied was ahead of its time are left to sound like failed political candidates who claim the fault was with the voters, not the message. Incidentally, that's the same thinking that leads people to embrace bad avant-garde art. When somebody comes up with a new idea, be reluctant if they assure you it will sweep the nation.

Chan Poling

On the contrary, the best-dressed men often do things that they understand will suit themselves and nobody else. It was a solution, a singular moment of inspiration, that led them to mix plaids, to wear shoes even if they get paint on them, or to wear a Western shirt with a double-breasted suit. Those that get it right don't look like the idea just occurred to them—they knew it all along or, more likely, grew into it. That's why you shouldn't buy your clothes all at once, any more than you should appoint a room all at the same time. Live with a jacket, add a shirt, later a tie, season to taste. Don't seek inspiration. Let it come to you. If it doesn't, there's no shame in that, just master the basics. There are restaurants that just serve an expertly prepared steak and nothing more. When I see men reluctantly buying bold shirts and daring ties that salesmen are holding up optimistically, it's a bad sign.

Of course, there are very well turned-out men who are far ahead of society, and they make you reassess your assumptions. Borges said that when he read the first line of Kafka's *Metamorphosis*, he set it down with astonishment and said that he didn't know that sort of writing was even allowed. It changed his life. Dressing doesn't reach that level of magnitude, but the best-dressed men can still make you wonder what you know about society. They make you ask questions you didn't think existed. They're familiar with classicism but not beholden to it; they feel free to rearrange it on their own terms. The results can feel downright dangerous.

They're not coming to any idea when they're seventeen. They know enough about the world to know what they want to communicate to it. In a way, it's a sense of generosity. They're not merely saying, "This is what I can afford to get away with." They're saying, "This is how I wish the world was." A little more irreverent, a little more improbable, a little more idealized. And you know what? They made mistakes when they went to prom too. They're smart enough to bury the evidence.

WHAT DID
YOU WEAR TO
YOUR PROM?

"I wore a kilt, a plaid kilt. I tracked it down in an Irish motel in town that actually had a gift shop with weird souvenirs from Ireland and I guess Scotland. I rented the kilt from them and I think my mom altered a short blazer—it may have been a women's blazer." —Taavo Somer

AARON LEVINE A rented tuxedo from a bridal shop in the Fair Oaks Mall. It was terrible. Lots of gel. What conveyed me to prom was my dad's 1991 Mazda RX7 convertible. It was a big deal that I got to drive that thing–a *big* deal. The next year was a more conventional neon-lit limousine situation.

during the week, so I had a lot of clip-on ties and a lot of dark polyester suits.

WHIT STILLMAN The only social outlets were mixers, so the key for us was the Masters School, Dobbs Ferry mixers, and the Farmington mixers. I went to a Farmington mixer and we paired off with differ-

"I can't believe I wore a ruffled shirt!"–Jay McInerney

CHRIS BLACK I wore a basic black tuxedo, but I drove a Mercedes S600, a loaner from an older cousin who was a Mercedes dealer. They delivered it on a flatbed truck to my parents' house.

RANDY GOLDBERG Oh God. I wore a tuxedo to my prom and it was horrible, it was aggressively bad. I didn't wear a bow tie, I had a jewel instead–my decision. I'm telling you, I made a lot of mistakes. I rented it in the mall. One of the options instead of a bow tie was this jewel; I thought it was fancy and awesome so I wore that. We rented a limo, rented a tuxedo, rented a girlfriend. Her name was–I'm drawing a blank–I can see her face. . . I was talking about this the other day with somebody. It's not like this is a repressed memory.

WALTER KIRN I looked like Napoleon Dynamite. My tuxedo was powder blue–I was a Mormon in those years. Sunday service took all day, and you were also in church

ent people, but I was able to dance with a Marilyn Monroe type, and I started writing her letters and she became my obsession.

J. C. MacKENZIE I was held back a year at school and missed my official prom. I did go to the junior prom, reserved for juniors and apparently juvenile delinquents. The only uninvited girl left was a Jehovah's Witness named Susan. I picked her up, wearing a lime-green, rented formal suit, with a matching lime-green corsage on a lapel large enough to drive a car down. Her mother opened the door and I learned very quickly that "God is not the Trinity, the doctrine is inspired by the devil, heaven is only limited to 144,000 people, *and* most importantly, her daughter is forbidden to have friends or marry anyone who is not a Jehovah's Witness. Oh, and have fun, kids." Susan, bless her heart, was clearly looking to rebel, even if it was with an idiot in a bad suit. As we arrived, groups of kids parted and we quickly moved to the

"I went to prom in 1996; you had to look like you were in Jodeci." –Josh Peskowitz

back in the corner—and in silence for two hours.

MARK McNAIRY A white rental tuxedo with white Capezio jazz oxfords.

ROB ZANGARDI A free—"rented"—ill-fitted tuxedo. In Columbus, there was a tuxedo rental shop that would hire a select few senior boys to actually wear a tux to high school and hand out coupons to the students. In exchange, we'd get a free tux for prom. I was one of the chosen ones.

MICHAEL WILLIAMS I wore a rented tuxedo with a vest and it was very ill-fitting, and the vest might've been a color.

ANDY SPADE I rented a suit from the mall.

JAY McINERNEY I rented a tuxedo. I went with an Irish Catholic girl. She turned out to be not so nice. I rented a probably relatively hideous tuxedo. I haven't seen any pictures since but given the fact that it was 1972, it must have been pretty bad. Imagine really wide lapels. I'm sure

the outfit was embarrassing, but luckily it's lost in time. No evidence.

MICHAEL HAINEY I wore a black tuxedo with a red bow tie and red Converse high tops with green laces. This was 1982, my New Wave/punk phase.

SID MASHBURN I wore a double-breasted suit—blue pincord from Country Britches—and it was really wrinkled by the time I arrived. With tan canvas crepe sole shoes with tassels on the shoestrings from Polo (they were cool) and a red tie from Reis of New Haven with a collar bar.

RUSSELL KELLY I had a really bad long hair, all one length. I had a bad rental tux with the typical cummerbund and tie that matched the girlfriend's red sequin dress. This was in Fordyce, Arkansas.

ERIC DAYTON An ill-advised band-collared tuxedo; I looked like a member of Boyz II Men. But my date that night is now my wife, so it all worked out.

"I remember seriously disappointing my girlfriend's mother, who had her camera all ready on a tripod to take a photograph. I arrived to pick up her daughter, who was wearing a little black dress. And instead of a tuxedo I was wearing a leather jacket." –Dan Rookwood

WHAT DID
YOU WEAR TO YOUR
WEDDING?

G. BRUCE BOYER Well, I've had two. The first one, I wore a single-breasted, shawl-collar, traditional tuxedo in a tropical worsted, because I got married in May. Very traditional classic tuxedo. I like that. The second marriage was considerably less formal. It was just a private wedding, so I wore a navy double-breasted blazer and gray flannel

John D. Rockefeller III (Eric Dayton's grandfather) and his wife Blanchette

slacks, because this marriage was in November. That worked out nicely.

AARON LEVINE Ralph Lauren sport coat and some jeans, because my wife and I eloped and got married while she was seven months pregnant, at City Hall, and then ran away to Cape May for the weekend. My wife's sister was the witness. It was pouring rain. My wife cried. I remember some coworkers taking me to Tao on Fifty-seventh Street, because it was the closest, and taking a shot of tequila and then running down to the wedding. That was it. Then we were parents.

JAY BATLLE A three-piece, custom-made, white-and-gray seersucker suit with pink Paul Smith oxford shirt and Paul Smith canvas shoes with pink rubber soles. No tie.

HIROFUMI KURINO I wore a kimono. For me, a classic hakama. But I was so thin I looked like a kid. My wife was very suntanned, so they had to paint her white for the traditional wedding ceremony.

TOM SCHILLER A shawl-collar Ralph Lauren tuxedo with purple lining. It was at Bill's Gay Nineties, when it was still Bill's. Mayor Dinkins married us.

MARK McNAIRY My first wedding, I have no idea. My second wedding, a black tuxedo that I had bought in Japan.

ANDY SPADE I wore a charcoal-gray suit with a striped repp tie and a white dress shirt.

NICK SULLIVAN I wore morning dress; it was the thing to do. It made it more of an occasion and everyone joined in. I had this very narrow Saxon taper down the sides to make it a little bit more Victorian. No hat. I look stupid in a top hat. I thought it was very fun. People enjoyed it. People still dress up like that in England.

GLENN O'BRIEN I wore a bespoke natural linen suit from Anderson & Sheppard. My first wedding, I think I got married by accident.

MICHAEL HAINEY My dear friend Thom Browne custom-made my tuxedo. He also made my wife's dress. . . . Her dress was the first wedding dress Thom ever made, and it inspired him to launch his women's line.

James and Margaret Sullivan (Nick's parents)

ANOTHER PARTY
HEARD FROM

> "A prominent hotelier once picked me up for a first date wearing square-toed shoes. I was so surprised that I was intrigued."
> –Susanna Howe

Claude Jean and Jean-Pierre Léaud in *Bed and Board*

Sloane Crosley

I once went out with a too-cool-for-me guy who wore a gray suit and high-top red sneakers, the hem of his pants tucked behind the tongue. I suppose I found this surprising in that I found it intimidating. It's a stylish outfit but one that also says, "I'm going out after this, with or without you."

For the most part, I think everything looks good on someone I care about. Though I once dated a guy who found a newsboy cap in the back of a cab and wore it all winter. And backward. I think he was in love with the story of how he came into possession of the hat, but, of course, the rest of the world was only privy to the evidence. I never said anything, but I do recall thinking, "I can't wait until it's spring."

I bought my boyfriend a beautiful cotton and cashmere checked button-down at Budd in London, and it turns out it was way too preppy for him. I could see him struggling in the mirror, trying to think of when and where he'd possibly wear it. It was very expensive, and so I let us both off the hook and returned it. Also years ago I dated a guy who was a sneaker fanatic, and so I bought him these vintage burlap Nike sneakers. He didn't object, but he also didn't want to "get them dirty."

Cintra Wilson

When I was younger I was much more strict and orthodox about my own airtight fashion laws. I had a big crush on this beautiful guy who was in a band in San Francisco. Through friends we managed to actually go out on a couple of dates, and everything seemed to be heading for romance—until one evening he got in my car and he was wearing a pair of suede slouch boots. I just couldn't see him the same way after that. I could only think about how mortified I was about the slouch boots. I was strictly a steel-toed girl—they may as well have been ballet slippers. I dumped him immediately.

If you are my date, and you have dumb-looking, outdated glasses frames, I will cringe every time I look at your face until I pick out your new frames. Men often have appalling tastes and/or very particular ideas when it comes to what women should wear—and historically, this is something I enjoy.

I have always enjoyed dressing up in silly outfits to stoke a boyfriend's fantasy: nurse, cheerleader, latex, what have you. That is fun. But when it comes to mundane fashion choices that I'd have to wear out of the house, I will not be moved, no matter how much they beg. I vehemently refused an earnest request that I wear sleeveless turtlenecks—because these are obviously the stupidest garment on earth. I was also

given some vanilla perfume once—I tried to wear it for the guy but gave myself a Silkwood shower in the restaurant ladies' lounge midevening because it was making me gag.

I am a big thrift store maven, and I sometimes find amazing things. I once found a black hoodie sweatshirt that some up-and-coming designer had painstakingly bedazzled a portrait of Darth Vader on in silver mini-studs. I did it one better, got out my own stud setter, and studded crossbones under Darth, which made him look even cooler, I thought.

The guy I was dating at the time couldn't get behind it—you have to possess a certain type of "Fuck you, Elvis" in you to pull off such a garment. So I dumped that guy and I gave the sweatshirt to my friend Alex Roy, who will wear anything as long as it might piss someone off.

Madeline Weeks

I grew up in Virginia and my dad was a very stylish man. He had really beautiful Brooks Brothers shirts, and he always wore a Cartier watch, a brown one with a white face and black strap, that was very refined. He had a very refined taste. He never wore jeans. Growing up, I didn't really have a pair of jeans until my mom got designer Calvin Klein jeans into her store, and I was absolutely determined to get them on my body.

My dad had an opinion about the way we looked, and he had his own dressing room, and to go in there was really exciting. He liked this crewneck sweater and corduroys. He wasn't preppy at all; he was from Brooklyn, and even though he grew up in Pennsylvania, he was much more of a New Yorker in taste.

He had a dark green Monte Carlo with an eight-track player in it, and he would always play a James Bond sound track or Dionne Warwick or Glen Campbell. We couldn't eat in his car, but in my mom's car we could do whatever we wanted.

Vodka and tonic was his drink of choice. I remember, as a little kid, he'd be mowing the lawn and he'd say, "Oh, can you go inside and make me a vodka tonic?" Just the way he liked it. He wore a lot of Ralph Lauren, and his favorite store in New York was Paul Stuart. I moved to the city when I was seventeen, and he would always say, "Just go in there and take a look around for me."

Men shouldn't be afraid to wear a well-fitted suit. A common problem is pants that are too long. When the Oscars come around, people sometimes look in their mirror—they don't look in a full-length mirror, or they would see that the hem of

178

the pants is practically around their ankles.

When I meet a man I don't always notice one thing in particular, but I notice if he wears his clothes in a way where his personality comes through. I like that. I also like if he has a nice touch and does something that's clearly very personal and reflects himself.

Anna Sui

My father was always meticulously dressed, usually in a suit. He had perfectly coiffed hair, slicked back. In the summer he wore beautiful white suits. He looked like he had been taught how to pose, like he knew how he looked good, and he went through his whole life that way. He wore Brylcreem; his hair was classic, with short sides and back, longer on the top. I don't think I ever saw it messed up, except when he went in the water, but then he'd just comb it again.

He had a platinum Rolex watch. His father bought it for him when he went back to visit when my grandfather was very elderly. Because my father grew up in boarding school and hardly lived at home, I think he really treasured that.

He was very classic; he liked herringbone jackets. I remember in the eighties, when it was Christmastime, I'd ask, "What do you want for Christmas, Dad?" And he'd say, "Just a white silk scarf."

I like either very classic—and it could be blue jeans and a T-shirt—or the whole dandy look. It's one extreme or the other. The middle part is not interesting to me.

I would advise a man that doesn't really know how to dress well to get a uniform and stick to it. Then they'll always look good. Figure out a really nice shirt and a really nice pants and stick with it.

Do you know who John Ahearn is? He's an artist, and he invited me to the movies. I was so excited, because I thought, Oh my God, he's so handsome, I can't believe he asked me out. So he shows up at my house—and he's got makeup on to make him look like an old man. He had just come from a theater class, and they taught him how to do makeup to make himself look old. And he wore it to go to the movies.

"I have come to blows with men over polar fleece. Some fashion crimes simply may not be tolerated." –Cintra Wilson

Susanna Howe

I think fear is the big problem, confidence the saving grace. What are they afraid of? I think mostly seeming gay. I tell you, there is nothing hotter than a guy in a striped maillot shirt, gay or straight. Or a tuxedo with a fat bow tie. But most American men feel gay wearing them. The thing is, thin men, like my husband, are often afraid of seeming effeminate. But the most confident—and interesting—straight men are the ones who like to play with that line in presentation. It's all context. I mean, the horrible frat boys in the South only wear pink, green, and madras, whereas the popular gay look in Brooklyn is a bearded lumberjack ensemble.

Erin Cressida Wilson

When I look back at the fifteen years with John [J. C. MacKenzie], I can tell you what he was wearing for every big moment of our life. He is a total clothesaholic. When he is anxious, he buys clothing, and one of the things we like to do together most is go into vintage clothing stores, take off in different directions, and bring each other what we've found. Inevitably he has found better clothing for me than I have found for myself.

I remember the T-shirt and painter pants he was wearing when I first saw him, the V-neck he wore when Liam was born, the costumes he wore with me every time we dressed up. It's interesting to remember a person and an event by what they wore; I notice clothing like I notice things in a home, and if the clothing is off, I can't love this person—they are not home. Clothing is what a person chooses to wear, and even if it's the same thing every day and costs nothing, it's still a choice. It doesn't need to be expensive or beautiful; it just needs to meet the personality of the man in a way that says, "This is who I really am, this is who I want to be, this is who I'm pretending to be." It is a statement, a lure, a game; it is part of our dance of life and seduction.

When my mother died, two young men climbed our stairs to zip her body into a bag and carry her away. One of them asked me which direction to her bedroom, but my eyes were stuck on his tie—it was polyester, faded and ripped. The filth on it was an entire layer of fabric itself. I looked him straight in the eye and said, "Please don't take my mother away with that tie on." He laughed, and I said, "Can I get you another?" He laughed again. I went to one of my drawers, where I had rolled up all my father's ties and kept them when he had died.

I chose the red-and-black silk paisley from the 1960s. I wanted my mother taken away by someone wearing a nice tie, not one that had picked up a thousand other dead bodies. I helped the young man put on my father's tie as he shoved the old one in his pocket, and then I locked myself in the living room as they took my mother away.

Maureen O'Connor

I have never really objected to or had a strong negative reaction to something a man wore. (The closest, I think, is when a guy has terrible underwear, but if that's the case I just focus on removing them.) But I have had some overwhelming reactions to beautiful men's clothing. There's something wildly romantic about a beautifully worn-in pair of jeans, which over time fades into a map of the body of the man who wears them and the way he moves. I consider the acquisition of a perfect pair of literal boyfriend jeans worthy of any amount of heartache, to the point that I routinely fall in love with men who wear the same pair of jeans. (Slim-cut Made & Crafted Levi's in size 28, a style favored by my first live-in boyfriend as well as the last man who broke my heart. Last year, when a gay friend purged his closet of clothes from his "skinny phase," I acquired two more pairs.)

Once, on a date, a man flipped the pocket of jeans inside out to reveal that he'd had a tailor extend the pocket two inches to accommodate his new phone, and I found myself swooning at his attention to detail. The jeans in question were manufactured in the Okayama prefecture of Honshu, Japan, by a company that dips each fiber in indigo thirty times before weaving it into a 14.5-ounce denim famous for its tate-ochi, "vertically falling fade." The first time I slept over, under the guise of looking for a T-shirt to sleep in, I rifled through his closet stocked with Band of Outsider tees and Thom Browne button-downs. He was a squarely built size 36, and six-foot-five, which meant his pants would always be useless to me, but when I came across an astonishingly luxurious sweatshirt from a Canadian brand I'd never heard of, I put it on and announced that I would remove it only under threat of breakup. Two months later, I'm still wearing it.

As you would expect, the man with extravagant taste in Japanese denim also has alarmingly sexy grooming habits. I have stood in the door while he shaved with a heavy double-edged Merkur razor, and marveled that the utensil was as angular as his jaw.

Leather goods also have an effect on me. I vividly recall walking into a bar for a first date and watching, in slow motion, as a stormy, dark-haired man turned on his bar stool toward me, his black motorcycle jacket falling open to

reveal a vibrant silk lining patterned with purple flowers, worn over a Supreme sweatshirt patterned with pink roses. Over the course of the next year, we would go on to take turns rejecting and falling for each other, with varying levels of sweetness and brutality.

Hannah Elliott

I don't know many women who want to be with a man who puts more thought into his wardrobe than they do. It's great when a man has a good closet of clothes and thinks about style for about ten minutes in the morning when he gets dressed, and then moves on with his life.

One man I dated would wear these really beautiful button-down shirts made of brushed silk. I think they were Saint Laurent. They had prints of flowers or birds on them, and they had short sleeves. Now, if anyone had described these shirts to me, I would have laughed or run away. But he pulled it off amazingly. He paired them with tight black jeans and cool city boots, sometimes with a hat and always with a super-slim vintage Rolex with a beautiful black crocodile band.

I once went out with a personal trainer who wore a purple vintage Anaheim Ducks hockey jersey with slim camo pants on a date to a basketball game. It actually worked great for him—but I would never suggest someone else should attempt that look.

I want to date a man who knows his own mind—not a boy who needs me to tell him how to dress. He should already know what he wants to say with his clothing, even if he processes the message on a subconscious level. If I actually have to say anything to him at all, it means the case has progressed to a very bad place, possibly beyond repair. That said, last year I casually bought a pair of slim, black Levi's jeans for the man I was dating at the time because I didn't care at all for the dark drop-crotch slouchy Dickies he had been wearing for three weeks straight. He made the switch just fine.

I now possess two perfectly soft, perfectly oversized J.Crew flannel shirts (one red, one green) that I bought for a boyfriend years ago for Christmas. He never wore them. I loved them, and told him occasionally that I would love him in them. They stayed with me when he moved out.

Most men could stand to have their jeans taken in an inch or two. Ladies like slim legs, fellas. Show us what you've got!

"As soon as you see a man's shoes, you know what he's about." –Anna Sui

Hollister Hovey

On a very blind Internet date, my first and the worst, the man wore Tevas. With chipped metallic blue toenail polish. He felt no shame over those toes or sandals. We made it through one coffee. I never agreed to a coffee date again.

Another man had a magnetic attraction to all things that were shiny turquoise. I launched a passive-aggressive mission, dragging him on shopping trips and showering him with compliments about his complete handsomeness in navy and white cotton and linen. That and some old-fashioned honesty eventually worked, and we got to the point where he let me weed out his closet. You can't change a man, but you can get him out of the shiny turquoise. Victory!

I gave a boyfriend Ralph Lauren Purple Label velvet slippers with gold crests. I was throwing a big black-tie event and really forced them on him. I squealed with joy when he put them on, and the moment I turned away he kicked them off. To force a guy to make the leap from sensible (at best), casual work shoes and sneakers to velvet anything borders on torture. In the end, he was a great sport and went through with the foot costuming for the party (with only a little fear in his eyes). The next day he even seemed a bit giddy that he got compliments on them all night. When my cousin's wedding rolled around a couple months later, they were on his feet, no questions asked. Victory again!

In the early aughts, I felt as if I was waging and generally losing a war over the soles of every man around me. I was pro-leather and they were defiantly not! I'd pull coworkers into the annual Paul Stuart and Brooks Brothers sales just so they could experience a properly soled shoe, but was met with so much whining. Ew, they don't bend! Ew, they're so slippery! I'd plead that the firmness and slipperiness would abate after ten minutes on the sidewalk . . . as they slipped their feet back into their square-toed rubber-soled Kenneth Coles and breathed a sigh of relief. Fail.

Lesley M. M. Blume

One time I was supposed to have lunch with musician Kenyon Phillips at Sant Ambroeus in the West Village, and he showed up with a naked chest and a fur coat, chest tats and necklaces on full display. There may have been some sort of extraordinary fur hat involved too. Anyway, I was speechless, and for a second I didn't know whether I was embarrassed or felt like the luckiest girl in the room. The then-manager

of the restaurant, an elegant man named Enzo, came over to the table, and I thought he was going to kick us out. But instead he gently complimented Kenyon on his look and asked politely about some of the accessories. I was so filled with love for both of them at that moment. We both had Bolognese.

My husband's taste is classic and there is little in his wardrobe that would offend anyone. There was, however, briefly a black Bruno Magli bomber jacket in his closet that caused a kerfuffle. It sounds like it should have been cool, but it was more Sopranos than Hedi Slimane. He never wore it—it had been a gift—but felt bad about getting rid of it. I finally took matters into my own hands and whisked it off to Housing Works one day.

I once bought him a very fashion-forward Tom Ford tie—heavy twine or tweed, and quite wide. It was awesome. I think he was bewildered by it at first, but he wore it bravely and looked very goddamn hot in it.

I also think men look beautiful in pink shirts, especially deep shades. Gatsby was right.

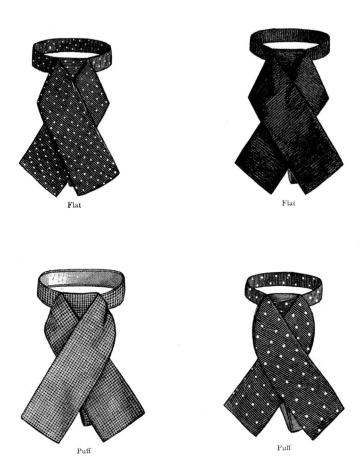

Flat

Flat

Puff

Puff

A while ago I sat at the bar of a smart Danish restaurant on Canal Street. It was an attractive place—clean Scandinavian design, appealing staff, with requisite jars of homemade aquavit lining the wall.

Prominently featured on the menu was a herring platter, the strongly flavored staple fish. When in Denmark, or at least our version of it here in Manhattan, I figured I should do as the Danes do and took the herring plunge. It was not until I finished—it was perfectly good—that I thought of asking myself, Do I even like herring? Yes, I suppose I do, but never quite as much as I wish I did. It's as if I think if I keep ordering it, I'll learn to like it and finally attain a level of dining enlightenment.

Essentially, I was in an acquired-taste holding pattern, neither loving nor rejecting the potential object of desire. I didn't know who to blame: the very singular fish or my own lack of worldliness? I certainly wanted to give my heart to herring, but herring does not give itself to love so easily.

Acquired tastes are a curious consideration, whether dining or music, clothing or film. Some foods become appreciated over time, like coffee, mushrooms, squid, and whiskey, which are generally at odds with youthful taste buds. In these cases, familiarity doesn't breed contempt; over time it evolves and brings pleasure, and an enjoyment of complication and nuance.

Others you resist before arriving suddenly with a full-form adoration. Like when you're fifteen years old and all at once every Smiths song makes perfect sense. Morrissey's voice doesn't sound mannered, it sounds as if it's singing just to you about a bucktoothed girl from Luxembourg.

It doesn't end with artful teenage angst. When I began reading Anthony Powell's series of novels, *A Dance to the Music of Time*, it felt as if they were meant for me at exactly that time. I was in my late twenties, traveling regularly to London, and the sensibility suited me perfectly. The fact that the books were written decades earlier by an author who had since passed on didn't deter me. It felt like there was a connection between us that was intimate.

Powell's novels, it should be said, are not for everybody—in fact, they veer dangerously close to being boring. You have to enjoy the fine distinctions of a certain sort of English social milieu. In fact, many people loathe them. But if they fit you right, good Lord, they're incredible. It's like natto, the fermented Japanese soybeans that have an absolutely vile smell. Though I can't stand natto myself, despite many Japanese friends reminding me how wonderful it is.

That's the interesting thing about acquired tastes: It's not just that sometimes you develop them and sometimes you don't; you have to decide when you're going to trust your first instinct and give up the hunt altogether. Have you had enough Philip Glass to know he's not for you? Or Kombucha? Or Eric Rohmer films? Sometimes conversion happens by chance: You're visiting friends who insist on serving aged rum in the summer (a pretty good problem, for sure). The first may be a bit rough, but soon enough you're buying it by the case.

So give yourself a second chance to form a first impression. And fear not when offered orange wine, shad roe, or duck hearts—it may be the beginning of a beautiful friendship.

Formal Aspirations

When Prune opened in the late nineties, it didn't have a liquor license. The waitress (and they were all waitresses then) directed you to a gritty wine store on Fourth Street where you bought a bottle of nondescript white from a Korean man through an opening in a plate of bulletproof glass. You walked back and set it on your table, covered with a sheet of brown paper, and your branzino arrived presently. Nice.

We've been devoted to Prune ever since—now you can enjoy a definitive Negroni without leaving your seat—and it's gone on to conquer its corner of the world. And we respond to other restaurants that share an appreciation of immediate pleasures and little pretension. They're direct, they get your attention, they're elemental in the best sense.

There were probably more changes in the last decade in New York dining than in the fifty years before that, and that evolution has been great. You know: market-driven, genre-defying, artisanal within an inch of its life, orange wine, and the rest. And a few not so good: booming sound tracks,

Jean-Louis Trintignant in _The Conformist_

small plates, waiters deferentially referring to "Chef," and a certain indifference to physical discomfort. Wait an hour and sit on a stool–sometimes that's simply not the answer.

There are occasions when one wants chamber music, someplace hushed. You want to slide into a banquette. Like A. J. Liebling, sometimes you require la cuisine classique. It's getting harder to find: Adieu, La Caravelle; au revoir, Lutèce. There's still something to be said for a vase of flowers, ironed linen, a silver knife that weighs a ton, and service from a man in a tuxedo, not a sleeve of tattoos. When it's done well it's not about snobbery, it's about enabling the great pleasures of civilized life. The terrific London chef Fergus Henderson (who would never be accused of supporting ornament for ornament's sake) has said his favorite feeling is the anticipation when walking across the Palais-Royal toward the incomparable Le Grand Véfour for lunch. Amen, brother Fergus.

The incongruity of a four-hour lunch in today's world makes it more transcendent, not less. It's a withdrawal from news cycles, market updates, and the social media hum. If it was once a sign of high society, it can now rightly be called contrarian. It's an engagement with sensory pleasure and, just as crucially, the pleasure of another's company. The intimacy of a languorous meal can be rivaled by few things–at least in public.

Does a leather-bound wine list running north of thirty pages strike you as too much? Does a waiter who takes pride in his French seem a little too, *comment tu dis*, aspirational? Does the fourth fork in a row hint of overkill? Point taken. But there's a place in the world, and always should be, for that type of elegant experience. The same way there's still room for a painter who knows how do draw. Rules may be learned and then broken, technique mastered and disavowed–but there's a purity in the expert execution of an omelet or a soufflé. That learning results in a taste that feels inevitable, and, like the line in a Matisse drawing, it only looks easy.

Serving sole meunière on fine china doesn't make a restaurant, just like wearing a tuxedo doesn't mean you're well dressed. Formality for the sake of formality is banal. But let us say this: There are times when the ambition of a talented chef in a superior setting is ennobling. Luxury has been hijacked by marketers selling handbags in China–about expanding a brand in the name of profit. Not this. This experience is local. The right restaurant may ask you to wear a tie, but it demands even more of itself. High culture has its place. Maybe not every day. But there remains a need for veneration, an increasingly rare reminder of the better nature in all of us.

Fire: Elemental Attraction

It's in our nature to cook over fire. Brillat-Savarin wrote, "Once fire was recognized, man's instinct for self-improvement led him to subject meat to it." And subject meat to it we do, because "Meat thus treated was found to taste much better."

In the enduring interest of self-improvement we employ a fieldstone grill, a lakeside campfire, an ancient hibachi, or the blessed Weber (praise this glorious, spherical American invention!). Maybe it's because grilling is the easiest way to cook while holding a drink. But it's more than that: When you're grilling you're outside, and for men (and often it is men at the grill) it fulfills some sort of primal instinct that's distinct from the technicalities of the kitchen.

Grilling recalls the joys of summer, the sun setting late. But I remember my dad bursting into the kitchen along with a gust of cold air on Christmas in Minnesota, holding a beautiful grilled *côte de boeuf*, the size of a piece of firewood. Yes, grilling in an overcoat has its place.

These memories are not limited to the food. I'm curious about the man illustrated on the side of the Kingsford charcoal bag. Recently he seems to

have grown stubble (though that may be me projecting—my beard certainly feels more verdant when I'm grilling). He looks like he drives a Jeep and lives a rewarding life somewhere in rural Colorado.

Everything is better with a grill, but not all grilling is created equal. In general, I prefer things cooked over high heat for a short time. That is to say, seared dark on the outside and rare within. Those of us who cook this way are united in a bond, and we raise a collective eyebrow at anybody who asks for meat well done.

Cooking over fire satisfies because it's visual. Is the salmon finished? Just cut into it. If not, put it back on. I like a fire that's just difficult enough to start (no gas, please). I enjoy the inexactitude, drawing the line at anything clinical that tells you the precise temperature of what's happening under the hood. It's more art than science, and really more improvisation than art.

Of course, some have raised grilling to a high art. That would include the great Francis Mallmann, the Argentine chef and author of *Seven Fires: Grilling the Argentine Way* (along with favorite food and fly-fishing writer Peter Kaminsky). Mallmann cooks under coals, between fires, and is perfectly comfortable splaying a lamb on the riverside in Patagonia. We salute you, sir.

Other master practitioners are the Japanese chefs at yakitori joints from Midtown to Tokyo. They are on intimate terms with all parts of the chicken, which they grill on small skewers (don't forget the knee bone or the seductive skin). The chefs are stylistically distinguished by their different bandannas. They are meticulous with their water bottles, which they use to control the flames, while they season their shiitakes and peppers just so.

At our family cabin in Wisconsin we have a fieldstone grill and have branched out into everything from eggplants to peaches. It takes more time to burn down the wood to get the coals you need, but that's why you drink one mediocre local beer after another while you tend to it.

Last summer, in a fit of carnivorous ambition, I decided to tackle a large brisket, carefully following a *Times* recipe. Six hours later I had sweated through my shirt, gone for a swim, and then presented the beautiful slab to my family. It looked perfect, inside and out, but something was wrong, very wrong. The charred exterior was impossibly salty. Woe to the slow cooker who over-seasons his brisket! These things happen—though I cursed the *Times* for months. Fire remains the elemental part of an ongoing education.

Interview

WHAT DO YOU
COOK?

RANDY GOLDBERG I cook for myself, generally not very exotic, but you take care with it. I think cooking is about taking an extra second before you start to really think about what you're doing, and then it's easier to do a good job.

WHIT STILLMAN Anything in the Harry Cipriani cookbook. My triumphant meal, from which I courted a lot of good friends, was sautéed beef liver with tons of butter.

AARON LEVINE I'm great grilling a steak. I want to make sure that everyone is aware of how perfectly I cooked that steak; though, it's the most simple process in the world. "Did everyone like their steak? How it's cooked—is it perfect?" There are six side dishes that my wife slaved over, but I ask, "How's the steak?"

JAY BATLLE Usually French classics like blanquette de veau, cassoulet, steak frites—part Richard Olney, part Elizabeth David, with a little dash of Mark Bittman for good measure.

GUY TREBAY My party trick is a soufflé. If you are a weekend guest,

you get extra points for pulling off something like a cheese soufflé, when in fact it is very easy to make. A very social lady of my acquaintance gave me her recipe for caviar soufflé, which I make but only with American paddlefish roe. You don't cook the roe, of course. You just blob it on top at the end. It's just a caviar delivery system.

ARMANDO CABRAL My summers are always spent in Portugal, where you can never complain about the food. The only thing I'm really good at is called *beshuare*. It's basically a stew of mixed vegetables, and you put chorizo, chicken, and pork in there and beans in there and you season it all well. It's really good.

MARK McNAIRY Steak. I like to get them from the butcher shop down in Hoboken, but it's not organic and so my wife moans. I do T-bones, porterhouse filets, cover them up with olive oil, salt, and pepper.

ANDY SPADE My specialty is grilled cheese.

Civilized Drinking

Bars have survived Prohibition, gentrification, and amplification. They have endured because people want to drink. You can do this at home, of course, but most prefer to drink in the company of others—some of whom, ideally, are good-looking. Now that we've got the truth out of the way, let's consider what distinguishes the good boîte from the bad.

The most important thing about a bar is that it suggests the better nature of drinking: conviviality, civility, with a lack of inhibition and a basic surge of optimism and solidarity. It should not remind you of imbibing's downside with an atmosphere of cloudiness, regret, and morose Willie Nelson songs. A good bar feels like the first crisp sip of champagne; a bad bar feels like the last slug of tepid beer. You want the bar where somebody goes to celebrate a new job, not to forget he just got fired.

The perfect bar formula is hard to master, so when you've found the right one, it's wise to stick to it. And there are many rewards for becoming a regular, although it's always a curious sensation when you're first recognized by the bar's staff. You have to confront just how much time you've spent on the rail devoted to the drinking endeavor. In that time you could have watched every episode of a critically praised cable drama—twice. Or finally have read all four of the Neopolitan Novels.

It came as a surprise to me when the owner of a bar I once frequented told me about his initial speculation about my presence there. "We would be having our weekly meeting," he confessed, "and you'd be sitting in the booth by the door, and I asked them, 'Who is that guy? Does he work here? Are we even open?'"

The relationship between a bar and a regular is an intimate one. Bartenders know as much about you as your analyst, your accountant, or your ex-girlfriend. They've seen you with your guard down but hopefully not with your fists up. Good bartenders understand human frailty—that is, after all, what drives their trade—and they use that bracing familiarity to found a professional but not superficial relationship. So good bartenders should be tipped generously, in cash, and don't insult their craft by ordering a pink drink. The good bartender also understands when you're taking a break from the hard stuff and opt for a club soda; you've earned it.

Tray Gray, Richard Baker

Bars with themes are generally not good. They're facile and distracting. Though there is a bar in London with a fierce Austrian alpine ethic that is an utterly compelling place if you're in the very specific mood to hear "Edelweiss" sung by the elderly owner in his lederhosen, accompanied by synthesizer and cowbells.

Televisions are not good. They attract grown men wearing the jerseys of sports teams—which is not a good direction for civilization. (If it's showing cable news, then don't even bother.) Of course, there are times when you must watch a game. That's fine, but order carefully if they serve food. If there's a TV in any establishment, then don't order fish.

What else? A bar without women feels dangerously like a locker room. Better to head someplace where the fair sex feels at home. Even if women aren't in your plan, they radiate atmosphere. Conviviality is good, but no bar should be so loud that you have to shout. You should not be afraid to order a glass of wine in a bar, but if a huge bottle of plonk is visible, it's not a promising sign. And snacks should not turn your fingers orange.

I've always preferred small bars, like those you find in old European hotels. Eight seats is good, five seats even better. At a smart bar in Florence, not only do they serve the rarely seen classic bullshot, they bring the beef broth (don't be frightened!) straight from the kitchen to mix the drink—now, that's how to do it. At Harry's Bar in Venice they might bring you a little grilled cheese from the kitchen between cocktails. At the Orchid Bar, a favorite bar in Tokyo (now tragically dismantled), they know that a martini should be gin and stirred until it's fiercely cold, the way God intended. With a twist of lemon.

A good bar is usually dimly lit—yet it doesn't suggest that the darkness obscures anything. In the end, a good bar is a place of refuge, a respite from a world moving too fast. Humphrey Bogart famously said the world is three drinks behind. A good bar gives you a chance to catch up, and the strength to venture forth.

HANGOVER CURES

NICK SULLIVAN The best solution for feeling like shit is to put on a suit and tie.

DUNCAN HANNAH Beer for breakfast. Actually, several beers.

JAY McINERNEY Chocolate milkshake. When any of the women in my life see me with a chocolate milkshake, they know what it's for.

RANDY GOLDBERG My hangover cure used to be a cheese pizza; now it's a workout and a green juice. Going in the ocean is always the best hangover cure.

WALTER KIRN I had a recipe that involved baked beans, pork chop, spinach, and tomato sauce. I'd just boil it in a pot until the pork chop came off the bone. I would freeze it—I don't know why, I was a bachelor at the time. I would eat it first thing in the morning.

WHIT STILLMAN If it comes to a hangover, it's already too late.

JAY BATLLE A long walk and then Trippa alla Toscana with an extra fried egg for lunch.

AARON LEVINE A beer and a sausage, egg, and cheese sandwich.

MICHAEL WILLIAMS Generally, you just need to eat something bad. A couple Advils and four or five hours of lying around will generally solve it for me.

HIROFUMI KURINO Each country has a hangover cure. Americans drink a lot of coffee, right? Japanese people will take a hot bath and drink miso soup.

MICHAEL HILL If I'm hung over I look in the mirror, briefly berate myself for taking a liberty, and tell myself it's now time to pay for it with a hard day's work. A productive forfeit, if you will!

NICK SCHONBERGER Two Valiums and another drink.

MICHAEL HAINEY I wish I had one. My problem with hangovers is that I refuse to boot. I hold my liquor. Unfortunately, then, the only cure is time.

ANDY SPADE A beer. Everybody says that, right?

Laid Low: Dive Bars

Everybody has a favorite dive bar. How could they not? Though the most venerated have often closed, like unappreciated TV shows that have gone off the air. You have to be in a certain mood for a certain show, and you definitely have to be in a certain mood for a dive. Dive bars seem to have some specific eccentricity unique to itself, but they share a great deal in common. What are they? Dark, frequented at opening time, a refuge from moderation, and unfamiliar with good luck.

We're all tired of bars that seem to take pride in how long it takes them to make your drink. There's a place for expertise, but sometimes it's nice just to have something poured into a glass. You can stride into a place that has only one kind of gin and it's served in a way that borders on indifference. When you're going to get down to it, you really just need one kind of gin, any kind will do—none that were made in the style of nineteenth-century Amsterdam, none that were made upstate by some agriculture majors who dropped out of Barnard, none that come from such a small batch that they've never been in a store—just gin. For four bucks.

Boat Bar, Sarah Malakoff

The funny thing about New York, however, is that for a city that can hold its liquor, there are fewer and fewer dive bars. You know the usual reasons: real estate, the bankers, the flight of the artists, a bunch of women wearing high heels in the Meatpacking District. But bankers like a good drink as much as anyone, and there continues to be a desire in some quarters to get down to the heart of the matter and get wrecked for a twenty.

It wasn't too long ago that Billymark's had certain dive credentials. It has a down-at-heel quality that conveys a welcome disregard for decor. One of the last times we went was for a book release party. We were greeted by a great-looking PR girl, and the whole event was sponsored by some dreadful vodka in a skull-shaped bottle. Billymark's gone corporate? What the hell is going on in this town?

Most dives have a weird tradition—at a favorite in Wisconsin they give you a free shot of peach schnapps every time the Packers score a touchdown. This is on Sunday afternoon, mind you. Now, that's a tradition! You want a bar where you know somebody will be worse off than you are, more likely to be able to quote Dylan Thomas, even if they can't remember their own name. You want a dive bar where the motto is the opposite of the Green Berets': You don't want to be the first in and the last out.

In the end, the best dive is welcoming because it understands the nature of low intentions—it knows what we want and provides it without judgment. Dives endure because while the landscape of the city may change, the human element never does.

Happiness Is a Warm Bun: Hangover Tactics

Years ago an English girl, who I'm no longer speaking to, was sitting across from me at the Waverly Restaurant, a definitive twenty-four-hour diner of the old school. This was before they needlessly renovated it, updating the mediocre 1950s décor, which was somewhat charming, to mediocre 1970s decor, which was not. It was a lazy morning after a night of drinking, and I ordered a fried egg sandwich. She had never had one, but thought it

Graham Greene

sounded good. Great, I said, but felt a need to explain: It doesn't really taste like what you expect. Once it goes through the diner process it becomes a new, unique entity that bears little resemblance to its founding elements—indeed, to logic itself. She took a bite and understood: It was on a whole different plane. This was one of the last things we agreed on.

In a way, this divine gift invokes the revelation of a martini: You can like gin and vermouth, but you're not prepared for what you're getting into when they're combined and served forth. A revelation, beyond the sum of its parts. But a martini embodies refined elegance—a coat and tie, *The Thin Man*, wry urbanity. It's a Platonic ideal, the drink of the gods. The fried egg sandwich is none of those things; in fact, it is often eaten the morning after drinking martinis when you are swearing at God and everybody else. It's still a winner, like a team of baseball misfits that plays beautifully together and overachieves to win the World Series. But that implies glory on a grand scale, when here the pleasures are more local, immediate, and fleeting.

The egg sandwich is a staple of the breakfast boudoir and a curious cultural phenomenon. The appeal is wide-ranging, differing from devotee to devotee. For some it's the rare instance of indulging in processed cheese without guilt—a veritable don't ask, don't tell policy of what's what inside the bun. Most of us, however, associate it with recovering from hangovers and have transferred our affection to what delivered us from our plight, like a gastronomic Florence Nightingale Syndrome.

Certain things aren't meant to be classed up, like light beer or canvas shoes. A key to enjoying the fried egg sandwich is context. That's to say, eat it in a diner. Attempts to re-create the dish in one's own kitchen invariably come up short. What matters is setting (and the accumulation of years of who knows what on the diner's griddle, a thought that can't bear too much scrutiny). A diner is for considering the previous night's excesses, for contemplation, for recovery. Kingsley Amis said the hangover is a unique route to self-knowledge. The fried egg sandwich rides shotgun on the highway to revival.

In the end, we return to the fried egg sandwich because of its simplicity, its lack of pretense, its surprising goodness. We don't have to have it all the time—indeed, even more than once a month may be too often. But like an unfilled prescription or a hip flask, it's good to know it's there, at the corner diner, available twenty-four hours a day.

DRINKING
AND DIVE BARS

MICHAEL HAINEY My grandfather in Chicago, he drank Miller High Life. I remember being five or six and seeing "the champagne of beers." I was always thinking, What did that mean? I'd ask my grandpa and he would say, "This is the best beer you can get." And on summer nights he'd pour it in a tall glass and sit in the backyard under a big maple tree.

DUNCAN HANNAH The 55 on Christopher Street, which is still there.

They used to say that the Lion's Head was for writers with drinking problems and the 55 was for drinkers with writing problems. It had a great jukebox and one table. I think Budweisers were a dollar. If you ordered a glass of whiskey, they just gave you a juice glass and filled it to the top.

JOHN BRODIE When I was growing up, the drinking age was eighteen. There was a bar you would get served at if you were fourteen, on

Second Avenue and Eighty-fourth Street. Picture a railroad car with a bar in it. It was run by a bunch of Czech immigrants. All the boarding school kids could get served there, and you'd go in the disgusting bathroom and there'd be graffiti on the wall, like "Flush hard, it's a long way to Salisbury school," or like "Duncan Kennedy sucks." Duncan Kennedy is a friend of mine.

WALTER KIRN My grandfather loved manhattans. My father was the same. When he would come to our house from Ohio in the summer, having driven seven hundred miles, you weren't allowed to talk to him unless he had taken his briefcase-like bar and put it on the counter, and opened it up. It had all the silver shakers and manhattan ingredients. Cherry juice, separate from the cherries. He'd mix a manhattan and then things would be OK. When I would go fishing with my dad in the summers, we'd come out to the Bighorn River in Montana. It was the same. You hadn't occupied your motel room until you had mixed a manhattan in it. That was my drink too.

WHIT STILLMAN I generally order the cheapest vodka on the rocks.

ANDY SPADE I drank a lot of Coors growing up. Now I drink Heineken more than anything, and South Side cocktails.

EUAN RELLIE My parents drank a lot throughout their lives. They were, broadly speaking, diplomats in the way that their job was what you try to do, you're cultivating people—and the best way to cultivate people is to get them drunk. He had malt whiskey. He would always have eight or twelve bottles of malt whiskey in his sideboard.

MICHAEL WILLIAMS I'm more of a wine person than a beer person, but I have weirdly covered both ends of the beer spectrum, and the one I really love the most, and I drink a lot of, is Miller High Life. A lot of people just really hate it and think it's an abomination. That's the tacky, terrible end of the spectrum, and on the good end of things is the Great Lakes Brewing Company Christmas Ale from Cleveland. It's something I grew up with and was always drinking, and it's really special, independently owned, comes in a bottle. It's great.

MICHAEL HAINEY My father drank Schlitz beer. People forget that through the sixties, up until the seventies, Schlitz was the number one beer in America. For my father's generation Schlitz was every upper-middle-class person's drink. I didn't start drinking until I was twenty-one, so I worked very slowly through it. But when I go back to Chicago, I always go to Old Style, because it just makes me feel good.

Jack Lemmon

PART IV

Gentlemanly Concerns: *Received Wisdom
and New Interpretations*

Beards: A Fierce Defense

The beard has a noble tradition among French painters, Russian novelists, and Union generals. It has a shoddier tradition among petty dictators, out-of-work actors, and unstarred chefs. Beyond traditions, though, the beard is an essential expression of man's nature. But for best results, nature should be carefully cultivated. The triumphant beard must tread the gallant side of the line that separates the heroic growth of Edouard Manet from the disheveled shrubbery of disgraced Brooklyn chocolatiers.

Above all things, the beard is a show of generous temperament. A man has a face full of hair, and he rightly wants to share it with the world. Or perhaps he just doesn't feel like shaving. Regardless, a beard is something that most feel compelled to try at least once, like vegetarianism. And some find that, like going steak-less, one month is the right length of time. Others, however, step into the bearded breach, let it prosper, and never look back.

A good beard suggests a man who's comfortable with himself and his achievements—perhaps he's earned tenure, received a genius grant, or taken up residence at Yaddo. Perhaps he's a seafarer and just captained a ship around the Cape of Good Hope. The reverse beard, of course, implies a lack of focus and effort. This is the man still scrivening his dissertation on Eastern philosophy, extolling the virtues of composting, or leading a minor religious sect. In other cases the sudden arrival of a beard may imply an unpleasant reversal of fortune, of a man going to seed after his girlfriend has moved out and he's living in a state of semi-squalor, subsisting on Chinese takeout and watching Charlie Rose with the sound off because he can't find the remote.

Yet, regardless of type, bearded men are a band of brothers. They feel an innate connection with Tolstoy, Matisse, and Melville. They may once have resorted to swordplay, but now they're more comfortable with wordplay. That's important, because growing a beard inevitably involves heated discussions with loved ones. This is the real reason bearded men are forced together: the wanton judgments cast upon them, from wives and girlfriends (gay men who have beards often share that taste with their beau) who do not care to see or feel a man who, in their view, closely resembles a bear emerging from hibernation. But the issue of beards is fundamentally an issue of nature, and each man must ask himself if he should tame it, civilize

Man with Pipe, Édouard Manet

it, or embrace it. A bearded man should look at home dining at an Uptown restaurant, not like he killed his food with a bow and arrow.

And another question: How do you explain the beard's arrival to your mother? When my mom saw my beard, she smiled and asked how long this was going to last. It was as if I'd brought a Rockette home for Christmas. I made up an answer: three months. I'd forgotten about the exchange when my phone rang three months later to the day. It was my sister who got right to the point: "Mom wants to know if it's gone yet." It was not. My mom, fearful of the truth, had forced my sister to make the call. That was more than five years ago. I have not bought shaving cream since.

Yes, the bearded man is brave—not because he lives in the woods, though he is at home there, but because he resists the tender voice of the woman in his life when she whispers, "Please shave. I want to see your face." Disregard this! The bearded man is too astute for such false flattery. But a beard must have time to establish itself and earn its sense of authority. To be safe, the beard is best grown far from the company of the fair sex. Like on fishing trips to Montana. Or aboard the *Pequod*.

Lesser men crumble under the withering daily insinuations about whether it makes you look old (nonsense! just sage-like) or larger than before (fie! a man in full). Do not underestimate what people will do to keep you from fulfilling your bearded destiny. Better to trek across Nepal without your razor and return home in grizzled triumph.

The fully bearded man tends to be tolerant. He knows that not all men can acquire sufficient beard density to partake in Civil War reenactments. He understands that some men sprout but a modest facial garden of wispy grasses while he boasts a thriving forest of lush grandeur. But even in the fervor of his growth, the bearded man should not leave his pride unkempt. On the contrary, he must cultivate a shape that suits his personality while paying homage to his bearded heroes. He is not averse to shampoo to keep his facial flock in order, and he knows that having his beard trimmed professionally is a fine pleasure. Above all, he aspires to a beard that conveys the easy sense of formality, which he rightly views a cultural victory against long odds.

The beard may present the appearance of certitude, but it also represents wisdom and the long view. The bearded man is fearless, but he never forgets that he is more than his beard—it frames his face but never defines the man. He knows it is there not to hide his flaws but to reveal his character. That's why he's never afraid to go under the blade. He's reassured by the fact that, like the tide, the beard always returns.

DO YOU HAVE A BEARD? TATTOO? PIERCING?

"I had pierced ears. I had a pierced tongue. Junior year in college, I remember my mom disinviting me from Thanksgiving. There was a delightfully shady tattoo parlor where I got my first tattoo in Virginia, and I trusted this guy with a curb 'stache and really thick glasses to not only pierce my tongue but also permanently ink my skin." –Aaron Levine

Taylor Tehan

> **"I had both my ears pierced, when I entered high school. I think my mom pierced one, actually, and I pierced one at a party when I was drunk."**
> —Michael Williams

GUY TREBAY For two weeks in high school I had a pierced ear. Of all of the things I put my parents through, that was the one thing that made my mother cry. She could live with, like, the long hippie hair. She could live with the platinum crew cut. But the pierced ear was too much. So I took it out.

MARK McNAIRY I always wanted a tattoo but I hate needles, so I was afraid. I think I'm over it now, but until very recently, when I was about to get a shot or have my blood taken, I would literally pass out. I was in Vegas at a trade show and said, "Fuck it, I'm going to do it." It was a daisy, my first one. I was in my forties.

NICK SCHONBERGER I got my first tattoo a week before I graduated from high school. It was a crap-looking lion that I just covered. It was on my shoulder, done in the south end of Hartford. My father knew the guy who owned the shop, and he took me and he took a friend. The guy said, "How much money do you have?" I said, "Forty dollars." He said, "The tattoo's forty dollars."

DUNCAN HANNAH I grew a mustache about fifteen years ago. It came in a little grayer than I expected. It turns out it was brushy instead of fine. I love William Powell's mustache and David Niven's and Clark Gable's—I love those pencil mustaches. But I don't have the right kind of mustache hair for that. Otherwise, I'd have one. It's the Scottish in me.

G. BRUCE BOYER I went right to the beard. I think it was around the time of my first marriage. I would have been about twenty-five. I've had it ever since.

RANDY GOLDBERG I had the worst facial hair. I had a goatee and an earring at the same time. There was one semester, sophomore year of college, and I had an earring in the top part of my ear, and I thought it was awesome, obviously—and it was not. And it was the same time I also got stitches from a food fight, so there was a moment where I had stitches in my face, an earring in my ear, and a goatee, and it was a very bad version of my physical self.

WALTER KIRN I was forty, living on Venice Beach. I was divorced. I was working on a book. Every day I'd pass tattoo parlor after tattoo parlor on the boardwalk. I had wanted a tattoo my whole life, but OCD had prevented me from getting one

because I couldn't decide what it should be. So one day, on a whim, I walked into a tattoo parlor and told the tattoo artist that I would tattoo any tarot card she drew at random from the deck, on my arm. I had given up trying to choose. So we went next door to some head shop and bought a tarot deck and pulled a tarot card. I said, "I don't care if it's the devil, or hangman, whatever." It was the wheel of fortune, so she tattooed that on my arm. I looked at it and said it wasn't quite big enough, it's not taking up enough space, I'll pull another one— and that was the knight of swords. So that's tattooed above that. And so I committed myself to randomness and magic in my tattooing.

TOM SCHILLER I used to draw on a mustache sometimes. The strange thing is that as I grow older my mustache comes in the strongest and darkest, a sort of hairline mustache. It's like a gangster or a sleazy person from 1940.

ENOC PEREZ I had a mustache when I was fifteen. It was in Puerto Rico, and I had bushy eyebrows, and people would say, "Oh you have three mustaches." So I shaved.

NICK SCHONBERGER Ten years ago I went to the Whaling Museum in New Bedford—the first trip after graduate school. I hadn't shaved for two days, and I went to a board meeting and a woman said, "Are you growing a beard?" I said sure. I haven't shaved fully since.

My father had a beard my whole life, until five years ago. It was strange. Everyone has those moments where you've accidentally trimmed it too short, but this was a full shave. He said that his wife was instrumental in it. But I don't know the circumstances.

ANDY SPADE I tried to grow a beard one summer in France. I grew it out halfway, and my daughter said, "Daddy, shave it off." It was so spotty. I'd love to, though.

NICK SULLIVAN I had an earring. It looked a bit like a napkin ring, but a tiny one, and it clipped on. I wore it about a week. I didn't really like it but I thought it was a thing that was cool, and then it got ripped off in a fight that I wasn't really involved in.

JAY McINERNEY I grew a beard for two years when I was living in Japan. All the expatriates in Japan had beards. I was blending in, although all the Japanese didn't understand it.

JOSH PESKOWITZ Everyone in my family has a beard: My brother has a beard, I have a beard, my father's father had a beard, my mother's father had a big bushy mustache, my uncle has a big bushy mustache, and my father has a beard.

GLENN O'BRIEN This is the first time I've been without a beard in four or five years. When I started to lose weight I thought, I think I'd look good without a beard now. I

was thinking of a beard as makeup for men, like, covering my flaws. But I noticed that when I shaved I got a lot of compliments. So I thought, Maybe I'll quit this for a while.

RANDY GOLDBERG I had my ear pierced twice and neither one lasted very long, thankfully. The first time I was in France on an exchange program in high school, and I was with a group of guys, and we saw

earrings, fluorescent triangles with stripes. I pierced them myself. Three in this ear and one in the other. When I started to work I took them out.

MICHAEL HAINEY When I was about fourteen my brother, who was sixteen at the time, announced to my mother at dinner that he wanted to buy a motorcycle. She slammed her hand on the table and said, "There are two things you are

> **"I had some superstition early on that a man should not put a hole in his body. Maybe it says that in the Old Testament somewhere."**
> —Walter Kirn

Helena Christensen. We recognized her from the "Wicked Game" video, and we followed her for a while, and then my friend went up and said, "Can we take our picture with you?" I took the picture so I wasn't in the photo, but it was exciting. We said let's do something crazy to celebrate, and we all went and got our ears pierced. It didn't last long—it got infected.

FRANK MUYTJENS When I moved to New York in 1996, I had my ears pierced. I had friends who made

never allowed to come home with: a motorcycle and a beard." My brother never got the motorcycle. And I don't know if she put a hex on me, but to this day I am unable to grow a beard.

MICHAEL WILLIAMS In my whole life I've never seen my father without a beard. I never had a beard until I was thirty-five. I never thought it would really look that good, and never had the opportunity to do it without looking ridiculous. That period of ridiculousness of growing

> **"I don't have any tattoos. I could never think of anything that I wouldn't get sick of. I finally thought of something I thought would be a good tattoo, which would be my anniversary because I always forget."** —Glenn O'Brien

> ## "The beard just happened in the last ten years. Now I can't remember the last time I shaved."
> —Frank Muytjens

it always prevented me from doing it. Then I had a really bad accident, I was bedridden for a few months, and at that point I thought, I have no interest in shaving and I won't be seeing anyone, so this is the perfect time to do it. I liked it a lot. And other people liked it and my wife was all for it—and then about a year later I shaved it off for my wedding, because I generally didn't wear a beard and thought that it would make sense for me to be clean shaven. I didn't want to look back and be, like, "Oh, that was the year I was wearing a beard." But I started to regrow it the next day.

ROBERT BECKER On my way home from clubs I used to stop at the Binibon on Fifth Street and Second Avenue for a slice of chocolate cake and a glass of milk. It was open twenty-four hours and was the restaurant where Jack Abbott, the author of *In the Belly of the Beast*, killed a waiter. One night I sat down next to a girl my age with a beautiful eagle spread over her entire forearm. I'd never seen anything like it. It was bold for 1980 and was shiny and fresh with a layer of Vaseline. She gave me the artist's number and I made an appointment for a week later. His name was Bob Roberts, and he worked in a parlor somewhere around Fourteenth street. He's now considered one of the masters of American tattooists.

ENOC PEREZ That was a house rule: no tattoos and piercing. And it's funny because I've been wanting to get inked lately, but I don't know what I would write on myself, which is weird. I love tattoos on women. Or if you're playing an instrument, it's nice to have a tattoo.

TAAVO SOMER I've never owned an actual razor.

BRUCE PASK I remember when I first grew my beard. I was driving along the coast of Maine for a week with my dear friend Mary during the off-season, right after Halloween. We ended up in Bar Harbor for a couple of days, which can feel pretty remote during the fall and winter. I had this old sweater with a hole near the wrist that I would wear with my thumb poked through and Mary, laughing, said it was no wonder why people were staring at us, the strangers in town. I had stopped shaving for the trip and decided to continue to grow the beard to better fit in up there. When I came back to NYC, the beard was seen as a bit surprising on me, they were certainly not as common as they are today. I decided to keep it, and it had the added bonus of (sometimes) making it easier for people to tell me and my brother apart.

Local Hero: Summer Beer

Nobody sets out to be what Kingsley Amis refers to as a "beer bore." When you're a teenager you don't drone on about Belgian lambics, how you only drink Kölsch in Cologne, and mercifully you never utter the phrase "hand-crafted." No, when you're eighteen you drink what's familiar, cheap, and geographically appropriate. And that's as it should be.

For me, summers in Wisconsin meant Leinenkugel's, which came, like Annie Hall, from nearby Chippewa Falls. The bottle declared that it's "brewed by 73 people who care," which is reassuring. It's been around since 1867 and has been run by many generations of Jacob Leinenkugel's descendants, which is good. Then it was bought by an international conglomerate in 1988, which is not as good, but perhaps not surprising.

Even for those of us who are devoted to wine, it remains a very fine beer. Well, perhaps not very fine, but certainly good enough. That's one of the funny things about the beer you grow up with: Your associations are so strong that they can overwhelm your judgment about the taste. This comes into sharp relief when you try your friend's favorite beer from Washington or Maine and hint that it's subpar (perhaps over the years you have acquired a few habits of the beer bore). Your friend looks at you icily, as if you've insulted his mother's cooking.

Yes, it's all highly subjective. Leinenkugel's has gone through some changes. They've introduced seasonal flavors for some reason, each one more cloying and unnecessary than the next—you drink this beer for continuity, not novelty, for heaven's sake! It's like when Sting sets a really good Police song to a pretentious jazz vibe. Please stick to the original.

This is a beer you drink on the shore of a lake and that costs less than fifteen dollars for a case, sadly no longer in their returnable cardboard case—I knew there was a reason I kept a few and forfeited my fifty-cent deposit! There's also been some back-and-forth about the woman on the bottle. For a while she had the look of a fierce Native American woman, which I always found rousing as a kid, though in terms of corporate identity that's probably frowned upon these days. Perhaps not coincidentally her ethnicity has changed, and now she's of no specific culture, just a tanned girl with a feather in her hair, possibly an environmental studies major from a good family. Who can explain these things?

On the wall of the Sapporo brewery in Hokkaido, where I once inexplicably took the guided tour (in Japanese), you'll find this saying written (in English): "As long as man has been civilized, he has been brewing beer." Now, that's downright inspiring. The equation for beer endures because it can't be improved upon. Most men want consistency in their beer, their Scotch, and, for that matter, their clothes. Over the long run they don't want novelty flavors or strange new bottles developed for no reason. It's like baseball: It's a great game, so just play it without endless music and absurd contests on the video screen. In fact, the only thing you need at a baseball game besides the baseball is beer. That's nature, my friends, and it's as elemental as it gets.

Passing Lanes: Behind the Wheel

A family's eccentricities are often invisible from the inside—how you grow up often seems perfectly normal. Which is a way of saying that my family's first two cars were Peugeots. That is the automotive improbability of being the child of a Mormon-Quaker marriage. The odds of owning a Peugeot are rare, like being hit by lightning. But the way people who've been hit by lightning supposedly have a better chance of being hit by lightning a second time, the odds go up and make it more likely you'll own a second Peugeot.

My sister and I knew none of that as we sat in what we later realized was a highly unusual French car in Minneapolis. After 1987 we said au revoir to all that and settled in to two decades of a Swedish love affair with Saabs that was sometimes bent but never broken. This is also true in Boston and other quarters of New England, and perhaps Oregon, but they're not that common. I saw a woman driving an old Saab once in Austin, Texas, and nearly fell in love on sight.

When you enter your driving age in a Saab family, you don't think there's anything odd about it. You're used to the ignition on the lower console and the fact that the Swedes have a stoic, possibly moral, aversion to all matters of what they consider design frivolity, like cup holders.

We had a silver Saab that was an automatic and didn't have a tape player, then one whose color might be called Dark Mist, was a manual transmission, and did. There were more Saabs. A dark blue one that I learned to drive on (and that didn't have too much drama) and a stick shift where I learned the ways of the clutch (that did).

In a lot near our house I sat in the car next to my father. I had never seen him in the passenger seat; he seemed enormous. He has his standards and certain expectations for himself and others. I lowered my foot on the gas, I thought with the requisite restraint. I didn't stall on my first effort, which was the best that could be said. Quite the opposite, in fact, and we peeled out. "You might want to give it a little less gas," he said, possibly the most understated exchange we've had in our lives.

I did all right that afternoon and managed to drive up the hill to our house. The next day, Sunday, I went out again in our neighborhood, on my own. There was light snow, there was stalling, there were flashes of anger. There was me pulling the car in front of the house, up onto the curb, striding up to the house, tears of rage in my eyes, proclaiming I'd never drive that car or any stick shift again. The snow stopped falling, and when the roads were plowed I was sent out again. There was no debate: I would know how to drive that car.

You know how this story ends: I've driven nothing but manual transmissions since, and would never drive anything else.

WHAT WAS YOUR FIRST CAR?

"A 1986 Camaro IROC-Z, brand-new, silver spooned, and proud. I wrecked it three times and had my license taken away for a year for speeding." –Brian Awitan

ALEX BILMES My first car was my grandfather's car: a 1985 green Volvo 264 GLE. The least sexy car that an eighteen-year-old boy could have, but I loved it. I think it's the same car that Michael Douglas has in *Fatal Attraction*. I had a girlfriend called Julie, and she called the car Mildred because she thought it was the least sexy car that ever lived. I was the only one that had a car, and we'd have eight people packed into that thing on a Saturday night. I loved the car. It died in the end.

BYRON KIM My first car was a 1969 Chrysler Newport. I loved that thing. I got it for $600 from a family friend up in Monterey. It was huge—it must have been the longest two door car ever made. I think it was longer than a Fleetwood. We used to joke that you could hide two people under the hood in front of the radiator. It was a boat. Unfortunately I can't remember exactly when—though I do remember who—but my first kiss must have been in that car, parked up near the cross on Mt. Soledad.

MATT HRANEK A 1971 BMW Bavaria 2800 auto, with a burgundy-tan interior, Blaupunkt cassette player, and an eight-track under the seat with *Goats Head Soup* from the Rolling Stones stuck in it. Blew the engine up once—stuck gas pedal—then rebuilt it. That car was handed down to my brother, who literally drove it into the ground. I will always miss that car.

EUAN RELLIE Rollo Fuller and I bought a Triumph Herald, probably a 1969, for 250 pounds. We each

Tom Schiller and his Citroën

paid 125 pounds for it, in 1986. It was a dull green. We wanted a British racing green but couldn't afford it. It was eventually deemed no longer roadworthy and scrapped.

DAN ROOKWOOD I have never owned a car, but for six years I rode a white 1961 Vespa 50cc around London. It had the engine of an electric toothbrush, but it was perfect. It was stolen by some local hoodlums, who couldn't work out how to ride it so they just trashed it. That broke my heart. It would be worth a small fortune now.

J. C. MacKENZIE My first car was a 1965 orange Mustang, with shiny mag wheels and a large-

car capable of accelerating from 0 to 60 mph in a good half hour. It barely moved.

DUNCAN HANNAH It was a Chevrolet Celebrity, and I bought it for one thousand dollars. It was burgundy and it was horrible. It was so not me. I also had some kind of Mazda station wagon that looked good. It cost fifteen hundred dollars, but it would just kind of die on the freeway with quite frequent regularity.

STEPHEN COATES I had a Ford Escort. It was purely functional. I've got an old camper van parked in London. It's dearly loved, but it hasn't moved for a worryingly long time.

> **"A used Jeep Grand Cherokee that was a shade of blue that I've honestly never seen on the road other than that car. My friends called it the Periwinkle Paradise."** –Eric Dayton

displacement engine so loud it caused auditory dyslexia and the near daily attention of the local police department. I was a sixteen-year-old runaway at the time, living in a halfway house in a place called Regina, Saskatchewan.

After a brief stint in the local jail, I spent the summer working at a steel mill, coating massive pipes with coal tar for the Alaska pipeline. One shift was the equivalent of smoking 750 cigarettes a day. I saved money from the mill and at the end of the summer bought a

RANDY GOLDBERG My first car was a "1964 and a half" Ford Mustang, black, hardtop, red leather interior, V-8, 289, automatic (strangely), AM/FM radio. Amazing in the straightaway, terrible on turns, can't drive it in the rain or the snow. It's the first Mustang ever. The year they launched it, they launched in between late for '64 and too early for '65. So they called it the 1964 and a half.

The morning of my sixteenth birthday, my mom woke me up early, earlier than I'd usually get for

school, and made me come outside, and there was a closed carrier truck, and they opened up the back—and this car was on a shelf in the truck. It was a real spectacle. It was amazing.

WHIT STILLMAN I worked in Bloomington, Indiana, for one year. To start there I needed a car, so I bought a very old Volkswagen Bug for about a thousand dollars. Yellow. I found it there. Then the oil crisis struck and I'd driven it to

G. BRUCE BOYER A brand-new 1957 Ford Fairlane. I wouldn't have anything like that now.

GUY TREBAY I had a great MGB convertible, fire-engine red with a black interior and roof. It was a good car but had a slight tendency to catch fire. I finally got rid of it. No matter how cool the vehicle is, it's no fun standing on the roadside alongside a car that's in flames.

> "My first car was a Chevy Impala, four-door. That strange avocado green—it was like all those cars: all power. It had major stereo speakers. You basically carried around a living room stereo in your car. That car was designed to be a make-out pit. And there was a rumor in school that, like Jovan Musk, if you got a girl in a car and you were able to play 'Whole Lotta Love' by Led Zeppelin, she would be helpless before your advances." —Walter Kirn

New York and sold it to someone at a significant profit. Because suddenly economical cars became very valuable.

AARON LEVINE We were a Mazda house. My first car was a 1984 Mazda 626, all blue. Sunroof. Manual transmission, four-cylinder. The stereo system was actually defunct, but for my graduation my parents kicked in for an Alpine receiver in the '84 Mazda! The six buttons!

TOM SCHILLER This was the coolest car in the whole world. It was a Citroën 11 CV, which is a long, black gangster car—a limousine. I was always the first one to drive to school, and I'd go in the back and play my guitar, thinking I was so cool. It didn't look like one of those pneumatic Citroëns, which look like ducks.

ENOC PEREZ I always rode in the family car. The first car was a Ford Fairmont. It was a piece of shit, but I never had to walk. Then there was

.fdsjafjd

a series of American cars. My dad thought European cars were too expensive and it had to be American.

MARK McNAIRY I bought the Love Machine from my girlfriend's father. It was a 1969 Chevy II. I bought it for two hundred dollars. I named it that because it was such an unsexy car. It was a faded gold with a brown vinyl seat. It was the cheapest Chevy you could buy.

NICK SCHONBERGER An Oldsmobile Bravada.

NICK WOOSTER A 1965 navy blue Volkswagen Bug. I got it on Christmas of 1976. I had it through my freshman year of college, for two years. When I was in college I got a red Rabbit with sheepskin seat covers.

ANDY SPADE My first car was a Volkswagen Fastback, 1968. Beige. I got it for nine hundred dollars, and I drove that thing all over Arizona. My first BMW 2002 broke down all the time. I got the cheapest one I could afford, because I loved the car. I met Katie because I started getting the late shift—we worked at the same store together—and my car had broken down. She would see my car in the parking lot, and she loved this burgundy 1969 2002. She said, "Whose is that?" She saw it was me, and I said, "Hey, I broke down." She said, "I'll take you home." We started our relationship that way.

NICK SULLIVAN It was a Toyota Corolla. It had watercress growing out of the windows when I bought it—it had been in a barn for ages. I drove it into the ground. I didn't drive until I was twenty-eight. I didn't get around to it.

JAY McINERNEY I was given a Volkswagen Beetle. It was a present from my parents. I drove that around Pittsfield, Massachusetts, and then I drove it cross-country with my roommate Gary Fiskachun, who went to Williams with me. We slept in it some nights. Cream, 1966 Volkswagen Beetle.

JAY FIELDEN It was a car that had been handed down to me from my uncle Larry. He had a Buick Regal that was gray with a T-top and velour seats. Totally decked out for that time. The thing had been driven pretty hard by the time I got it, and the paint job had completely oxidized. I called it "the Gray Ghost."

JOSH PESKOWITZ I had a 1996 Ford Taurus sedan with no hubcaps that everyone called "the Jump Out," because when I came around a corner, people thought the cops were going to be jumping out of the car. If I pulled into a neighborhood, kids would just scatter. But I never got pulled over.

GLENN O'BRIEN I would drive the family car, an Impala convertible. But my grandfather would loan me his Cadillac. My first car was a Pon-

tiac Firebird, 1967. Red convertible, 400. I got rid of the car and became a motorcyclist. I had two Triumph motorcycles.

FRANK MUYTJENS A Peugeot.

MICHAEL HAINEY In high school my brother and I shared a Chevy Chevette. It was a 1977, red, four-door Chevy Chevette. It was an awesome car. I had a lot of fun in that car. Then the first car I took possession of solo was my grandfather's. After college I bought it from him: a 1972 Chevy Malibu, a muscle car. It was brown with a black bench seat.

MICHAEL WILLIAMS My first car was a 1985 Buick Century. My dad bought it for me, and I think it was twenty-five hundred bucks. He was smart enough to know I was going to fuck it up in short order—which happened, I think, the first night I drove it out by myself, with my friend, and I hit a curb and got a flat tire.

ROBERT BECKER My first car was a 1968 Ford Mustang with a 302 V-8 and a three-speed manual transmission. The undercarriage was so rotted you could see the street through the floor. I owned it the summer of 1977, on the shore in Rhode Island, and sold it for a bag of grass before I moved to New York that autumn.

HIROFUMI KURINO I don't have a driver's license.

CHRIS BLACK A white, four-door Acura Legend. I covered the back with stickers.

MARK McNAIRY I bought another Maserati. At that point I had two. I had to put a lot of work into it. It broke down in the middle of the Lincoln Tunnel one winter. It was awful—they cleared out the whole tunnel; it took an hour. Then they pushed me out, so I was in the tunnel all by myself—which was kind of cool.

SID MASHBURN 1955 Buick Special with three on the tree.

RUSSELL KELLY A very pale yellow Buick Regal, 1973, that my aunt gave my brother and me, so we had to share it. It had this, like, faux suede material; it was horrible.

TAAVO SOMER A Porsche 912E, which is basically a 911 with the 4 cylinder. It's actually because

Donald Judd's Land Rover

"My first car was a Mercury Sable station wagon, 1987. The bumper was held on by masking tape, it had gray leather seats, you could fit fourteen dudes in there—which we found out pretty early on." —Josh Peskowitz

my stepfather died of alcoholism when I was in eighth grade, and that car was one of the only things that was left to my mom and I lived with her. So there was this car that wasn't worth much so she just kept it. At first it was silver but the silver was falling apart, so we, at Maaco, painted in black. Not the worst, just a very inexpensive paint job. It was a stick shift; I loved that car. It was a fun car to drive. Tan leather interior with this tan carpet. I remember the smell of the interior.

TUNDE OYEWOLE A big brown BMW 735i sedan/U-boat that I used to drive up and down the East Coast and through the mean streets of Providence, Rhode Island's diamond district.

JEREMY HACKETT My first car was a Triumph Herald that my parents gave me when I passed my driving test at age seventeen. A few days later I smashed it up.

ROB ZANGARDI It was a silver Volvo that used to be my dad's. It had a fuzz buster and a built-in car phone that was for emergencies only— under no circumstances were we allowed to use it otherwise. When my brother and I turned eighteen, they bought him the same exact car.

We had twin cars. At one point, my family had four Volvos.

TIM SCHIFTER My first car was a used BMW 320i in metallic powder blue, which my father gave me in my sophomore year at college. I went to the Claremont Colleges in southern California so a car was a must. We'd pack it full and drive into LA to see Elvis Costello concerts, to the punk club Madame Wong's (a Chinese restaurant by day), and to Redondo Beach.

WESLEY STACE A green Jeep Cherokee in San Francisco. That's also where I passed my driving test at a relatively advanced age. I got 100 out of 100 and the examiner told me my driving was perfect. There's a punchline: On my very first ever solo trip, to the FedEx office to pick up tickets for the World Cup Final (down in Pasadena at the Rose Bowl) that weekend, I hit the gas in a moment of panic, when I should have hit the brakes, and gently smashed into the car in front of me on Duboce Street. Its driver must have been guilty of something, because he said that everything was totally fine if he could just open the trunk of his car, which he hardly could. He then just drove off. It was totally my fault. I then went to get the tickets.

GROTON SCHOOL
GROTON, MASS.

November 15th,06.

My dear Sir,

I beg to inform you that your
son is on the Black List of the School for
the second week on account of misbehaviour.

I am,

Yours very truly,

[signature]

Standing Room Only: Teenage Fanclub

In November of 1989, I had been in high school for two months. Then something big happened and it had nothing to do with the football team, which was one of the worst in the state, part of my pattern of attending schools that are awful at football. No, it was the Rolling Stones. The Rolling Stones, who rose to fame more than a decade before any of us were born, were coming to the Metrodome.

At that time, the Metrodome was perhaps the highest-profile bad building of its era. It was less a building than a structure, the way a parking lot is a structure, or a landfill. But it had hosted the Minnesota Twins' 1987 World Series Game 7 victory over the St. Louis Cardinals—which my dad and I attended in the last row of the upper deck. He hugged me when Dan Gladden scored Tim Laudner in the bottom of the eighth and it was clear victory was near, rightly knowing what it was going to mean to me, a twelve-year-old devotee. The 1991 Game 7, 1–0, Jack Morris, tenth-inning win over the Atlanta Braves, which we were also at, this time slightly closer, was just as satisfying and has overwhelmed any sporting emotion I've felt (other than rage and injustice) since then.

But the Stones were coming. Most of us had never smoked marijuana. I'm not sure I knew what it was.

I remember Mick Jagger in the distance, in a T-shirt and tight black pants, doing the things we all associate with Mick Jagger. I liked it. My familiarity was based on their greatest-hits double cassette, which I listened to on an AIWA Walkman (with its graphic equalizer that I carefully adjusted) on the bus to school. Living Colour was the opening act.

The next day, those of us who attended the show proudly wore our concert T-shirts to school, with the pride of an Olympian wearing a gold medal. I had never been to a concert before, never spent a steep twenty dollars (twenty dollars!) for a t-shirt, and never stepped into high school announcing myself as part of a tribe. There were fellow travelers wandering the halls like celebrities, we select few who had managed the crowds, had stayed up late, had been driven home by our friends' parents. But we had seen the Rolling Stones. There was even more urgency because they were playing at the Dome again the next night, and we had to plant our flag, as it were, like Neil Armstrong, into the moon.

The attendees of the second show would have their revenge. It was my first exposure to revisionist history. It began with Ron, a friend who'd been to the second show, casually saying, "Everybody agrees that the second concert was better." This infuriated me, though I now realize that I use similar rhetorical devices when I'm defending some pronouncement I make about prestige TV show. Arguments between people about the merits of shows they hadn't seen prepared me for my time in the art world.

Ron could not tarnish my experience. And I began a career of seeing many concerts, thankfully none at the Metrodome. Young people have a sense of ownership toward music. That's why you buy shirts from the first concerts you go to. It was a good run, with the exception of the Billy Joel *Storm Front* tour, which I went to on consecutive nights (why, Lord, why?). I saw many shows at First Avenue, the great club in downtown Minneapolis: Dinosaur Jr., My Bloody Valentine, Sugar, Nirvana. Some have vanished except for the occasional song in an ad: Material Issue, the La's (five dollars, with half the crowd leaving after "There She Goes"). Others I'm still devoted to: the Cure, Morrissey, Depeche Mode. A separate category for a Van Halen phase so blinding, so oblivious, that I tolerated Sammy Hagar and bought guitar magazines when Eddie was on their covers.

I saw the Pixies sing "Where Is My Mind" and thought I would tour with them. My dad said, "Who are the Pixies? Don't you have an orthodonist appointment tomorrow?" And that was that. Made it into a private Judybats show by winning tickets by being the first caller into the contest line, which I made on my mother's *car phone*. The DJ's name was Tony and he laughed as he said on the air, "David called in on his mom's cell phone and HE'S PSYCHED." Tony, truer words were never spoken on the air of KJ104, the self-described "hippest station in the nation."

I've written about music over the years, going to South by Southwest. It's much maligned, but I loved seeing bands starting out playing small shows, some that went on to greater things (Sharon Van Etten, Beach House, Warpaint), and others that I liked even if the public never caught on. At that point in their careers they drove themselves in minivans, carried their own equipment, and would drink at the bar after the show.

I've interviewed people that were minor heroes to me. In hotel rooms while they were sick (Aimee Mann), backstage though they stopped drinking (David Lowery), in their trailer because they thought I was working for a nonprofit organization (sorry, Stephen Malkmus!). Your taste evolves—of course it does—but the attraction doesn't. How could it? It's a connection that remains primal, long after you've been thrown out of the mosh pit.

FIRST CONCERTS

> **"The first concert that I remember expressly asking for tickets was Puff Daddy's *No Way Out* Extravaganza, which my father also attended with a number of teens."** –Nick Schonberger

JAY FIELDEN My first concert was in bad taste, but it coincides with the costume thing: Kiss. My father took me and a friend who at Halloween had dressed up as Gene Simmons to my Ace Frehley. My mother was without doubt that Kiss was a demonic cult. I had to really beg to get my dad to take us. He was a den-

tist. He loved the big-band ballads, jazz, the great romantic singers of the past. Being a father now, I realize how much it must have killed him to let his son attend such a circus, much less serve as an escort. He was probably wearing gray wool pants and a short-sleeve button-down, a uniform for him. I recall that we had

mezzanine seats, not far from the stage. We got there early enough to really get a good look at what Kiss's other fans looked like, and they didn't look like us. My dad looked very out of place, especially when he put cotton in his ears when the lights went down and a blue cloud quickly formed above our heads. Whatever it was, it didn't smell like cigarette smoke.

MICHAEL WILLIAMS I remember seeing Bone Thugs-N-Harmony in Cleveland in the mid-nineties, which was pretty amazing.

BYRON KIM My first concert was James Taylor at the San Diego Sports Arena. I was a co-captain of the track team and was invited by my co-captain. We were so far back that I can't remember much except being passed joints by strangers and just the general haze of marijuana.

RANDY GOLDBERG The first one I was taken to was Kool and the Gang in Las Vegas, by my parents, and Arsenio Hall was the opening act as a stand-up comedian before he had his show. I saw a lot of shows with my parents in Atlantic City and Las Vegas. Cher, Barry Manilow, Air Supply in the Catskills.

WALTER KIRN I was dragged to a lot of bad shit in big stadiums: Kansas and Kiss. But the first time I decided to go on my own was Elvis Costello in 1979 in downtown St. Paul, in what must have been his first American tour. There had been a Danish exchange student in our rural public school who turned me on to Elvis Costello at a time when everyone in my school was listening to Judas Priest, Nazareth. Not only was it the first one I ever went to on my own, but it was the best concert I ever went to. The emanations of the new coming off that guy were so intense for a Midwestern kid raised on your prog-rock stadium shit. I felt like I could feel history being made.

WHIT STILLMAN The Four Tops. A Wellesley girl who hung out at our suite in Matthews North, she knew that I liked soul music, and the Four Tops were going to be at the Sugar Shack, so she arranged it all. It's probably the only concert I've ever been to in my life. No, in Paris I went to a lot of Chet Atkins concerts.

AARON LEVINE It's a little foggy. I think it was Guns N' Roses, Metallica, Faith No More–just had surgery on my ankle; my friend and I took the subway to DC. "Mr. Brownstone"–I mean, come on!

ALEXANDER GILKES Michael Jackson. *Bad.*

GUY TREBAY I had a band when I was in high school; I have no musical talent at all. My best friend then was a very talented guitarist, and his father was, I think, head of A&R for CBS Records, which had all the bands before anyone else knew who they were. My friend and I, still in our early teens, were taken

to see Jimi Hendrix, whom no one had heard of. He said, "Oh, you have to see this amazing guy. I just signed him."

TOM SCHILLER Dimitri Tiomkin conducting classical music for young people, at El Rodeo Junior High School in Beverly Hills. Begrudgingly I went to the Monterey Pop Festival. I had a Volkswagen Variant, which was a long Volkswagen where you could sleep in the back. On this empty fairgrounds that I drove on, I was helping my friends, the Whitney brothers, project an abstract film with three screens for the festival. I asked the guy, "Do you mind if I sleep over in my car on the grounds?" He said, "No, go ahead." So I slept over and when I woke up, there were like ten thousand hippies walking around smoking dope, wearing beads, lighting incense . . . and then Jimi Hendrix was on stage and lit his guitar on fire. I didn't go for the hippie garb.

ENOC PEREZ It was Siouxsie and the Banshees. I remember it very well; it was amazing.

I was into New Wave at the time, even though my buddies in Puerto Rico would say it was gay music—I would blast it in my room. They would come shouting from out the window, "Aha! The gay music!"

MARK McNAIRY The Greensboro Coliseum is about the same size as Madison Square Garden, and it was my job to go out to the court and start all the concession stands and turn on the popcorn machines and get all the pizza crusts and turn on the pizza ovens and stock the Snickers bars. I liked Snickers bars a lot, so imagine being in Madison Square Garden all by yourself in the afternoon with cases of Snickers bars. I would always treat myself, and I'd throw the wrappers behind the ice machine. I didn't put them in the garbage; somebody would find them. But then the guy came to fix it and slid out the ice machine, and there were like a hundred Snickers wrappers back there. And I blamed it on my coworker and he got fired. I got to see all the concerts for free, because my job would finish when events started, so I saw everybody: Ted Nugent; Willie Nelson; Earth, Wind & Fire.

RICHARD CHRISTIANSEN Dolly Parton was the first concert I went to. I must have been about five or six. I remember it vividly because my brother and I were very dressed up: We had long white socks on and black shoes. Then we heard Dolly descending out of the back of this dark entertainment complex, with the spotlight, with a sea of normal people and farmers. This sparkling, magical, effervescent unicorn walks through who's all sequined and glittery. I was suddenly in some kind of epic crazy, unimaginably magical visual place. I knew it was like eighties *Dynasty* and just like America, a confident, maximalist wonderland that had to be explored.

NICK WOOSTER Earth, Wind & Fire. In Kansas City.

ANDY SPADE It was Deep Purple and Nazareth. ASU's outdoor stadium. The first time I smoked pot.

NICK SULLIVAN A band called Haircut One Hundred. It was a jazz-funk band I didn't really go to, because I only caught the first song and then I had to go home, which was really embarrassing. Fortunately, it was their big hit so it was OK.

JAY McINERNEY I think it was the Who performing *Tommy* at Taylorwood. Maybe '74.

EUAN RELLIE The Police and Rod Stewart, at a very young age, both of which were fucking cool. Both at Wembley.

JOSH PESKOWITZ I saw the Roots at the 9:30 Club, in 1993.

GLENN O'BRIEN I was really into jazz at a young age. I remember making my parents drive me to Cleveland Coliseum to go to the Cleveland Jazz Festival, where I saw Cannonball Adderley, Nina Simone, Jimmy Smith. I was twelve and was one of the only white people there. It was great. When I was a senior in high school, we used to sneak into Leo's Casino to see Ray Charles. We used to go to the Howard Theater to see James Brown. There was a lot of great music. There was a great jazz club called Salvadore's; it seemed like Roland Kirk lived there.

FRANK MUYTJENS I went to see Yes in Rotterdam. My mom let me go; I took the train. But it turned out that the band got stuck at the German border, they wouldn't let them in, so the concert was delayed. I had to catch the last train back, and I think I only saw five minutes of them, and then I missed the train and had to stay in a hotel.

MICHAEL HAINEY Bruce Springsteen at the Rosemont Horizon. I didn't go to many concerts as a kid, so this was 1979; *The River* had just come out. I saved up some money and got tickets, I was a total Springsteen nut, and this show was just transcendent. I still think about it.

ROBERT BECKER Sly and the Family Stone was my first concert. We were thirteen, and I'm surprised that my girlfriend's parents let us go on our own.

BRIAN AWITAN Kiss, *Animalize* tour, Houston, Texas. I feel like it was around 1984.

ALEX BILMES Prince, *Sign o' the Times* tour. I was around fourteen and I loved Prince. But this makes me sound cooler than I am.

DUNCAN HANNAH The Yardbirds played in a department store in downtown Minneapolis. I didn't go, and I was even downtown at the time with my mother. I saw them leaving a garage in a taxi, hanging out the windows with screaming girls chasing after. It was like a

> ## "When I was fifteen, I went to Greenbelt, which was a Christian music festival in the UK. It was even worse than it sounds." —Dan Rookwood

swinging London vignette in my hometown. Jeff Beck was hanging out the back window, laughing his head off. That is branded in my brain forever, and I still kick myself that I didn't see that show, because they remain one of my favorite bands.

JOHN BRODIE There was a double bill of the Specials and the Go-Go's that was big.

SID MASHBURN Three Dog Night, when I was eight.

RUSSELL KELLY Pearl Jam. The *Alive* tour. Little Rock, Arkansas. I had to hitch a ride with my girlfriend's brother. She and I sat in the back and sipped Jim Beam all the way from Fordyce, Arkansas, population 5,178.

TUNDE OYEWOLE I had the advantage of growing up around the music biz, since my father was an NPR and managed an affiliate in Amherst, Massachusetts, and then another in Washington, D.C. (before changing gears to practice law). So I started going to concerts with my parents early on: King Sunny Adé, Dizzy Gillespie, the great Max Roach. Prince (*Purple Rain* vintage) was the first concert I went to on my own.

Duke Ellington

ERIC DAYTON Michael Jackson, *Bad* world tour, 1989.

JEREMY HACKETT The very first concert I went was to see Cream at the Colston Hall in Bristol, probably in 1967.

BRUCE PASK My mother drove me, my brother, and a friend two-and-a-half-hours to San Diego to see the Eurythmics. It was the *Touch* tour, where Annie Lennox had that vivid short red hair and she wore a black mask on the concert T-shirt which, of course, we bought. She waited with visiting friends at a restaurant nearby to pass the time and then drove us all the way back Yuma, Arizona, in the middle of the night. She is quite something, our mom.

TIM SCHIFTER My first concert was Donovan at Madison Square Garden. He sat on a pillow in the center of an empty stage with his acoustic guitar and played "Mellow Yellow" and "Sunshine Superman" to twenty thousand enraptured teenage fans. After that, the concerts came fast and furious—Jefferson Airplane at Sheep Meadow in Central Park, Santana at Central Park's Bandshell, and my father bought tickets for the two of us to go to Woodstock, but we didn't end up going and I don't recall why.

You remember cash, right? The greenback, graced by our forefathers, possibly marked with Masonic imagery. If you're a carnivore it's how you pay for your porterhouse at Peter Luger; if you're a petty dictator it's what you hoard for the day when you're deservedly deposed. Yes, cash is many things to many people. And yet, more and more, cash is rarely the coin of the realm.

I recently stood behind three people who each paid for their coffee—coffee—with credit cards. Or debit cards, or some card that had to be swiped and signed for. Don't introduce credit into what should be the easiest transaction of your day—order a coffee with no soy milk and hand over a few singles, and tell the pretty girl behind the counter to keep the change, thank you very much.

How did we arrive at this point where people walk around with nothing in their pocket besides an ID paper-clipped to a credit card? Is it taxicabs now accepting plastic? Is it evil financial corporations trying to encourage us into deeper debt? Is it an aversion to ATMs charging ever-higher fees? (You hear horror stories of fifteen-dollar fees at a strip club in Las Vegas—for those of you who exceed your lap dance budget, consider yourself warned.)

Whatever the reason, let's establish one thing: A man should have enough cash for his evening on the town. Perhaps you go to a dive bar where beer costs two dollars. Then you can get by carrying a twenty, though smart money means another twenty if you can't find your way home and

require a cab. If your tastes are more extravagant, then plan accordingly. That's not to say you need to drop five hundred dollars on your bill at 21, but you should be prepared to tip the coat check woman, and the waiter—and the bartender, for that matter, if you begin your evening with a martini at 21's standing bar, which is a very fine idea.

We're not talking about carrying a garish wad of bills here—you're not a gangster or a bookie. But you should be liquid at all times. Oh, and carry it in a wallet. No cash clips, thank you, or anything that revels in how much you can afford or how little you actually need to carry with you. Some of us favor a narrow wallet that fits in the chest pocket of our coat, which is perfect for the essentials, not a Costanza-like brick that will have you at the chiropractor.

A wallet remains symbolic of the man, not as profound as handbags for women but still revealing. How you carry cash says a lot about you—and it pays to be discreet. You probably remember your first wallet, possibly given by a male relative, or better yet, inherited. It's an important step: Even if you have very little to put into it, you feel like you've arrived. Mine was a gift from my father: brown leather, small, from Dayton's, the once great Minneapolis department store that is, alas, no longer. I was young enough that it contained a few bills, a library card, and a photo of my younger sister. It will not surprise you to know that I still own it.

Somewhere along the line, credit became king. But as a culture we've moved beyond being impressed with exotic cards. Hers is gold, his is black, yours is some metal that's so rare that only you and Jack Donaghy have it. We are unmoved by your limit or your minimum or your concierge service that will get you backstage to the Rolling Stones. In fact, I suspect if credit card companies came out with a simple credit card that looked like a credit card—literally the classic Visa, striped with blue, white, and mustard—people would be very happy. Maybe Discover has never changed its card, but I can't be sure since I've never seen a Discover card and don't believe they really exist.

Having money on your person imparts a sense of assurance—even confidence to do what needs doing. Who can forget the scene in The Sting when Paul Newman wins the poker game with four stealth jacks? Doyle Lonnegan realizes his wallet is missing and Newman yells at him, eyes blazing: "Don't hand me any of that crap, when you come to a game like this, you bring your money!" That's right, you're in the big time. From coffee to poker, be ready for the stakes of the day, a man ready to settle accounts.

Scents and Sensibility: The Power of Old Spice

Old Spice, Walter Robinson

Proust wrote that memory informs the senses, but Old Spice confirms it. The distinctive scent became synonymous with a classic mid-century American sensibility. It's like a sharper Bay Rum, which you know very well even if you don't know what Bay Rum is, or if you've never worn Old Spice. It's like knowing what a kiwi tastes like: You can't remember the last time you tried it, but you just know. Depending on your age, it could remind you of your grandfather, your father, or a gym locker room that's decades behind the times.

I knew a man in college who wore Old Spice because he thought it reassured women who were subliminally reminded of their fathers. I'm not sure how far this got him. I remember he was the first person I ever met from Wyoming. But it definitely has a powerful reach; just the shape of the smooth porcelain bottle conjures strong memories. It may be surprising

to learn that it's designed to recall a buoy, invoking the scent's completely fabricated nautical aspirations.

When Old Spice was introduced in 1934, it was meant to be an exotic escape; the boats on the bottle were representations of the *Grand Turk*, the *Friendship*, and other actual ships. It suggested naval leave in far-off lands, sitting in tiki bars with women in straw dresses. These men weren't wearing it to be reassuring, they were wearing it to be daring. It was their Eau Sauvage, their Obsession, their, dare I say it, Drakkar Noir.

Things evolve, of course, and what's an outlier for one generation comes center stage for the next. It's with regret that when Old Spice changed hands, their porcelain bottle became plastic. They now even engage in television advertising! You don't need more of an advertisement than seeing Old Spice on the shelf of the locker room, next to a jar of combs sitting in blue disinfectant. Sadly, that world has vanished where men didn't even know their skin could get dehydrated. Both of my grandfathers were fortunate enough to never use the word "moisturize" in their entire lives. If one of them saw a bottle of mister, he probably would have tried to spray it in his mouth.

Now we have endless choices of scents that come out every season. You see slick ads for them in magazines and stacks of them in a duty-free shop. Think of a cologne as a bottle of Scotch: If it hasn't been in existence for a decade, you probably want to steer clear of it. Otherwise you'll have to explain why you spent six months of your life doused in Cool Water. Yes, a man should find an enduring scent or two and stick with them. Use sensory power to your advantage—you should be the beacon that people associate with. You don't smell like a certain scent, other men who wear it smell like you.

I remember standing next to my father as he shaved and put Old Spice on his face—later Eau Sauvage. He would wince—"It's supposed to hurt a little," he would say. It was probably about 90 percent alcohol. I was given my own silver razor and allowed to shave my smooth eight-year-old face. I approached this process with utmost seriousness—I was careful not to nick my cheek, blissfully unaware that there was no blade within.

Even at that tender age I learned something about how private routines set the stage for public perception. You set out into the world knowing you're presenting the best version of yourself. Just remember that in the same way you shouldn't laugh at your own jokes, you should never be able to smell your own scent.

WHAT WAS YOUR FIRST COLOGNE?

> **"I was so obsessed with Polo in high school I used to iron my money with it. I would spray it with water, iron it and then spray it with cologne."**
> —Mark McNairy

JOSH PESKOWITZ What I liked the most was Versace Blue Jeans, and I did find that Fahrenheit was the one that covered the smell of weed the best.

DUNCAN HANNAH Eau Sauvage is probably my favorite. I've worn that since the seventies. I moved to New York in 1973, and sometimes I'll pass a man somewhere and it

Collage by John Gall

takes me right back to 1973 when I was going to foreign movies by Bloomingdale's, on Third Avenue and Sixtieth Street. Elegant men wore cologne then, and Eau Sauvage is one of those smells. Vetiver by Guerlain is one that I still wear. Some of them I don't know, and sometimes I'll stop a stranger and say, "Excuse me! I love that scent, could you tell me what it is?" And they never remember—or they think you're trying to pick them up. It never works.

can to seem cool or more attractive. I don't know how everyone knew about these colognes—it was like they had a representative in every high school.

WALTER KIRN I was absolutely determined to put Jovan musk all over my body. And any early cologne wearer knows, you become immune to its smell. So I would get called out by girls on dates: "What happened? Did you spill something on yourself?" I think it probably smelled more like Raid than anything else.

> **"When I was thirteen I went for it. If you didn't wear Drakkar, you were nothing." —Aaron Levine**

G. BRUCE BOYER Every fifteen years I try a new cologne. It's the height of wildness for me.

JOHN BRODIE I associate certain club scents with my father: Bay Rum, Lyme's, there's an Edouard Pinaud scent called Clubman, which has a lot of spice to it. I associate that with my father as well as the spray-on aerosol Right Guard. He was not someone who wore cologne.

RANDY GOLDBERG In high school there were two choices, Drakkar Noir or Cool Water, and I had them both. I don't know what it is that gets into adolescent boys' heads about what cologne will do for you. But there was just a desperation where you don't realize you're fighting a losing battle, and you sense it and you grasp onto whatever you

GUY TREBAY My dad created a company that produced a cologne called Hawaiian Surf. In the sixties it was the second or third most popular cologne in the country. It was right up there with Hai Karate, English Leather, Canoe. I was well into adulthood before I could stand the smell of aftershave. But lately I've started buying bottles of this stuff on eBay, where it's very much sought after. And, you know, Hawaiian Surf is an interesting product. The fragrance is still not my favorite, but the bottle, which was wrapped in cork rings, is an artifact of proto-surf culture. It's odd that we grew up steeped in surf culture, although no one could surf. My parents went to Hawaii all the time. We kids were not interested.

MATT HRANEK I would steal a splash of my dad's Aramis or even Hai Karate. But my first chosen scent was Halston Z-14.

MICHAEL HILL My father was always was very keen to impart on me that a gentleman doesn't wear scent. Nonetheless I could smell something that I later came to realize was sandalwood, which came from the soap he used, and, of course, that's now a very evocative scent for me.

TOM SCHILLER When I was younger I experimented. I have to secretly admit that I tried Canoe. It was a really horrible smell; it was a bad seventies thing.

ENOC PEREZ Drakkar Noir. That's the eighties. It had the reputation that you could get laid. It worked. I felt like girls were more attracted to me when I wore Drakkar Noir. You have no idea: I had so many bottles, it took a while to get out of that. Every time I smell coconut butter, it smells like people tanning on the beach in San Juan. I remember that vividly. I cannot wear a coconut smell, I think it attracts bugs—I can't wear it.

NICK SCHONBERGER My grandfather and my father both had a complete disregard for grooming products. My dad only bought stuff from dollar stores, despite having bought very expensive suits and living in rather expensive homes, owning significant pieces of art. He had no interest whatsoever in consistency in grooming products. I think I've inherited that.

G. BRUCE BOYER One Christmas, when I was maybe thirteen years old, I had started to have an interest in clothing, and my mother bought me a bottle of Old Spice. My grandmother bought me a tin of talcum powder, one of my aunts bought me some kind of hair preparation, and another bought me an item of something else scented. I used everything all at once in huge quantities. I mean, the air was heavy with the scent as I walked down the street.

DAN ROOKWOOD It was called Brut, and it was in a dark green plastic bottle. It used to be advertised in the 1980s by a footballer with a perm called Kevin Keegan. It was cheap and it was nasty. I used to water it down to make it last longer, and I think this greatly improved the bouquet.

RICHARD CHRISTIANSEN I cycled through all the trendy gay colognes. In college I dabbled in that awful Jean Paul Gaultier stuff when it first came out. Kenzo, Fahrenheit. It's successful marketing. The most perfect example of it.

"My dad never wore deodorant until 1976. He didn't believe in deodorant." –Euan Rellie

JAY FIELDEN The gateway drug to a button-down Polo shirt, of course, is Polo cologne. When I smell that green bottle now, it brings fantas-

between a lozenge and a sex toy. The white lettering on the black in an interesting font. I guess you have to say it was a well-designed thing.

> **"There was a rumor that went around school, around eighth grade, that Jovan Musk had some kind of irresistible aphrodisiac effect on women. I think I shoplifted a bottle, which will last you, even with heavy use, seventeen years."**
> —Walter Kirn

tic memories back to me. I don't know how I found it, but I also wore Romeo Gigli in that wacky Memphis-style bottle. My twelve-year-old son is getting into cologne now. Sometimes he comes up to me, and I say, "Whoa—what'd you do, pour that over your head? All you need is a splash!"

EUAN RELLIE We thought we were incredibly sophisticated as fifteen-year-old Etonians when we discovered Eau Sauvage.

THOMAS BELLER I don't think my dad ever worn cologne, and I've never worn cologne. I'm not someone who wants to have too much fragrance on me. But I did once buy and wear cologne for a period of time. It was called Drakkar Noir. I've seen evidence that I was not alone. That tapped into my generation, something about being fourteen, fifteen, sixteen, and it's the perfect starter cologne. The bottle was a kind of shape somewhere

GLENN O'BRIEN I love cologne. When I was a boy I probably wore something hideous like English Leather. Or Bay Rum, which I still like. My favorite is Melograno from Santa Maria Novella.

MICHAEL HAINEY To this day, if you say, "Why do you smell so good, what are you wearing?" the sad secret is that since I was twelve, I've been putting on Old Spice deodorant.

MICHAEL WILLIAMS The first cologne I remember was Polo Safari. I remember Woods, the Abercrombie cologne. I never wore Drakkar.

ROB ZANGARDI Neither my dad nor my grandfather wore cologne, but they did wear Mennen aftershave, the green liquid that burns your face.

ROBERT BECKER My father never wore cologne, but the scent of Coppertone does remind me of him

> ## "I do wear some Bay Rum, locally made."
> –Tom Schiller

and the best days of childhood. I wore something from Calvin Klein for a while in my early twenties. Andy Warhol gave all the men who worked for him what I remember as a fifth of that stuff one Christmas.

WESLEY STACE My first ever cologne was Pour Monsieur by Chanel. I wore it for one reason only: My mentor, the songwriter, Tom Robinson–with whom I toured much of the UK in my early musicianly days, and who taught me, sometimes inadvertently, a great many lessons about stagecraft and audiences–pointed me the way of it, and he always smelled very nice, so I thought I should wear that too. It simply hadn't even occurred to me to wear aftershave before then: Why would you bother? Besides, it was so expensive. I could hardly believe how expensive it was. I guess they probably still make it, but it started to smell powdery to me at some point and I gave up. And now I've wound up with Blue Noir and Wonderwood, and I basically wish people would ask me these kinds of questions much more, because I really like talking about things like this and never do.

SID MASHBURN English Leather or Brut, both short-lived. I always wanted Hai Karate though.

JEREMY HACKETT I think Brut was the first cologne I wore–foul-smelling stuff. I remember being given a bottle of Eau Sauvage one Christmas and feeling very sophisticated.

ERIC DAYTON I don't remember the brand, but it definitely had pheromones in it and was guaranteed to work. Which it did not.

Eminence Grise: Be Careful What You Wish For

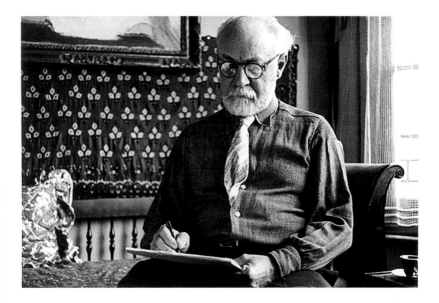

In the last few years my beard began slowly, but discernibly, to be flecked with gray hairs. Actually, flecked sounds like a light dusting of snow that may melt. It's more than that, more like a determined blizzard that's not going away with the first sunshine. That is to say, it's turning gray. I didn't overreact and start strategically clipping these foreign hairs, or worse, dyeing the beard. In fact, I welcomed the development.

It felt like this was an easy path toward being distinguished without actually doing anything distinguished, like chairing the Eastern religions department at a small liberal arts college or reimagining a Bertolt Brecht play set to a Philip Glass score. I sensed my opinion on current affairs would now be delivered with gravitas; I would take long pauses between thoughts as if I was sifting the vast wisdom of my days.

In any event, I like old men: They're direct, they're good fishermen, they wear tweed coats, they take naps. Smart ones can get away with flirting with waitresses. It doesn't end there: I like gray hair on women, the effects of age not hidden. From the streak (Mrs. Robinson, of course, and Frankenstein's bride) to the complete silver fox (Helen Mirren, first and foremost). It's the same with young women who begin to get gray hairs.

Henri Matisse

People who embrace a well-lived life are attractive, and, fundamentally, it's just nature's way.

For a few weeks I was sailing along on a sea of tolerance, goodwill, and self-satisfaction, content that I was taking the long view. Then I got over it. Day after day it became less of a novelty and merely familiar. I was slightly embarrassed that I was ever intrigued with the idea at all. I don't go in for reinvention and new looks, for men—it carries the faint air of desperation. Find what makes sense and stick with it; most dapper men I know have refined their sensibility and don't stray far from it. I've essentially had the same haircut as long as I can remember: Just cut it every few months and forget about it. Maybe some youthful shifts in the altitude of my sideburns (there was a little McCoggins era in college, but nothing convincing enough that it looked like I could have been playing bagpipes).

Essentially, it's hard to recognize change as we're living through it. You always seem to identify phases of your life after they've ended. Then you realize that you listened to the Magnetic Fields all summer or that you've moved apart from a certain set of friends, or you no longer frequent that bar. All of which is to say, my beard will probably be entirely gray and I won't even realize it until I look at photos long after the fact.

In the end, not surprisingly, I like the idea of being old in the abstract more than the fact of it. But, of course, that's not the end, that's the new reality. That soreness in the lower back, how it takes less to drink too much, the wrinkles, and the rest. In my mind, the gray beard was supposed to be a gesture, a brief acknowledgment of wisdom coming my way. But aging isn't a reference, it's not a quote, it's a novel that keeps going in real time—you just hope the author knows what he's doing.

At Leisure: A Cautionary Tale

After some months of emotional turmoil, I decided to jog one Saturday morning along Manhattan's West Side Highway. The fact that I use the word "jog" betrayed my novice status to a friend accustomed to hardcore training. "Does anybody jog anymore?" she asked with derision. Point taken. Yet what I do cannot technically be classified as running, after the persuasive opening dash from my apartment, which is merely tactical: I'm trying to get away from anybody I know as fast as I can. This torrid pace lasts about a thousand yards, before settling in a perfectly respectable pace, which lasts about fifteen minutes. It slows to the tragicomic for the final painful, wheezing five minutes when I've been passed by older men pushing strollers. I'm in terrible shape.

Saturday mornings seem like the most strategic time for my newfound outings. The West Village is not crowded, the streets freshly washed after the previous evening's vice. My virtuous morning doesn't end with my

Ramon Casas and Pere Romeo on a Tandem, Ramon Casas

elaborate post-run walk down, which is really the only part of the process I enjoy. No, I would continue, post-jog, to the Abingdon Square Greenmarket. Here I would gather my micro-greens, free-range eggs, and other natural hyphenated goods, cost be damned. I was living the self-satisfied New York life that most people can only dream of overpaying for.

And yet I didn't want to be recognized. This seemed safe at Saturday at 8:30 or 9 A.M., hours generally devoted to recovery. No girls waiting in line for some awful brunch; no weekend shoppers migrating into the boutiques enjoying favorable exchange rates. Who could I possibly run into? Well, five minutes after my first venture I ran almost directly into my college girlfriend. Now happily married with children, she looked at me with warmth, slight confusion, and a bit of alarm that I was not causing myself considerable health strain.

Without breaking stride, I made a hand gesture that indicated that I would call her, though it could have been interpreted that I was unable to speak and jog at the same time (which was probably the case). At the green market I was asked by the man who sells me eggs if I was all right. My vigorous post-workout sheen had veered from a winning glow to an unsettling red. I assured him I was fine, never better in fact, and continued on my way, convinced that some chemical was going to kick in and I would start feeling good. Unfortunately, in the next stall was an editor at the *New Yorker*. I would rather not run into an editor at the *New Yorker* while wearing shorts. It feels diminishing, somehow, and I suspect she would agree.

Oh, did I mention I was wearing a bandanna around my head? I hadn't felt the need to admit that to anybody who didn't ask. Yes, the virtuous life, nobody said it would be easy. But if you see me jogging by, show some decency and look the other way.

Reverend Robert Walker Skating on Duddingston Loch, Henry Raeburn

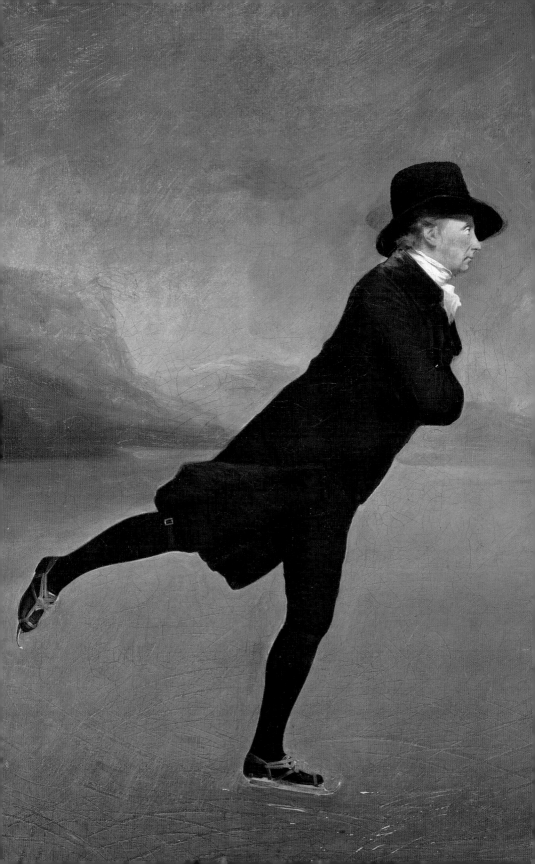

Improbable Optimists: The Angler's Ongoing Pursuit

Fishing is a curious pursuit. You set yourself up for failure again and again, though the embarrassment comes in different forms, and still manages to surprise you. Of course, there's always a chance, however remote, of success—but then when that happens, take a photo or nobody will believe you. All of which is to say: Anglers remain, at heart, improbable optimists.

We hope against hope that this time it will be different. We try our luck against the odds, but we also have to deal with metaphors. There are simply too many, and these parallels never end. There's the one that got away, of course. But don't worry, there's another fish in the sea. Maybe it goes back to *Moby-Dick*. But the metaphors are too much—sometimes, my dear, a fish is just a fish.

As young kids we visited my grandparents' house on a canal in south Texas. My sister and I would run downstairs first thing each morning to haul out the crab trap that hung off the dock. It was a big chicken-wire cube with an opening at either end, with a cylinder in the center full of gnarly chicken meat my grandmom stuck in there.

The crabs entered through the openings and fell down to the bottom and couldn't climb out. We never really understood the physics of the thing, or even why crabs like chicken. But we loved to see the blue crabs when we pulled the trap up out of the water, though we were frightened of their

Markley Boyer (Markley's father)

claws and the strange way their color shifted in the sun, like gasoline. When we had our crab dinner, my sister and I abstained; we didn't like crabs (we held out for fried shrimp). But the catch was the thing. Like scratching off a lottery ticket—the anticipation gives you a high.

That does not really qualify as fishing; the trap does all the work, and you just show up to check on it. But I was already obsessed. When I got older I hung a lure over the edge of the dock and if I was lucky caught an ugly gray catfish. They have sharp barbels that look like whiskers, and I made my uncle take them off the hook before we threw them back in the water.

At that age you simply like the possibility of catching something. These days I don't troll for catfish in Texas, but fly-fish for trout in Montana, yet the impulse is the same. You like the mystery of what's happening beneath the surface and the first sight of the fish when it comes out of the water. Not much changes as you get older; you still love the pursuit. You strategize more, you understand your failures better—though you can't always correct them. Does that sound like ageing? Wait, is this another metaphor?

One remarkable thing about fishing is the incredible capacity—in spite of all your experience—for you to feel like a novice. The more you know, the more you realize you have to learn. But even after the endless disappointment, there's still another chance. That's why we always make one more cast.

Francis Boyer (Markley's grandfather)

My father grew up fishing with his father; a lot of his gear was handed down. Rods and reels, but also small things—little tins that he kept flies in, old cigar boxes with leaders that might still have some life left in them. There were also a lot of supplies from old brands that I never knew whether they still existed anymore—the bits and pieces are really multigenerational.

I remember when I got my first fly rod, there was a very specific way you put it together and took it apart. Back then the ferrules were metal and they were a little fiddly. I remember my father always used to rub one end of the ferrule against the side of his nose, where it would pick up a little grease to go together smoothly.

THE SPORTING LIFE

"I think if you're born in the seventies and grow up in Cleveland, you don't really know any other way than the way of disaster and last-minute misery. I think that that's what I'm used to. When Ohio State wins a national championship, it feels weird, to be honest." –Michael Williams

ARMANDO CABRAL To this day I am a big fan of the Minnesota Timberwolves; don't ask me why. For some reason, when I was away and I'd never been to the United States, I didn't know where Minnesota was but I just loved the name, and Kevin Garnett is my favorite player of all time. I played soccer; that was one of the things I wanted to do. I also wanted to be a basketball player. At some point I played basketball too, but I realized I wasn't big enough. There's never been a Portuguese player in the NBA. I wanted to be the one.

STEPHEN COATES I just played cross-country smoking. Well, it's cross-country running, which you were forced to do at my school. We lived in northwestern England, where it rained every day, so cross-country smoking was where you ran far enough from the school to be able to smoke. And then ran back. I remember going through a phase of More cigarettes. I don't think they make them anymore. They were at least one and a half times as long as a normal cigarette and half the diameter. They gave you a sense of impossible glamour.

John L. Sullivan, the Boston Strongboy

WALTER KIRN I was a baseball fan. I was also a kid with a big vocabulary who wanted to be a writer. I decided at some point that the most intellectual position, the most gentlemanly position, on the baseball team was the third baseman. And the best third baseman at the time was Brooks Robinson of the Baltimore Orioles. I think it was because they were both doing something that was unheralded—fielding, and also they were preventing things from happening. It was a negative way of looking at baseball, a totally defensive way. And he was, oddly, an anonymous character. He didn't get in fights. He was like the F. Scott Fitzgerald of the baseball field.

MARK McNAIRY Sports was a huge thing in junior high school. Mainly basketball. NC State was my college team. The Carolina Cougars, you

probably don't even know what that is—but it's the Greensboro ABA team. I was a ball boy and water boy and got to be around ABA players and all the college teams—NCAA finals, David Thompson, Bill Walton, and all that. I always worked in a sporting goods store in the summer, so that's where I started making my own stuff in the back of the store with a heat press, all the iron-on letters and numbers. Just made whatever, fucking around, putting on names and numbers. At the same time in high school, in my art class, I learned to screen-print, so I would screen-print but would cut the stencils on wax paper by hand, so I was making rock-and-roll T-shirts for Paul McCartney, and things like that.

DUNCAN HANNAH I used to go with my grandfather to baseball and foot-

Young High School, New South Wales, "The Cherry Pickers"

252

ball games, because he was trying to turn me into a man—unsuccessfully. I liked the peanuts and popcorn, that's about it. And I always liked that color of the field; I liked that green. But I couldn't care less what was going on around me.

NICK SCHONBERGER I dove competitively from age six through high school, and Greg Louganis was the gold medalist and the best diver ever. My father took me to meet him. I, of course, knew nothing about Greg Louganis other than what I had—I had a tape of the '88 Olympics that I watched all the time. So I must have seen him in '89, and it was me and my dad, and hundreds of men were holding *Playgirl* magazines.

NICK SULLIVAN Growing up, I supported, technically, Arsenal, but not really. World Cup, supported England, obviously, until they got knocked out, and you'd pick the nearest country, which was Wales.

MICHAEL HAINEY I loved the Blackhawks; that was my first team. In my neighborhood I grew up playing street hockey; we played every day after school. The Blackhawks back then had legends: Stan Mikita, Bobby Hull, Tony O. Chicago is such a hockey town and I just loved playing hockey. I was raised on the North Side, but my grandparents lived on the South Side, which meant they loved the White Sox. And they took me to my first games, so I have always been a Sox fan. I really am grateful for that.

MICHAEL WILLIAMS Cleveland is a big sports town and obviously a long-suffering sports town, but I definitely loved the Browns players: Bernie Kosar, all those receivers, Webster Slaughter, and Eric Dickson, who played cornerback.

The Interior Life of Man

Michel Piccoli in *Contempt*

Fellow men of the world who are lucky enough to live on your own in a great city, I congratulate you. I would add: Make your living quarters worthy of a man who has outgrown his college dorm and the banalities of the generic bachelor pad. The good news is that the bar has been set relatively low, by such widely held cultural associations as the man cave. The assumption is that men, when left on their own, will revert to a premodern state, stop grooming themselves, have the television locked on the sports channel, and subsist entirely on takeout.

There are a few simple things you can do to counter that assumption and to prove that you are a truly evolved modern man. Of course, if you still have a black leather couch, your job is that much harder.

Downsize your TV. Your house is a not an entertainment center—you don't need a television the size of a saltwater aquarium. Your life is better than TV: You travel, you date, you read books, maybe even a novel. Your time

doesn't revolve around what's on the big screen; your apartment shouldn't either.

Rugs. Your wooden floors are shy: They don't want to be naked, they want to be covered. Get some nice rugs. It's not hard. Go to an estate sale; go to eBay. They'll be there and they won't be expensive. If you find one you're set on, get it, otherwise layer a few. It's empowering.

One good chair. Preferably two. They can be club chairs, they can be spare, they can be Danish. They can be new or old, but they should be inviting. They should call you across the room and beg you to sit down. If you have room, please do not set them in front of the television. If your chair is comfortable but unsightly or is beginning to come apart, just throw a piece of fabric over it. Nothing wrong with that. Furniture should look used, like a corduroy coat; that's why they have elbow patches.

Books. You can't have too many—unless they are stacked in so many places that you have a hard time moving. I'm suspicious of any man who doesn't have a weakness for books. Your life should be full of anthologies of letters, definitive biographies, doomed poets, forgotten painters, country houses in Finland, Japanese textiles, old Sotheby's catalogs—there's a lot to look forward to. Start buying the catalogs of every museum exhibition you see. After a few years you'll be grateful to have a personal history of what you've seen.

Good lights. Few things are less gratifying than harsh overhead lights. So get a few small side lamps. Every restaurant you like has good lighting; your apartment should too. Also some candlesticks—candlelight is terrific. It flatters rooms and, more important, faces.

The Long View. An apartment, like a wardrobe, isn't built in a day. Acquire things over time, when you travel, when you luck into a good estate sale. Don't worry, it will make sense one day, and in the end, you'll have an apartment that suits you.

LIVING ARRANGEMENTS

> **"In college, I had a neon light, with my name written in my handwriting, that I'd gotten for my bar mitzvah that I thought was ironic. But I was just a guy who had a neon sign of his own name in his dorm room."** –Randy Goldberg

STEPHEN COATES My roommate and I lived on the twentieth floor of a council flat. We stripped all the wallpaper off our walls, and it was quite minimal. We both got into Jung and talking about dreams. Every morning we'd sit in kitchen chairs opposite each other and describe the previous night's dream. It wasn't really a stylistic arrangement, but it was functional.

We'd both been through major heartbreak over relationships, and that flat became a refuge for the brokenhearted men. Who have abandoned hope, enter here. We acted as double therapists for a while, on the principle of the wounded are the best to hear.

Dal Ray Brown (Chris's father)

TOM SCHILLER It was a modest apartment in Santa Monica for seventy-five dollars a month. There was a Matisse painting, some wicker furniture, a Scandinavian bed.

FRANK MUYTJENS At art school we didn't really live in a dorm, just a house they divided up into sections: a small room with a sink. I

we got along. His side of the room was black; my side of the room was quite chaotic.

RANDY GOLDBERG My college roommate was a guy named Jonathan Hopkins, who wore a hat from the school—Hopkins—at all times because it had his name on it. And I'd come home from going

> "I went to Eton in 1981 and the new fashion was the duvet. One of the more heated debates I had with my dad was when he said, 'I'm going to go to BB Jones and if you really want a duvet, I'll buy you one. My dad had a more Protestant approach to spending money. I said, 'It's very important, it has to be at least 17.5 togs.' The tog rating was how thick and warming the duvet was. My dad said, 'I'm embarrassed we're even having this conversation. Are you telling me that you're only willing to accept a duvet that's at least 17.5 togs?' I said, 'Honestly, unless it's a proper 17.5-or-more-tog duvet, there's literally no point.'" –Euan Rellie

had an Andy Warhol poster and a Roy Lichtenstein poster. I was into Pop Art. I remember wanting to be really experimental, and I threw some red paint at the wall just to see how it would look—and also to piss off my landlord.

DUNCAN HANNAH My college roommate was Lloyd Bosca, from Englewood Cliffs, New Jersey. He was curly haired. I was lucky because

out, and he'd be in his room with giant headphones on, learning Chinese out loud, which I always found incredibly amusing.

WALTER KIRN In college, I was defiantly austere. The room was decorated with books, piled up everywhere. I think I saw books as architectural early on. I still stack books. Every way but lined up alphabetically on the shelf. I've

made tables out of books, four pillars with something on top of them.

ANDY SPADE I did have one roommate who was a stoner, named Jeff Hailey, who would try to get me not to go to class. It was my first semester at Northern Arizona University, and that was a complete disaster. I decorated with posters. I was very outdoorsy. I went up to Northern Arizona University to ski. So there were pictures of skiers skiing from those old Warren Miller films. On this white brick dorm wall, all posters of skiers, skateboarders, and surfers. That was all the decoration there was, along with a record player.

ROBERT BECKER My first apartment was above Rocco Restaurant on Thompson Street in the Village. It was a studio the size of a closet. There was just enough room for a single bed, an armchair, a bookshelf, and a dresser. George Plimpton gave me a *Paris Review* poster for my wall; I was his intern then, and I filled the shelves with books from the Strand, where I had my first paying job in the city. I was eighteen and wouldn't have cared then if it was only a closet; for me it was all about living in New York City.

EUAN RELLIE My dad always used to tell me, as a young boy, this is the way he pronounced deluxe, as "de-loox." He said, "You don't always have to have the super de-loox." I would say, "Oh no, I completely agree, but you need to have the super de-loox quite often."

RUSSELL KELLY I had this apartment in Chelsea; it was a fifth-floor corner, great space, tiny bedroom, tiny kitchen, fourteen-foot ceilings, really cool. It was the oddest thing, four closets. One bedroom, four closets. My girlfriend moved in, and I gave her *one* closet.

NICK SULLIVAN Even at university I went through phases. I bought *The Face* religiously. It came out when I was still at school, and I bought every single copy when it came out. I bought *Glimpse* as well, which was another magazine that didn't last long but was good. But *The Face* was my window into what was happening in fashion.

Some mail the author received from his father

A Conversation
with My Father

Afterword

At the end of working on this book, I sat down to talk to my dad. Here's the conversation, with some fact-checking by my mother, Wendy.

Let's talk about different clothing you've worn over the years, things that stand out in my mind. But first I wanted to ask about the crew cut you had growing up. That's so symbolic of a different era. To start with, who cut your hair?

It happened in Greece, actually. I can't remember if it was a Greek barber. I probably went to the military barbershop, and it was his idea. That was about 1958.

So it wasn't Granddad's idea, since he was in the air force?

I don't remember if he was even there. I think he may have dropped me off. It was so arbitrary, and then I had it throughout high school. It was a terrible mistake.

You had it in high school in Virginia, where you wore a letter sweater?

Right, you wore a letter sweater on game day. You had to wear a tie as well. In high school in Virginia, kids were very dressed up, almost like a prep school. Kids wore ties to school—I didn't even have a pair of jeans; the only thing I wore to school was corduroys or khakis or slacks. At J. E. B. Stuart High School it was a navy blue sweater with a big red S, but I don't even know if I put my S on it. I didn't really like it. I didn't like the showiness of it.

You were the quarterback of the team?

Yes, and I was on the basketball team.

What did people call you?

Dave. Dave Coggins. When I was young I was called David, and then I made a declaration that I wanted to be Dave. When I got older I wanted to be David again.

I think I was the same way, except people called me Davie when I was very young, which is hard to believe. How

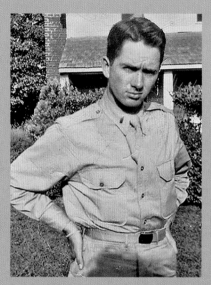

Clockwise, from top left: Col. David "Bob" Coggins (the author's grandfather), David (the author's father) in Paris, and playing quarterback for Colorado College

do you remember Granddad dressing? What was his presence like when you were young?

Granddad had to wear a uniform to work almost every day. But when he didn't, he was always dressed up. He was always paying attention to his clothes and would wear a coat and tie. He was very meticulous. And so was his father. That's part of their Southern heritage.

So what happens when you get to college? You're at Colorado College, not in Virginia, and it's a very different era.

Right. When I moved to Colorado from the East Coast my senior year of high school, I went from J. E. B. Stuart to George Washington. Big public schools. People wore letter jackets; I never wore letter jackets. There were a bunch of juniors, and they were impressed by my clothes. They called me Jim Beam, because I was always dressed up. That was even true in college, at least in my first year or two.

When do you start to grow out your hair?

As soon as I got to college. I also started to dress more hippie-like. Not really hippie, but jean jackets and army jackets and boots. More bohemian, I guess.* But I never really grew my hair that long in college.

Your mother reminded me that I had many Gant shirts from my time in Virginia. And that I owned a Baracuta jacket.

You and Mom move to Holland after college, and there are pictures of you then: Your hair is quite long; you have a beard.

That's 1970. We were in Amsterdam, where we stayed a night or two before moving to The Hague. We went shopping and I bought this incredibly tight leather jacket. It was beautiful. I said to the man in the store, "I can't wear this." He refused to sell me a larger size. I went back and said, "This is just too tight," and he said, "Sorry, I won't sell you a larger one."

Then I bought this long, black wool coat with epaulets that went down to my boots, also very tight fitting and swashbuckling. I loved that. I looked like something from a nineteenth-century romantic novel, with long hair and beard. Everything got very tight—my suits were tight, and I remember a black corduroy suit* and even a denim suit.

Your mother says this was black velvet, not corduroy.

Yeah, the denim suit, don't just gloss over that.

When we moved to The Hague there was one shop I went to, I can't remember the name, but there was a very nice man who worked there and sold me the suits. All our friends—many were students or artists—wore tight clothes, things that you would have to peel off.

You don't just go into a store and buy a denim suit—

It actually had orange trim as well, and the pants were bell-bottom. It was for a wedding in California, in Palo Alto. Good grief.

The first time we went to France as a family in 1982, you were dressed up for the flight over—you were wearing a suit and tie.

In those days flying was still a big deal. You were supposed to dress up when you got on a plane. A lot of people wore ties, or at least made an effort.

Going into your closet in later years, I was always surprised how formal the clothes were that you had from that era, English suits and ties. It seems like you've moved into more colorful Italian clothes now, and don't wear ties as much.

When we moved back to the States, we moved to Minneapolis. My hair was shorter again. No beard. That was because I was back in the Army Reserve, so I had to be a little more spruced up, and then I was working and I wore a tie and coat to work.

You went to Sim's.

So I went to Sim's . . .

How did you find that place?

It was well known. It was a place you went to get nice, traditional things. It was sort of the Brooks Brothers of Minneapolis. It had been there forever and was run by the same family.

These incredible specialty stores that don't exist so much anymore.

That's right. Then Polo came and that's where I got a lot of those fancy English-type suits. Beautiful suits. Michael Sommers used to tease me when I showed up in a tie and suit at the New French Bar, where artists hung out. He liked it, though.

I didn't know about that.

I was writing and editing and going to meetings, so wearing a suit seemed more appropriate. It was also interesting having come through the sixties and even the seventies, and then all of a sudden there was a return to dressing up and looking more formal.

You still sometimes give me a hard time about being formal, but it turns out that when we were about the same age, people gave you a hard time about the same thing.

Well, they would. Not necessarily a hard time, but they would comment on it. And some of my friends, some business people or professional people like Charlie Zelle, were always dapper. When I think back to those clothes, they were really grand.

It's funny you mention the Polo Store because I think of going there as a boy, when Paul was working—and being very reluctant. Having a blue blazer put on and not wanting to put it on all

the way, and you pulling the lapels for me and saying, "David, you have to put in on properly." It was like I didn't want to actually get into it and wear it. But I would still get a blue blazer with gold buttons every two years.

I remember you when you had your first blue blazer, with your blond hair and white pants. You wore it to a wedding in Chicago. You were nine or ten and starting to dress up.

Well, that's how it starts. First you're dragged into the store and then, later, I would always look forward to seeing Paul, who worked there for years. I loved to see him—we'd talk about clothes and dressing, and he even once sold me a pair of pumps that belonged to him.

Oh my God, he did?

Yeah, for twenty dollars, and they were very lightly worn. Not only that, he encouraged me to wear that somewhat disastrous tuxedo jacket with jeans to the prom.

I told you to do that.

Are we taking credit for that?

Yes, absolutely! I told you to wear jeans, and I even have a drawing of you somewhere wearing that.

I think it worked in theory better than practice—I wasn't quite ready to pull it off. If I saw it now I would enjoy it more.

It may have been a little ambitious. But you did it and I was impressed that you did it. I sometimes think that was sort of a turning point, down the road to more serious nattiness.

Well, the other thing I think I did, more on my own, was when I came home from a haircut with sideburns. That was even before I was listening to Morrissey. You had sideburns in the seventies, which I thought looked great—they were huge. What did you wear to your wedding, by the way?

A morning suit. It was in Chicago in 1970. I'd just gotten out of my Army Reserves basic training. The wedding was in June. I still had to keep my hair short, but you could have sideburns. So I had this short hair with long sideburns, which were sort of rebellious, I thought.

When we played tennis, you would wear a tennis sweater with a pink-and-black V-neck out onto the court. And you carried your racket in a carpenter bag—which I think now is very cool. Where did you get the idea to do that? Was it just sitting around?

Good question. I didn't buy it for that purpose. But I liked it and bought it, and then I thought about using it to carry my rackets. I didn't have any tools!

Well, I like it now—then I didn't understand it, I thought you were bringing some ridiculous bag. I also remember being very fascinated with your shaving brush and the whole process of shaving, and so you got me a little

razor without the blade so I could shave too.

Yes, that's true. I was using foam out of a can and then found this soap in a wood bowl and a brush and liked it, and then I kept doing it. I still do. And you wanted to shave too, so I took out the blades—you still inserted individual blades back then—and you would shave too.

That's funny. I shaved more then than I do now. What about cologne and fragrance? I remember the Old Spice, but I think you moved beyond that at some point.

I think I used to have Brut in college. And then this great Polo smell, which I wore for years.

I think some of those are still in your cabinet. And Eau Sauvage.

Eau Sauvage is great, though I don't wear it much anymore. I wear more Hermès these days. And Paul Smith.

As you get older you move into more bold colors. And stripes and patterns. And a more unstructured look. Except for a brief summer when you wore gladiator sandals.

I wore a lot of sandals. I always liked sandals. Even in college, I remember once getting a pair of sandals made in India and wearing them in Mexico.

You're tall. I've always thought big men can wear color well.

That's partly being athletic but also artistic and a little dandified. I didn't want to be flashy, but I liked having certain vivid looks, a striped shirt or bright scarf, but with a more conservative sport coat.

Also on Christmas Eve you make a cheese soufflé, and then you wear—I don't know how this became part of the tradition—but a pair of purple velvet slippers. How did that start?

I have no idea. I didn't want to just cook something ordinary so I thought I'd try soufflé, and Mom loved the idea—she didn't have to cook. I saw the slippers in a store in Paris on boulevard Raspail, so I bought a pair. They just felt Christmasy.

One other thing is Paul Smith, because I remember when we first started going to New York in 1990 and the store on Fifth Avenue and Sixteenth Street.

He's a big influence. He would take traditional things and update them with something eccentric or colorful, and I really responded to that. I didn't want to dress like a professional person, like a banker or lawyer, but I still liked to dress up.

And unexpected details like enameled buttons with fish on them.

Right. I think some shirts had different details, or even a jean jacket with patches of flower and fabric, and always different buttons. There was one shirt with the trout buttons and one with Victorian flower buttons.

You wear colorful scarves, and Mom and Sarah do too. You all have a lot of them, and they wear yours and you wear theirs. Is that the way to describe the situation?

They wear mine but I don't wear theirs! Whenever we go someplace like Paris or Italy, it seems we buy scarves. They are such an easy thing to buy, and they are so beautiful. When I turned sixty, you and Sarah gave me a beautiful blue scarf. I wore it that day and never wore it again. Mom and Sarah commandeered it.

Well, it's funny, we're not the same size, so I've never really worn your clothes. I've worn ties—somehow there was an idea once that I fit into a sport coat of yours that was too small for you. Now that I see photos of it, it didn't remotely fit—it went down to the middle of my thigh.

It's a pity because I still have so many nice suits.

When you lived in Holland, you bought a car?

A Triumph. We bought it in Amsterdam. It was a brand-new, brown 1970 GT6, a hatchback. Three thousand dollars. Which seemed like a lot in those days.

Where is the first place you took it on a long trip?

When we lived in The Hague we took some short trips to Germany, but the longest trip was around France. No, our first long trip was through Scandinavia. All the way through Scandinavia to the northern tip, the North Cape. We went up through Sweden and Finland and down through Norway. We were gone five weeks. It was wonderful. We even camped out a few times. A couple of years later we took a trip to France that took four or five weeks. Those were very formative years. I still think of them that way.

Portrait of the author, by his father, 2016

Contributors

Unless noted, contributors live in New York.

KAMROOZ ARAM is a visual artist.

BRIAN AWITAN is a creative consultant who has worked with Levi's, among other companies.

RICHARD BAKER is an artist represented by the Tibor de Nagy Gallery in New York.

JAY BATLLE is an artist with an upcoming show at Museum of Fine Arts in Santiago, Chile.

ROBERT BECKER is the author of *Nancy Lancaster: Her Life, Her World, Her Art*. He's currently writing a book about Hawaii.

THOMAS BELLER is the author of *J.D. Salinger: The Escape Artist*. He lives in New Orleans.

ALEX BILMES is the editor-in-chief of *Esquire UK*. He lives in London.

CHRIS BLACK is the founder of Done to Death Projects and the Public Announcement podcast.

RUSSELL BLACKMORE is the founder of Sonic Editions. He lives in London.

LESLEY M.M. BLUME is the author of *Everybody Behaves Badly: The True Story Behind Hemingway's Masterpiece The Sun Also Rises*.

MICHAEL BORREMANS is an artist represented by David Zwirner and Zeno-X Gallery. He lives in Ghent.

WILLIAM BOYD is the author of numerous books. His most recent novel is *Sweet Caress*. He lives in London.

G. BRUCE BOYER is the author of *True Style: The History and Principles of Classic Menswear*.

MARKLEY BOYER is a conservationist and board chair of the Catskill Center for Conservation and Development.

JOHN BRODIE is the vice president of content and branding at J.Crew.

CHRIS BROWN is the publisher and creative director of *Refueled* magazine. He lives in Keller, TX.

SHAWN BRYDGES is a partner in the photography agency, Brydges McKinney.

ARMANDO CABRAL is a model and the creative director of Armando Cabral, his line of shoes.

GREG CHAPMAN is a creative director.

RICHARD CHRISTIANSEN is the founder of Chandelier Creative. He lives in Los Angeles and New York.

BEN CLYMER is the founder and executive editor of *Hodinkee*.

STEPHEN COATES is a musician who records under the name The Real Tuesday Weld. He lives in London.

ERIN CRESSIDA WILSON is a screenwriter whose most recent film is *The Girl on the Train*.

SLOANE CROSLEY is the author of *The Clasp*, among other books.

ADRIAN DANNATT is a writer and curator whose most recent exhibition and publication is *Impasse Ronsin* at Paul Kasmin Gallery.

ERIC DAYTON is an owner of the men's store Askov Finlayson and the restaurant The Bachelor Farmer. He lives in Minneapolis.

STEFAAN DUPONT is a photographer and a partner of the creative agency Miles & Miles.

MARCEL DZAMA is an artist who recently designed the costumes for the New York City Ballet.

HANNAH ELLIOTT writes about cars for *Bloomberg Pursuits*.

JAY FIELDEN is the editor-in-chief of *Esquire*.

JOHN GALL is the creative director of Abrams Books.

ALEXANDER GILKES is the co-founder of the online art auction house, Paddle8.

RANDY GOLDBERG is a co-founder of Pop-Up Flea and Bombas.

PATRICK GRANT is an owner of the Savile Row tailor Norton & Sons.

HUGO GUINNESS is an artist who wrote *The Grand Budapest Hotel* with Wes Anderson.

JEREMY HACKETT is the founder and chairman of Hackett, the men's clothing line. He lives in London.

MICHAEL HAINEY is executive director of editorial at *Esquire* and the author of *After Visiting Friends*.

DARRELL HARTMAN is a writer and co-founder of the travel website *Jungles in Paris*.

DUNCAN HANNAH is an artist who is currently working on his memoir.

MICHAEL HILL is co-owner and creative director of Drake's. He lives in London.

HOLLISTER HOVEY is co-founder of Hovey Design and the author of *Heirloom Modern*.

MATT HRANEK is a photographer and the men's style editor at *Condé Nast Traveler*.

AL JAMES is a writer and musician, who lives in Portland, OR.

RUSSELL KELLY is the head of Tudor Watch.

BYRON KIM is an artist represented by James Cohan Gallery.

WALTER KIRN is the author of numerous books, including *Blood Will Out*. He lives in Livingston, MT.

HIROFUMI KURINO is the senior advisor for creative direction at United Arrows. He lives in Tokyo.

AARON LEVINE is the vice president of men's design at Abercrombie & Fitch. He lives in Granville, OH.

GLENN LIGON is a visual artist.

J.C. MacKENZIE is an actor currently starring in HBO's *Vinyl*.

SID MASHBURN is the founder of his own line of men's clothing and retail shops. He lives in Atlanta.

JAY McINERNEY is a writer whose most recent book is *Bright, Precious Days*.

MARK McNAIRY is the designer and creative director of Mark McNairy New Amsterdam. He lives in Los Angeles.

DERRICK MILLER is the founder and creative director of Barker Black and Miller's Oath.

FRANK MUYTJENS is the men's design director of J.Crew.

SHIN NAKAHARA is the founder of Landscape Products. He lives in Tokyo.

GLENN O'BRIEN is a writer, editor, and talk show host.

MAUREEN O'CONNOR is the sex columnist for *New York* magazine.

TUNDE OYEWOLE is a lawyer who lives in Paris.

BRUCE PASK is the men's fashion director at Bergdorf Goodman.

ANTHONY PECK is a writer, producer, and mountaineer. He lives in Aspen, CO.

ENOC PEREZ is an artist with an upcoming solo exhibition at the Dallas Contemporary.

JOSH PESKOWITZ is the co-owner of the Los Angeles men's store Magasin.

POGGY is the fashion director of United Arrows & Sons. He lives in Tokyo.

EUAN RELLIE is a senior managing director at BDA Partners.

WALTER ROBINSON is an artist and critic who recently had a survey of his paintings at Jeffrey Deitch.

DAN ROOKWOOD is the U.S. editor of *Mr. Porter*.

TIM SHIFTER is executive chairman of the American leather goods company J.W. Hulme Co., and senior advisor to the private equity group at Blackstone.

TOM SCHILLER is a comedy writer and filmmaker. He lives in Connecticut.

NICK SCHONBERGER is a writer and editor. He lives in Portland, OR.

TAAVO SOMER is a designer and owner of Le Turtle, Freemans, and other bars and restaurants.

ANDY SPADE is the founder of Jack Spade, Sleepy Jones, and Partners & Spade.

ANNA SUI is a fashion designer.

WESLEY STACE is a writer and musician who has released albums under the name John Wesley Harding. He lives in Philadelphia.

WHIT STILLMAN is a director whose most recent film is *Love & Friendship*.

NICK SULLIVAN is *Esquire*'s fashion director and editor of *Esquire*'s *Big Black Book*.

GAY TALESE is the author of fourteen books, the latest, *The Voyeur's Motel*, was optioned in 2016 by Steven Spielberg.

TAYLOR TEHAN is a designer and co-owner of Maconnais, a clothing company in rural Texas.

GUY TREBAY is a style reporter and chief menswear critic at the *New York Times*.

MADELINE WEEKS is the fashion director at *GQ* magazine.

DON WEIR is co-owner of the STAG men's stores. He lives in Austin.

JP WILLIAMS is a creative director and co-founder of the agency Design MW.

MICHAEL WILLIAMS is the founder of the website A Continuous Lean and a partner at Paul +Williams. He lives in Los Angeles.

CINTRA WILSON is a writer whose most recent book is *Fear and Clothing: Unbuckling American Style*.

NICK WOOSTER is a fashion director and designer.

ROB ZANGARDI is a stylist and a partner in the firm RandM. He lives in Los Angeles.

Acknowledgments

This book is about the best qualities of the men I admire. I'm grateful to all those who sat down for interviews, shared photographs, and opened up about what they wore to prom: Their spirit of generosity and good humor is an example to all of us.

Key insight and aid came from Stephanie Chao, Wes del Val, Glenn O'Brien, Jenny Pouech, and Kat Irlin.

Particular thanks to:

John Gall, who designed the book with his usual combination of knowingness, wry humor, and singular good taste.

Stephanie Koven, my agent and favorite lunch partner, who saw this project through from beginning to end and made sure everything got done. She's the good cop even when she's supposed to be the bad cop.

Rebecca Kaplan, my editor, who oversaw my specific demands with grace, insight, and a welcome amount of indulgence. It's not always easy to deal with an author with strong opinions about commas.

Abrams, who supported this book and helped get it out in the world in the way we all wanted.

Everybody at Janklow & Nesbit, who laid the groundwork for this project and then helped in countless ways.

Also the invaluable counsel of my good friends: Randy Goldberg, Michael Williams, Taavo Somer, Aaron Levine, Megan Wilson, and Duncan Hannah.

Finally: my father, David; my mother, Wendy; and my sister Sarah, the first people of style and substance in my life.